IMAGES
of America

FOX HILL ON
THE VIRGINIA
PENINSULA

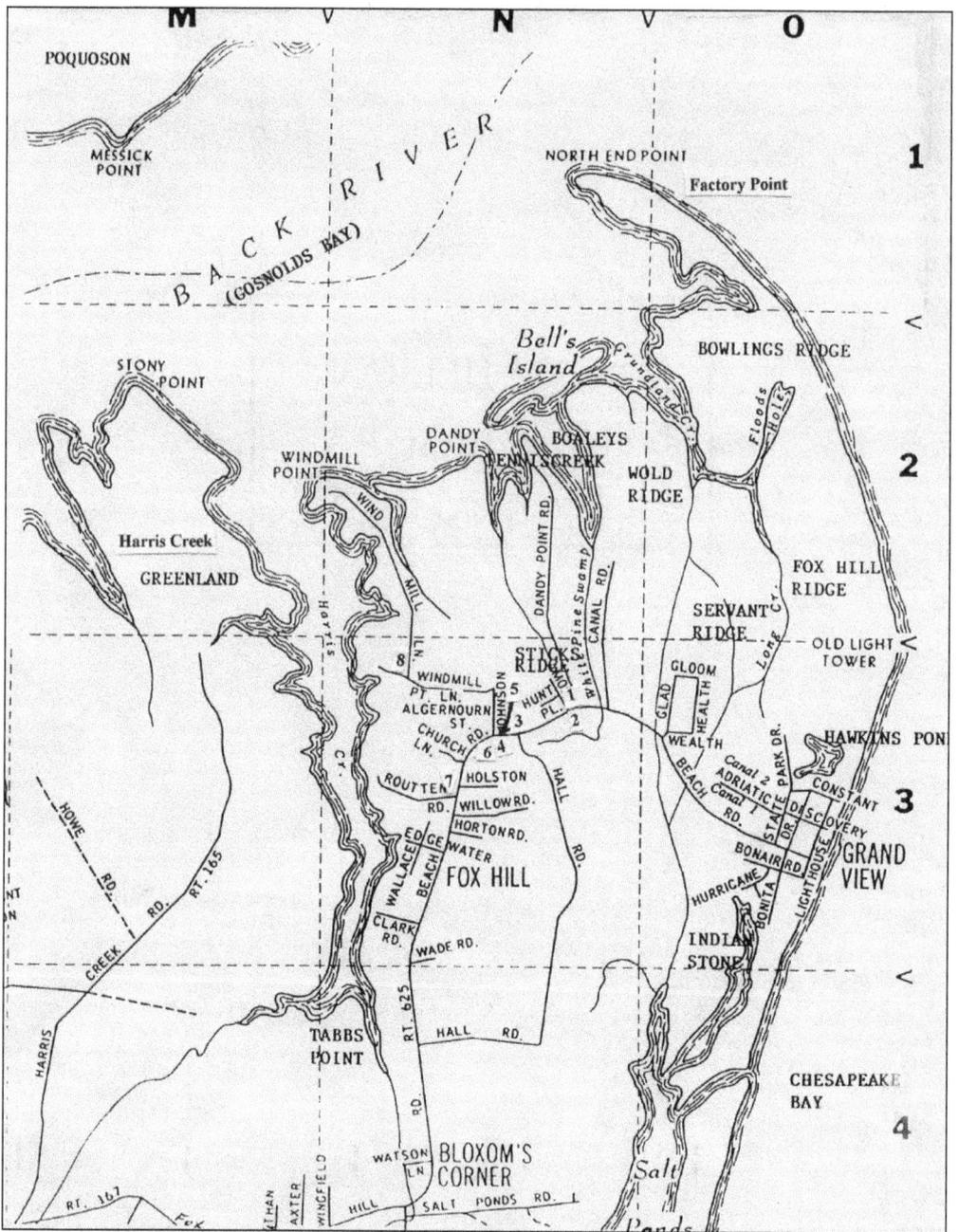

This is a map of Fox Hill marking important locations in the area. The numbers correspond to the locations of the following store owners: (1) Rob Wallace, (2) James Johnson, (3) Jeff Johnson, (4) Jack Wyatt, (5) Ben Rowe, (6) George Watson, (7) Richard Routten, and (8) William Wallace.

IMAGES
of America

FOX HILL ON THE VIRGINIA PENINSULA

Fox Hill Historical Society

ARCADIA
PUBLISHING

Published by Arcadia Publishing
Charleston, South Carolina

Library of Congress Catalog Card Number: 2003112427

For all general information contact Arcadia Publishing at:
Telephone 843-853-2070
Fax 843-853-0044
E-mail sales@arcadiapublishing.com
For customer service and orders:
Toll-Free 1-888-313-2665

Visit us on the Internet at www.arcadiapublishing.com

Contributors to the production of *Images of America: Fox Hill* include the following: Katie Evans Arredondo, Marjorie Gage Ballard, Melodye Ballard, Ann Johnson Behm, Gloria Elliott Case, Howard Cole, Jennifer Congleton, Sandy Dennis, Melodye Dorst, Marian K. Elliott, Betty Wallace Evans, Shirley Mason Green, Jack Hall, Mary McElheney Hall, Robert E. Horton, Patricia H. Horton, Janice S. Hurst, Elizabeth Clark Joynes, Marshall Johnson, Martin "Marty" Johnson, Nancy Bazemore Kearney, Rosemarie Arredondo Kidd, Mildred Lewis, Carolyn Johnson Lingenfelser, Ann Wallace Masters, Linda Wallace Melson, Gwen B. Milholen, Ruby Smith Morris, Ann Evans Perry, Judy Clark Riss, David C. Routten, Phillip Routten, Virgil Rowe, Edward M. Smith Jr., Mary Watson Smith, David Stewart, Barbara Johnson Wallace, Carl Wallace, David H. Wallace, John T. Wallace IV, Katherine K. Wallace, Raymond C. Wallace, Brenda Thomas Watson, Judith Lewis Woolsey, and Betty Harper Wyatt.

CONTENTS

ACKNOWLEDGMENTS

The Fox Hill Historical Society would like to acknowledge the following: Charles Alston, Katie Evans Arredondo, Marjorie Gage Ballard, Melodye Ballard, Ann Johnson Behm, Fred B. Case, Gloria Elliott Case, Jennifer Andrus Congleton, Sandy Dennis, Melodye Dorst, Marian K. Elliott, Betty Wallace Evans, Shirley Mason Green, Robert E. Horton, Patricia H. Horton, Elizabeth Clark Joynes, Janice S. Hurst, Marshall Johnson, Nancy Basemore Kearney, Rosemarie Arredondo Kidd, Mildred Lewis, Carolyn Johnson Lingenfelser, Linda Wallace Melson, Gwen B. Milholen, Ruby Smith Morris, Ann Evans Perry, Judy Clark Riss, David C. Routten, Phillip Routten, Virgil Rowe, Edward M. Smith Jr., Mary Watson Smith, David Stewart, Barbara Johnson Wallace, Carl Wallace, David Hornsby Wallace, John Thomas Wallace Jr., Katherine Kautz Wallace, Raymond C. Wallace, Brenda Thomas Watson, Betty Harper Wyatt, and Judith Lewis Woolsey.

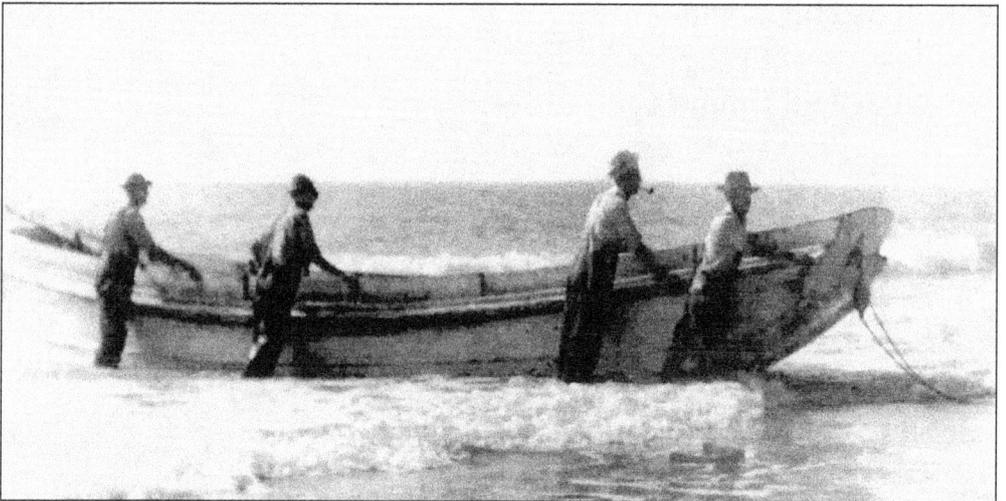

From the 1800s through the 1940s, pound net fishing was the main livelihood of Fox Hill men. Locally built pound boats could be brought through the surf and up on the beach at day's end. Pictured above, left to right, are the following: Marshall Johnson, Harry Johnson, Wilbur Johnson, and Rowe Jenkins.

INTRODUCTION

Before April 26, 1608, when the English ships *Discovery*, *God Speed*, and *Susan Constant* sailed the entrance to the Chesapeake Bay, Native Americans populated the area of Hampton known as Fox Hill. According to research of local genealogist, Hugh S. Watson, "Elmer Phillips of Elizabeth City County, Virginia bought 100 acres near unto Fox Hill known by the name Indian Spring." Residents of Fox Hill have found arrow heads, axe heads, oyster openers, and other tools made of stone left by these earliest residents. The Indian stone found was an early Indian health spa. After hunting game or fishing, the Indian stone was heated red hot and tented. Water was poured on it, which released steam that gave relief from body aches and pains. Afterward, they would leap and jump into the surf of the Chesapeake Bay off Grandview.

Time, erosion, and land development has altered the bay shoreline and peninsula of land known as Fox Hill, a suburb of Hampton, Virginia. The Fox Hill Historical Society is eager to continue the research begun by sisters-in-law Manola Patterson Clark and Virginia Johnson Clark, and continued by friend Charles Elliott. Since 1800, when waterman arrived from up the bay, Fox Hill has grown into a nurturing community where family life flourished and hard work was fulfilling. With the combination of seafood harvest, farming, plentiful wild life, and a strong belief in God, the village of Fox Hill was independent and caring for its citizens, most of whom are related by blood and marriage. Estelle Lewis Clark said, "We were poor by world standards but we never realized that we were poor because we had shelter, clothing, food and family." If tragedy struck, neighbors were ready to give a helping hand.

One of the members who came together to work on our book was David H. Wallace, who tirelessly compiled text and pictures in the original draft copy. He also contributed from his picture collection. Additionally, we appreciate the work and contributions of the following committee members: Katie E. Arredondo, Judy C. Riss, Rosemarie Kidd, Marjorie G. Ballard, Melodye Ballard, Ann J. Behm, Jennifer Congelton, Brenda T. Watson, Judy L. Woolsey, Carolyn J. Lingenfelser, Ann E. Perry, David Routten, and Marian K. Elliott.

The book contains photographs from 1850 to the present. Chapter one introduces some of our watermen and pound net fishing, once a way of life that has gone into past memories. Chapter two is a drive down Beach Road from First Methodist Church to Grandview and the shore of the Chesapeake Bay. Chapter three has some of our family members, and chapter four has our home grown heroes, who served in the Civil War, World War I, and World War II. There are many faces and places from our past, but all will remain forever in our memories.

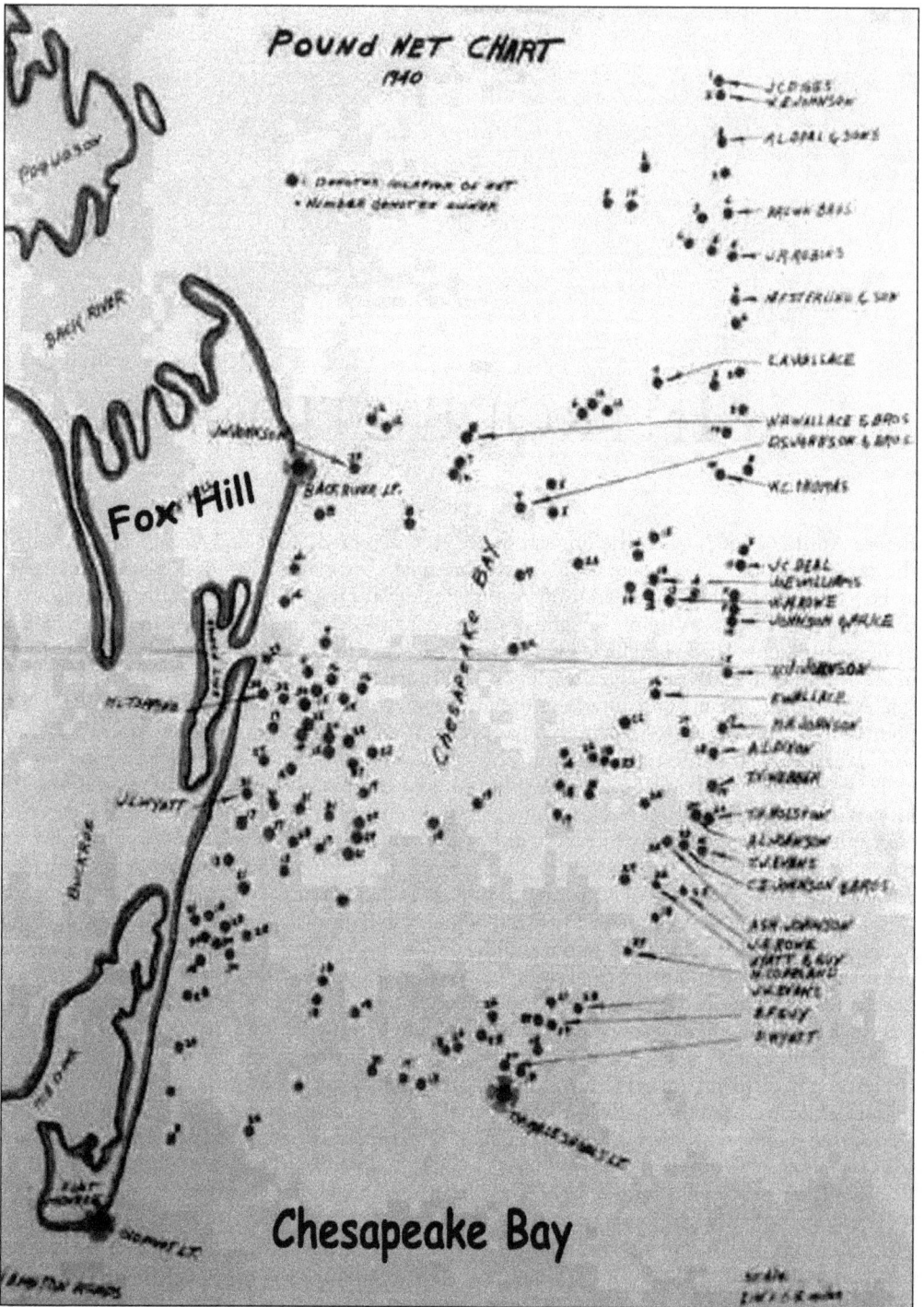

This map/chart, prepared by the federal government, identifies all the pound nets set off of the shoreline directly in front of the entrance to the Chesapeake Bay. Patrols provided security and protection, especially during World War II against German U-boats.

One

FISHERMEN, POUND FISHING, AND WATERMEN

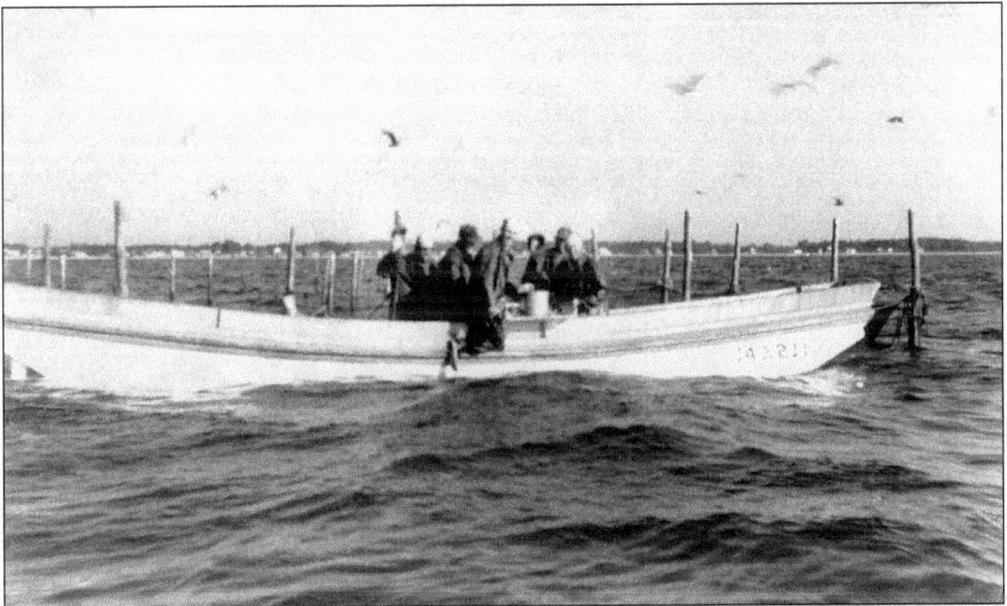

Pictured above are, from left to right, Johnson Evans, George Evans, John William Evans, Joe Evans, Boo Top, and Captain Johnny Evans (Papa Johnny). The Evans brothers are fishing their pound nets off Buckroe Beach, Elizabeth City County, now the city of Hampton, Virginia. They worked the waters of the Chesapeake Bay from Old Point Comfort to North Point (Factory Point). The pound boats were built and used exclusively by the fishermen of this area, as were the pounds (pole and net fish traps). Today, this way of life is gone.

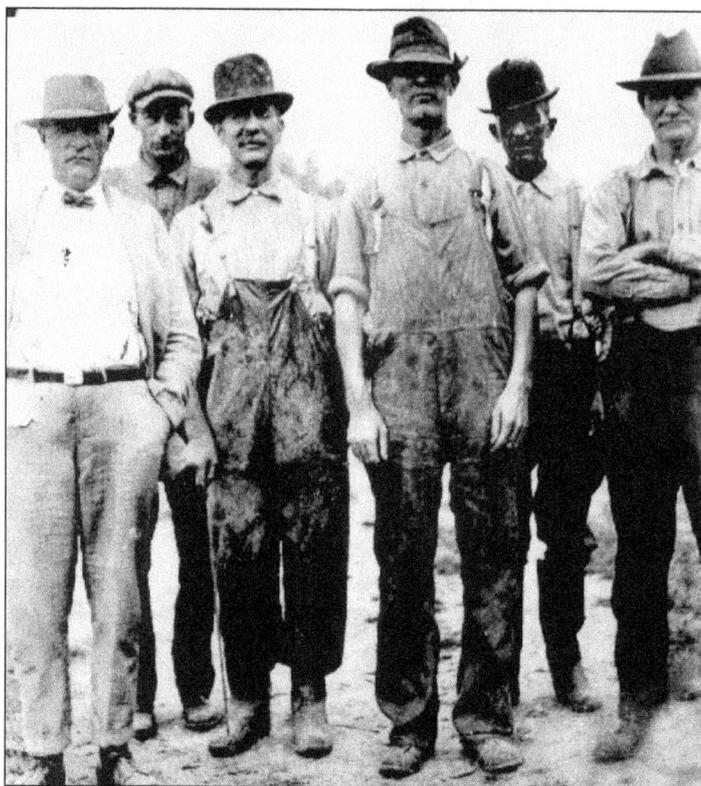

From left to right, Nick Dixon, Garland Evans, John Evans, Frank Horton, P.J. Routten, and Tom Evans fish the Chesapeake Bay c. 1910. They fished pound nets in pound boats from North End Point (Factory Point) to Old Point Comfort. This shoreline is directly across from the entrance into the Chesapeake Bay. The fishermen pictured had homes in the fishing village of Fox Hill but had fish camps at Buckroe Beach.

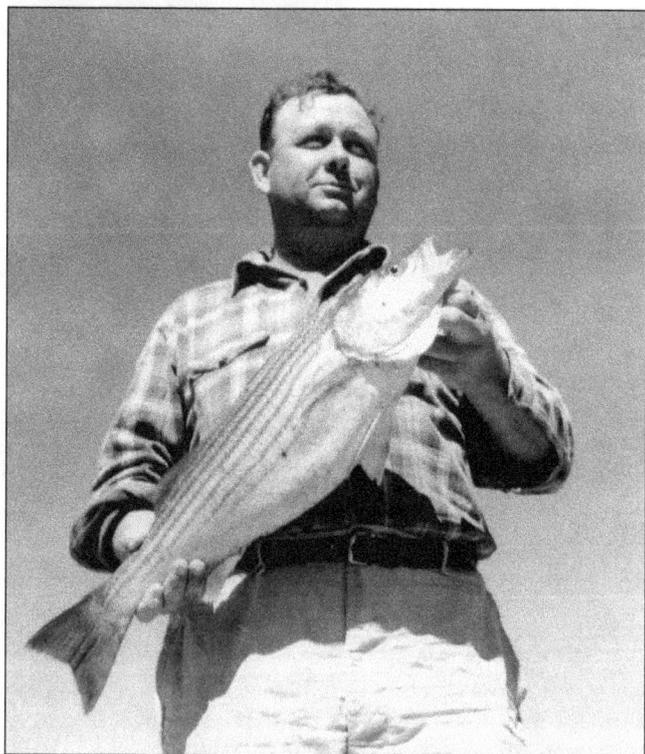

Not all fishing was for "work." Alonza Wyatt Clark ("Babe") had a good day on the bay when he caught this rockfish in 1952.

David Wyatt (1865–1940) was a Fox Hill fisherman. He lived his entire life in Fox Hill. He married twice. The first time was to Madge Johnson, daughter of "Dipper" Johnson. He next married Annie Spencer and raised three children: Elmer "Buddy," Nora, and Nell. When his daughter Nell Wyatt Gage (who was married to Richard Lee Gage) died, David raised his granddaughter Nell Gage. His sister is Jennie Holston, and Robert Horton is her great grandson.

David Wyatt's home is located on Wyatt Lane, now Horton Road. Robert Horton Sr. now has a ranch house at this address.

Jesse M. Routten (1873–1949) was a local waterman. He was licensed by the U.S. Department of Commerce, Bureau of Navigation and Steamboat Inspection, to operate vessels of 15 gross tons or less to carry passengers for hire. He also raised terrapins for sale in addition to pound fishing. Jesse is David and Ida Routten's grandfather and Clifton Routten's father.

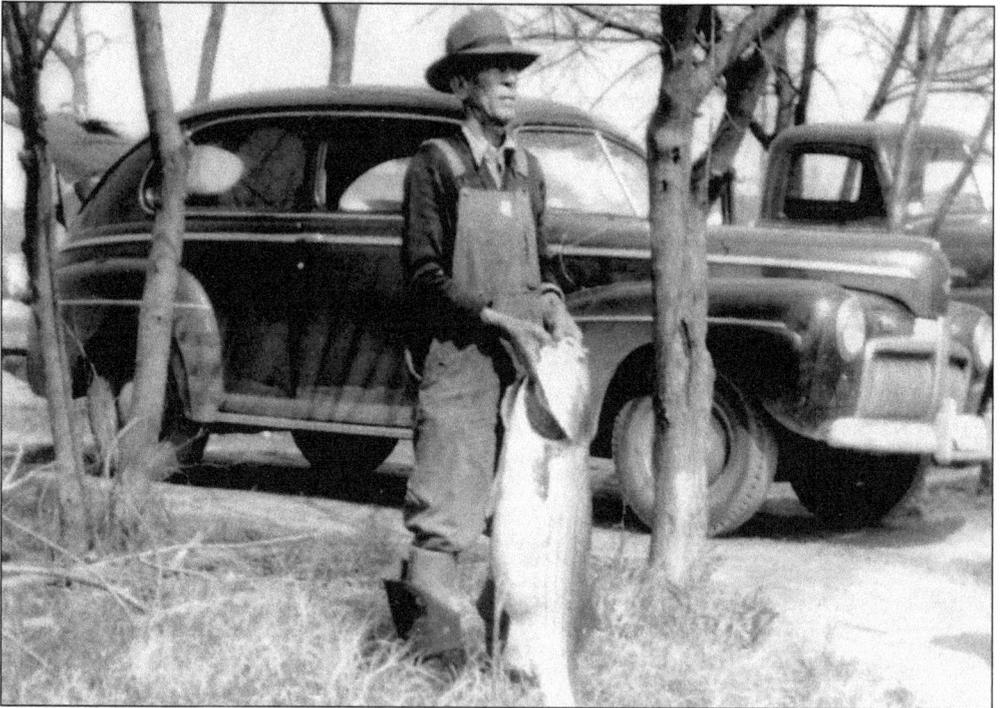

Edward Taylor Lewis, born February 9, 1892 and died December 8, 1982, was a lifelong Fox Hill resident. He and his brother, Rosser, were fishermen and had a camp on "the Boulevard" in Hampton. He always wanted to look his best, so he would wear a suit and tie to work and change into his work clothes at the camp. He changed back into his suit before going home after work. He is pictured with a very big rock fish.

From left to right, Hugh Horton, Edwin Horton, and Walter Jackson separate fish just caught in a pound net owned by the Horton brothers. Hugh and Edwin's father, Frank Horton, started the business many years earlier. The Hortons would set up as many as six pound nets every spring. This picture was taken by a friend of the Hortons on a early spring morning of April 1950 off Buckroe Beach in the Chesapeake Bay.

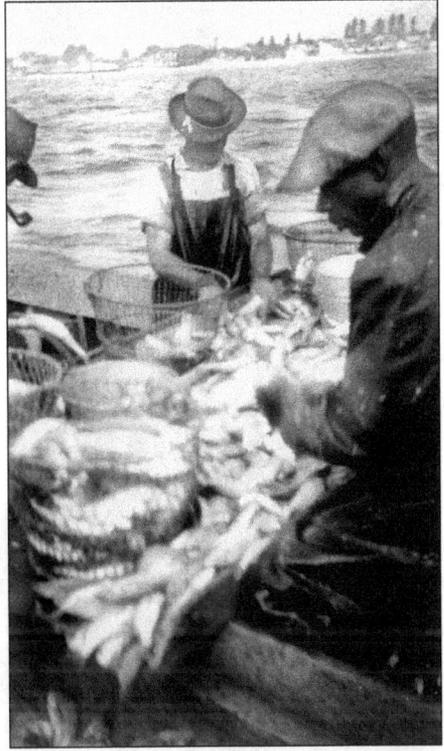

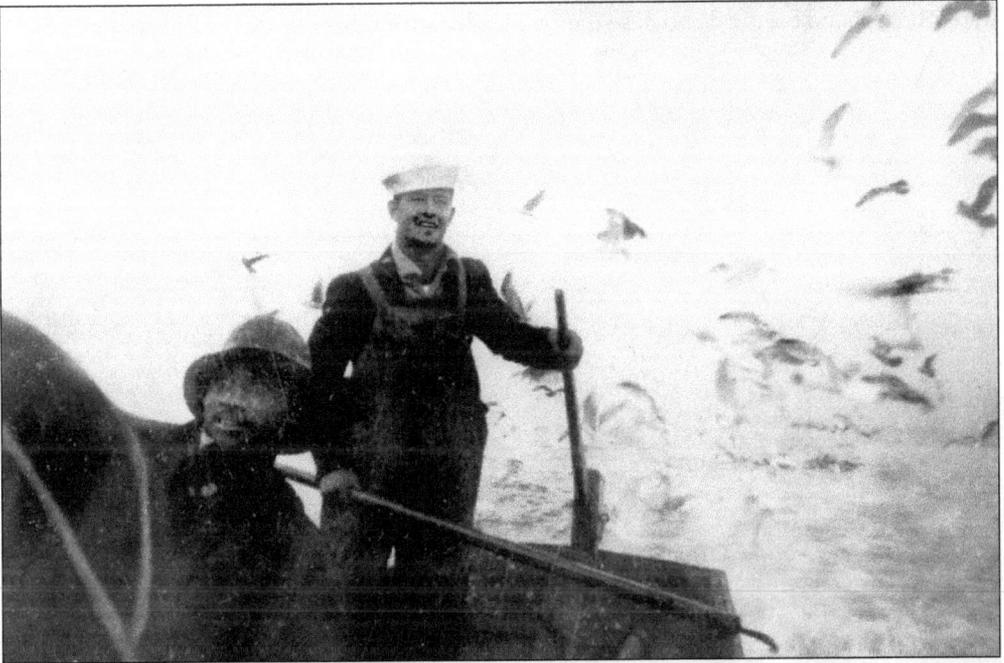

This early spring scene on the Chesapeake Bay off of Buckroe Beach took place in April 1941. Pictured is Edwin Horton standing on the stern (rear) of the pound boat, steering the boat into position to fish a pound net. In front of Horton is Walter Jackson. The photo was taken by a friend of Edwin Horton.

This is a "buy" boat in Back River in 1920. After the packing plant at Factory Point was destroyed, the fishermen in Fox Hill sold their fish to this buy boat. Notice how low in the water these pound boats ride because they are loaded with fish.

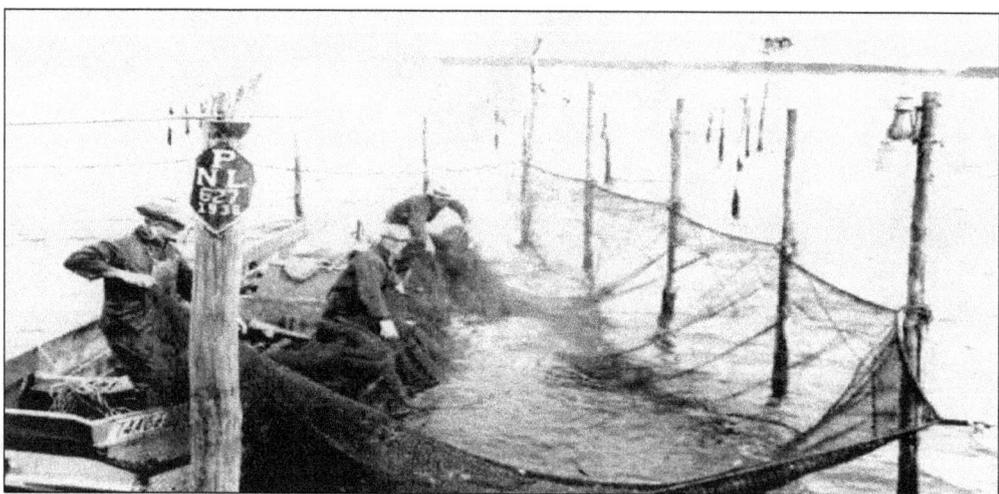

These men of Fox Hill—Frank Horton, Hugh Horton, and Edwin Horton—are pound fishing in Chesapeake Bay off Grandview Beach in the 1930s.

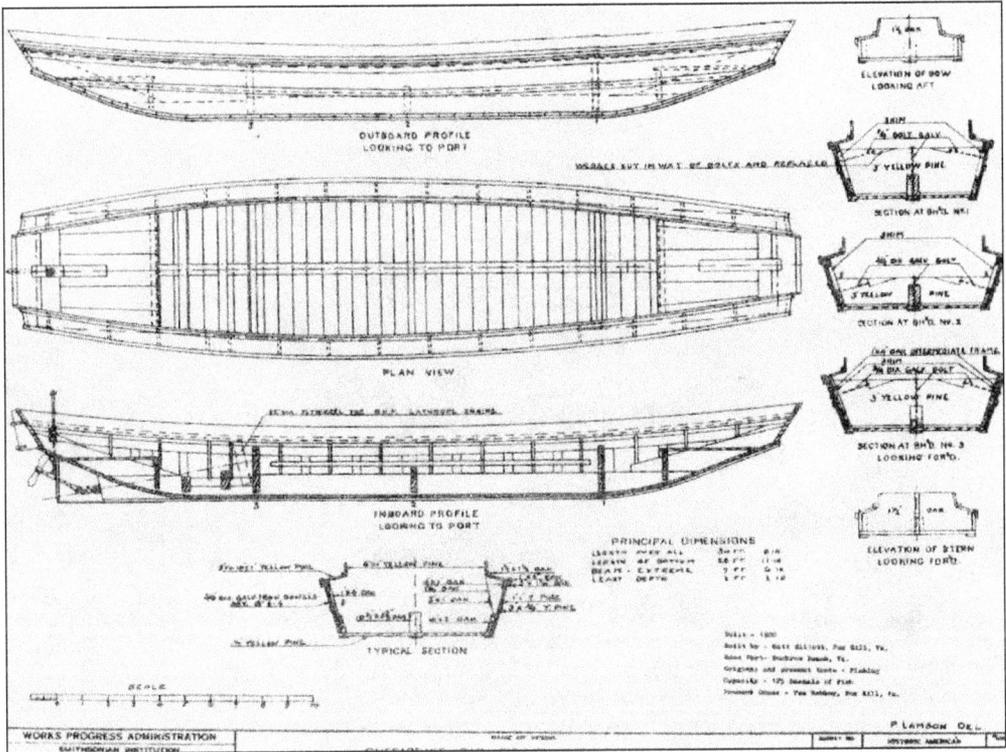

These are blue prints of the pound boat. The pound boat was built and used only in the Fox Hill area.

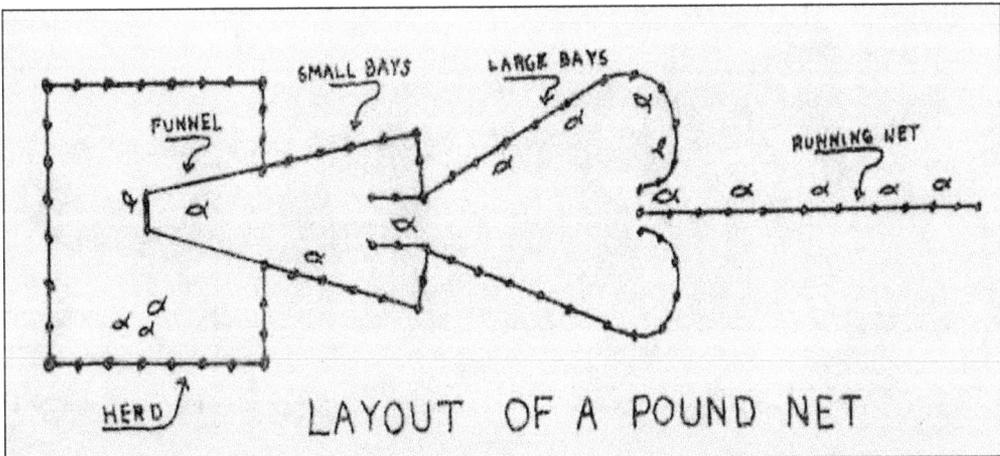

The running net is called the hedgen and the bays are called the fykes. These words came from the Algonquian language spoken by the Kecoughtan and Powhatan Indians who lived in the area before settlers from Europe arrived.

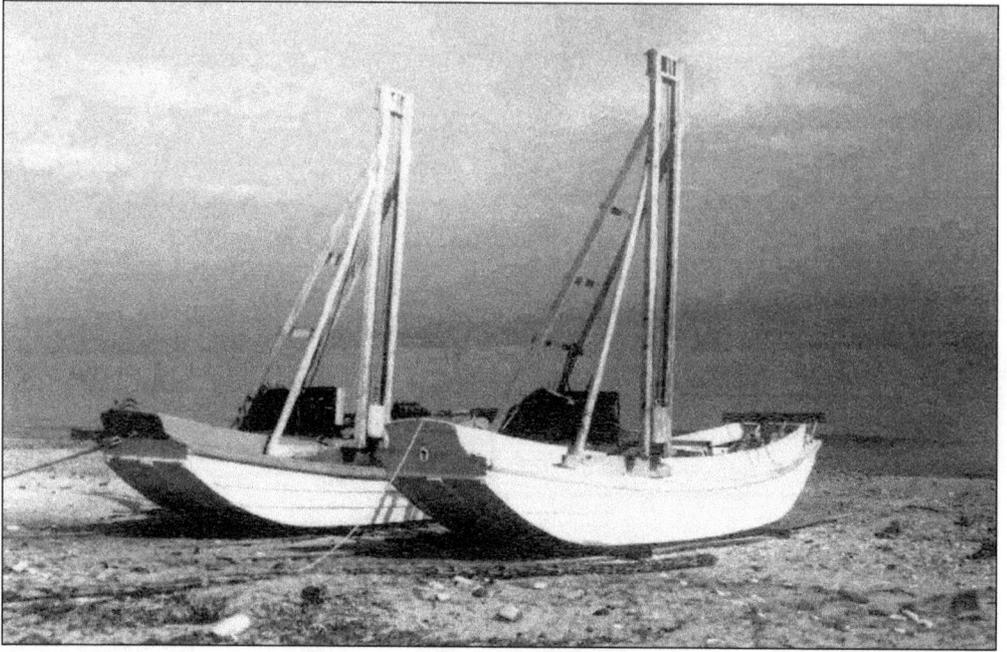

For many years, pound net fishing was the main livelihood of the men of Fox Hill. The pound net is a large stationary fish trap used in the Chesapeake Bay. It is made from heavy net and held in place by wooden poles that are driven into the bottom. The pile driver, attached to the pound boat, was used to drive these poles into the bay floor. Once the pounds were complete, the drivers were removed from the boat until they were needed again.

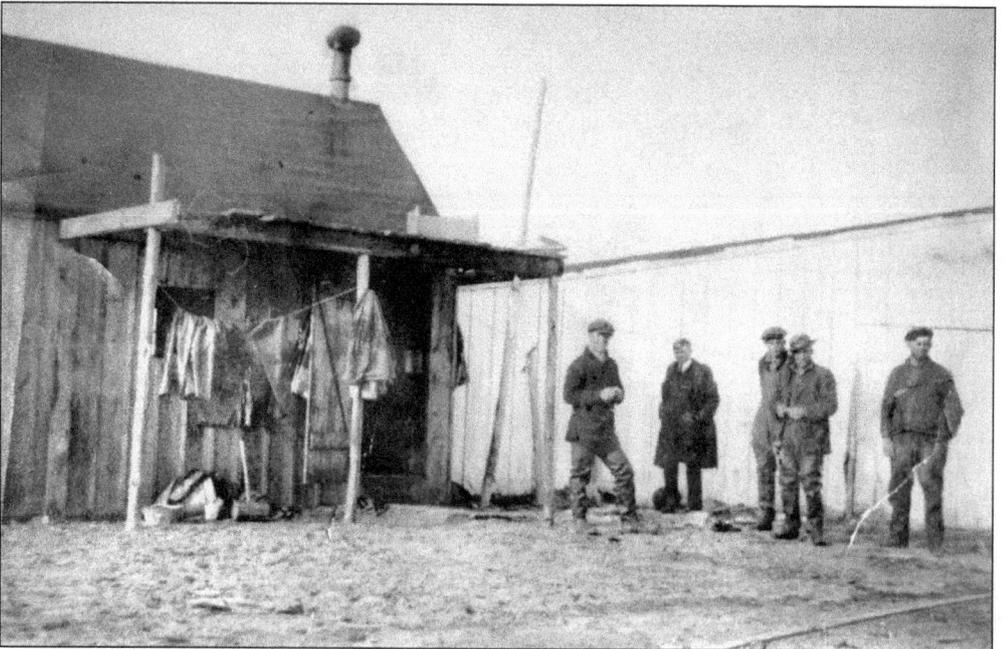

Fish camps were the base of operations for the fishermen along the shoreline of the Chesapeake Bay. Each camp included a shanty where the men ate after fishing their nets. Pictured is a typical camp site.

16

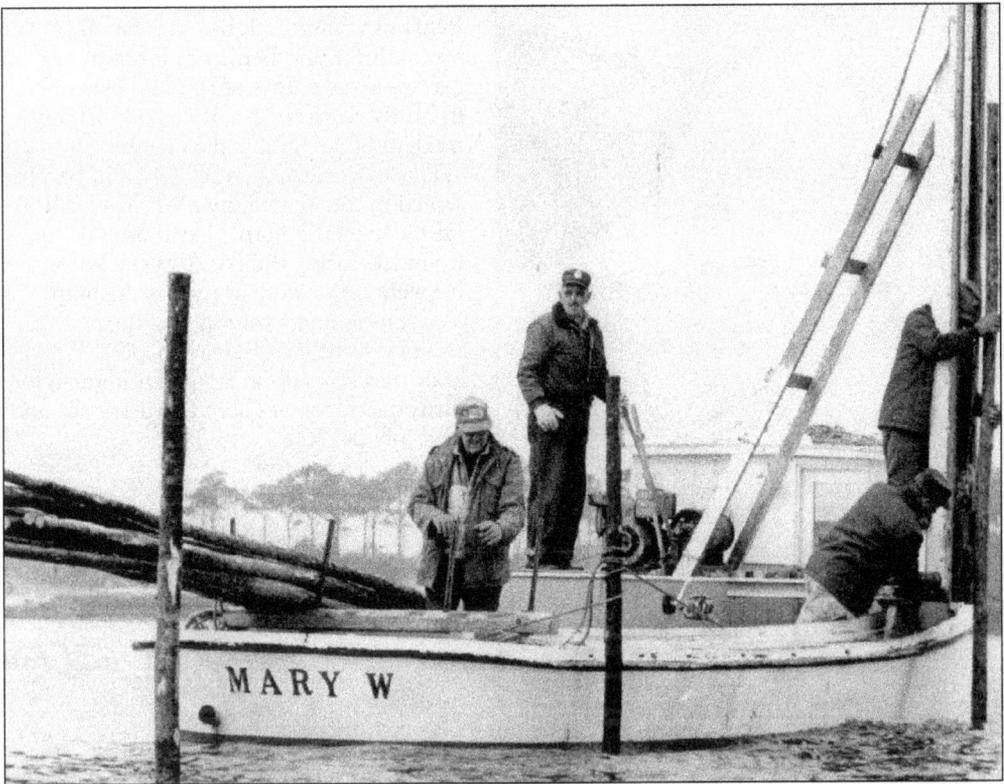

George Evans, Calvin Williams, Irving Wallace, and Bennie Wallace work the boat with a pile driver attached. The pile driver was attached to the boat, usually in the early spring or late winter when the poles needed to be replaced. This was the "shad run" in early spring.

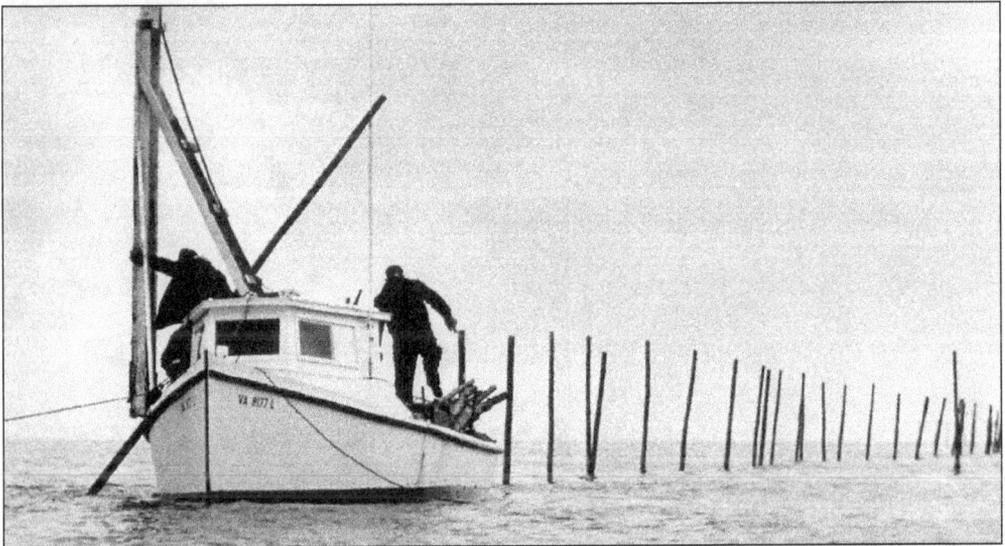

By 1980, the Chesapeake Bay Deadrise had replaced the pound boat. Here, Irving Wallace is driving pound poles using the new Deadrise. The Chesapeake Bay Deadrise, the official state boat of Virginia, is a wooden boat with a sharp bow, a small cabin, and a long cockpit, and it is used for crabbing, fishing, and oystering.

Benjamin Franklin Johnson ("Ben Jr."), son of Burke and Benjamin Johnson Sr., expresses the nature of Fox Hill fishermen in his fishing gear. A native and lifelong resident of Fox Hill and a member of Wallace Memorial United Church, Ben Jr. served in the army during World War II. He received the Purple Heart after being wounded during the Battle of the Bulge. He went on to work at the Kecoughtan Veterans Administration, retiring as a security guard and fireman in 1972. He was known in Fox Hill as an avid fisherman for many years. He was born April 1, 1921 and died July 24, 2003.

Vernon Johnson, Ben Jr.'s brother and son of Burke and Benjamin Sr., remembers starting to work with his father at age 18. They worked six days a week on the pound boats. Vernon used to work at Fort Monroe.

The Oyster House is located at end of Edgewater Road and owned by William Wallace. Carl Todd, Brad Todd and Bishop Guy own the pier. Pictured from left to right are Ilma Dixon Lewis, Eva Rowe Weikel, and Eleanor Lewis Houston. Oyster houses were rough wooden structures built along the shore line of Harris Creek. The oyster men would often have a wood stove burning inside these structures to provide warmth as they shucked (opened) oysters. This process involved using a drill and a heavy metal "knife" to pry open the shell and remove the muscle. Several of these houses were located along the banks of the creek, at the end of Edgewater Road, and along an inlet of Harris Creek on Routten Road. Several were owned by brothers who were watermen: Jesse Routten, David W. Routten, and Peter Routten.

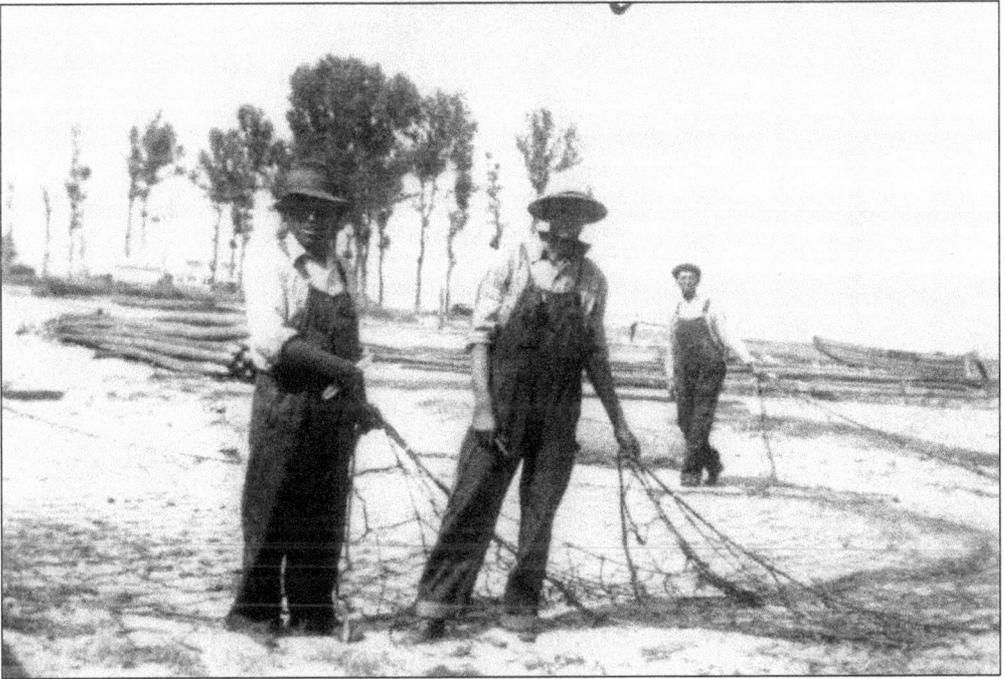

Watermen mend nets at Grandview Beach in the 1940s. Pictured from left to right are John Price, Marshall Johnson, and Edward Watson.

Linwood (Pappy) Wallace enjoyed both writing poetry and hunting, as you can tell from his poem.

Hang Loose—To Shoot a Goose

Elroy and Jimmy bless their hearts
knew what they wanted from the very start
That crew is always hanging loose
when they go to Eastville to shoot a goose
We arrived on the river at 5 a.m.
loaded the floater and the hunt began
Out through the sand bars we did go
dark as pitch and the tide was so low
Six inches of water cause some grief
but Elroy put her out on the reef
Out went the decoys at his command
couldn't see the stars not even the land
The clouds were low but the fog was thin
the day light hours had just began
A lot of honking was not too far
the skipper said "There on the bar"
Then out of the fog on cupped out wings
came a flock of geese with lots of zing
At Elroys's command "Take them boys"
those magnum guns made a lot of noise
At 1 o'clock when the hunt was over
there were five geese on the bow of the floater
Now a little advice my shooting friend
happy hunting to you I extend
You can shoot deer, bear, and moose
but you have never hunted till you shoot a GOOSE!!!

Blue Bill Blues

The duck season for 76-supposed to be good-
but it is mighty sick
We have had some cold, we have had some rain-
with a little snow upon the pane
We still remember in our minds-
the heavy winds that wrecked the blinds
Patiently we watched the stake-
hoping for a flock to take
Blue Bills today, we could bet our boots-
but all we got was a flock of coots
A little story—I'll tell you mate-
this duck season is getting mighty late
Jake, Dud & crew just had on their minds-
to get out there in the floater blinds
They filled the tank to go afar-
went out way on Plum Tree Bar
They are trying hard to take up slack-
by shooting at some canvasback
Elroy & crew are hanging loose-
hoping to kill a Canadian goose
Skinner & crew say we will get one soon-
their goose turned out to be a loon
Our bunch is trying with all our might-
not to shoot the ducks at night
But if the blues don't come mighty soon-
we will have to take them by the moon
Carl & Charlie have a lot of guts-
to leave at five & freeze their butts
But out they go with a bunch of shells-
boy what a story they could tell
Blue Bills and scooters were part of the loot-
and dinner for all with the breast of coot
Pappy and Grady bless their souls-
the echo's—you could here them roar
Eight shots rang out—the ducks flew on-
to lite upon another pond
I can't make fun of those shots you see-
because six of those shots belonged to me!!!

Linwood (Pappy) Wallace

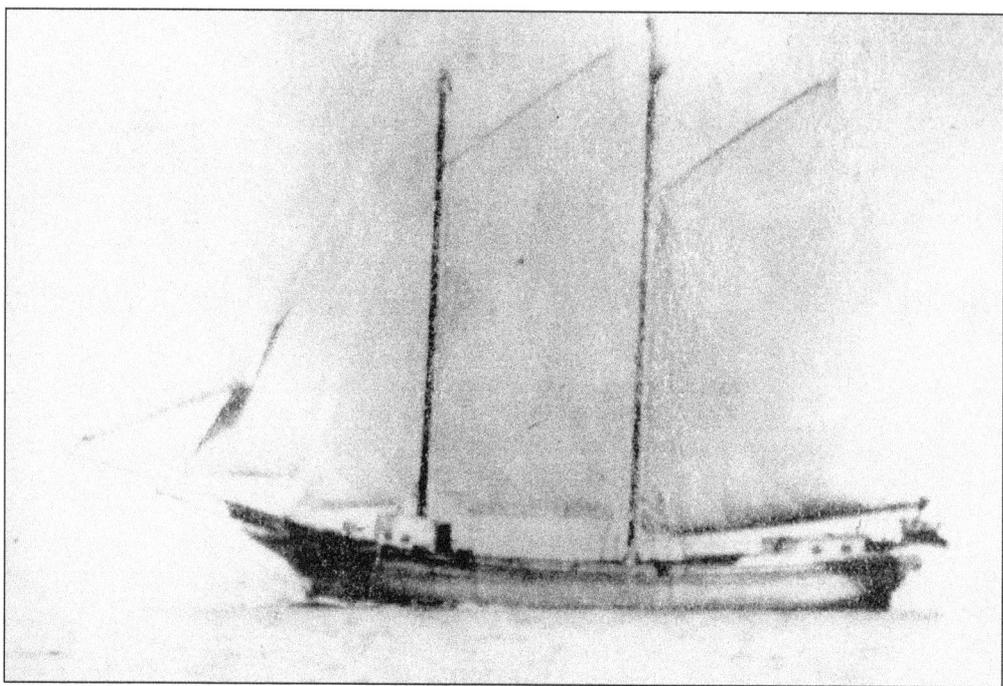

The OS *Bozeman* was owned by Gene Johnson. The *Bozeman* was a two mast, 65-foot Brogan (skipjack) with Sharpe at both ends and a false drake tail deck. It was later converted to one mast and powered by a 36 horsepower, three-cylinder Laythrope gas engine. It was a "buy boat" that was used at Factory Point to haul fish to Hampton for sale. The boat was run by Wallace Johnson, the son of Gene Johnson, who ran the fish packing pier at Factory Point. He took fish to Newcomes in Hampton around 1919 and 1920.

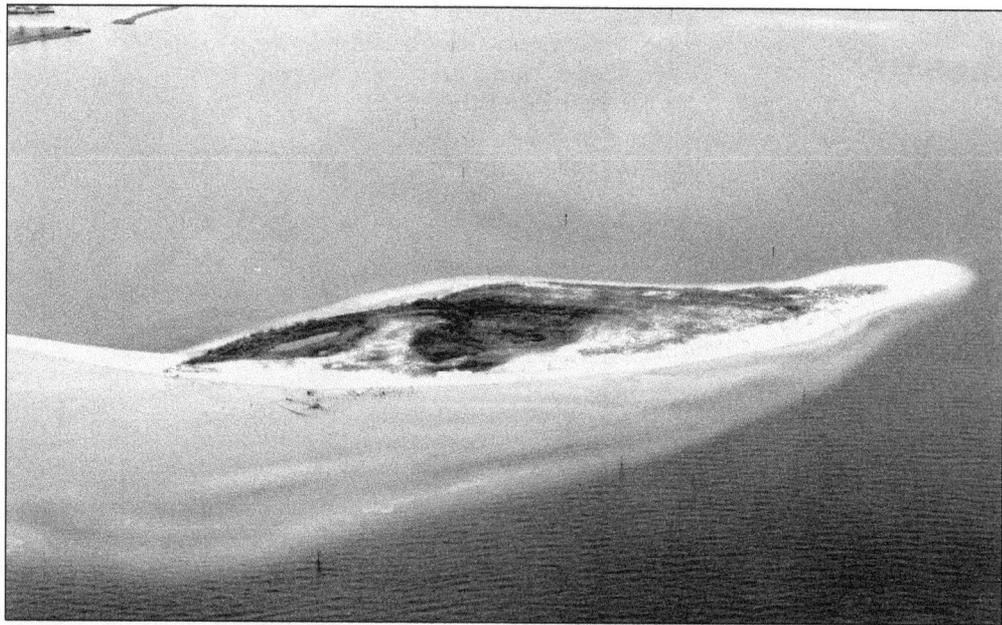

In the lower left corner of this 2003 photograph of Factory Point is the location of the fish factory. Only the pilings remain.

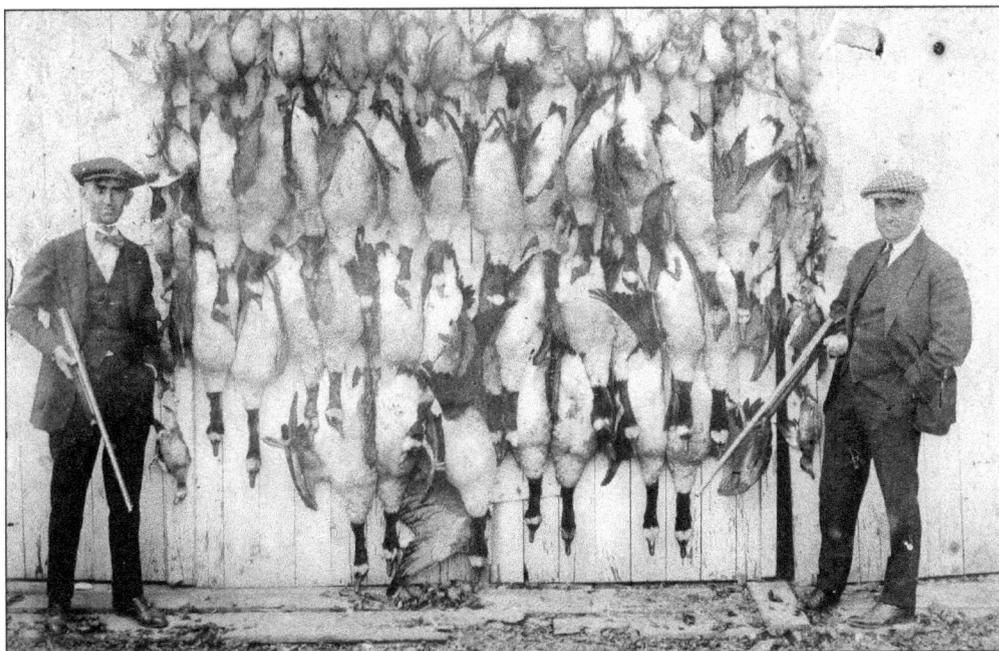

Alonza L. Wyatt ("Windy") and John S. Wyatt ("Jack") have a good day duck and geese hunting in Back River. Windy, born in 1880, and Jack, born in 1881, quit school after the elementary grade to start fishing full time with their father, William T. Wyatt. In 1903 they opened Wyatt Brothers clothing store in what is now downtown Hampton. The clothing business was a new venture for the Wyatts. It was said there was hardly an excuse for anyone to be other than well dressed so long as there are stores in a community like Wyatt Brothers.

Fox Hillians enjoy hunting, especially goose and duck. Two successful hunters, Herb Guy and Bill Wyatt, are cousins and expert duck hunters.

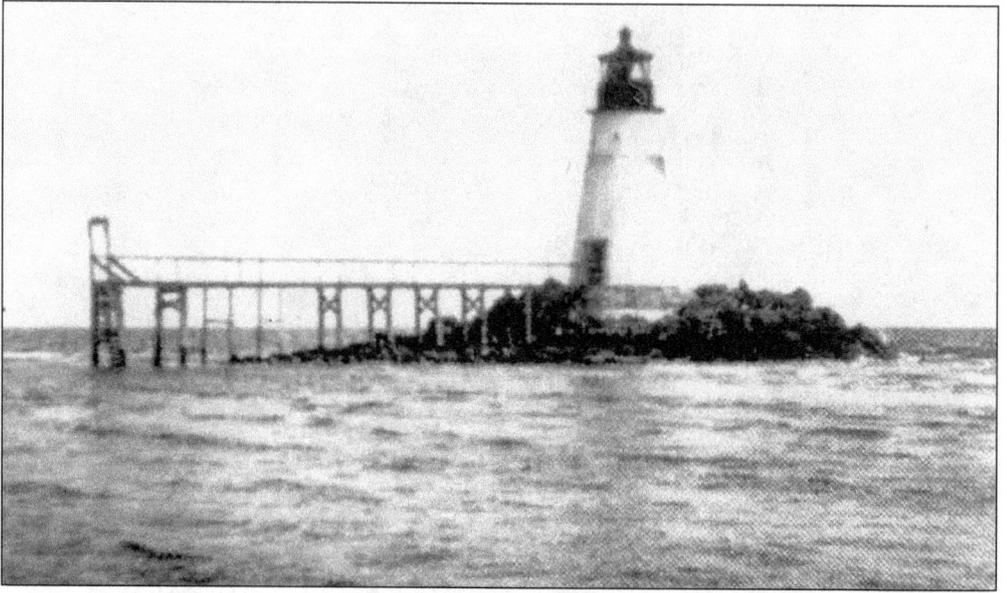

The Back River Light Station was a Fox Hill landmark for well over 100 years. It was established in 1829. It was automated in 1915 and decommissioned in 1936. Until it was destroyed in 1956 by Hurricane Flossie, Back River Light was a popular destination for oyster roasts, beach comers, church get togethers, and courting couples.

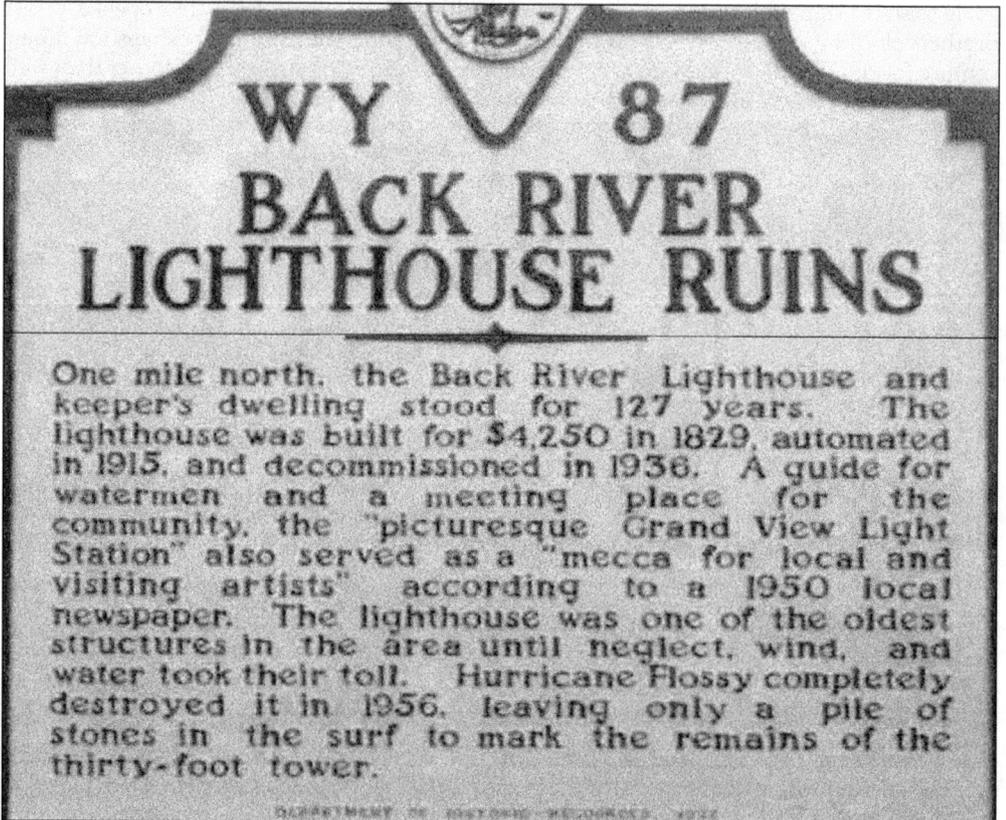

WY 87

BACK RIVER
LIGHTHOUSE RUINS

One mile north, the Back River Lighthouse and keeper's dwelling stood for 127 years. The lighthouse was built for $4,250 in 1829, automated in 1915, and decommissioned in 1936. A guide for watermen and a meeting place for the community, the "picturesque Grand View Light Station" also served as a "mecca for local and visiting artists" according to a 1950 local newspaper. The lighthouse was one of the oldest structures in the area until neglect, wind, and water took their toll. Hurricane Flossy completely destroyed it in 1956, leaving only a pile of stones in the surf to mark the remains of the thirty-foot tower.

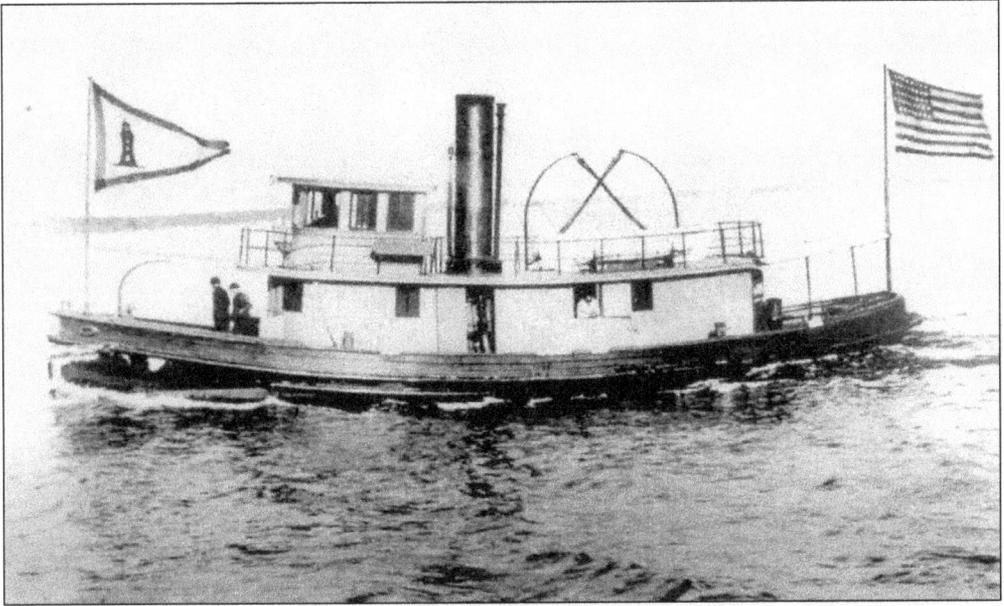

Lighthouse service "tenders" made regular trips to the Back River Light to check and repair it. One of the boats, probably the one pictured above, was named the *Thistle*. The tenders extensively repaired both the dwelling and lighthouse in 1904, after a bad storm.

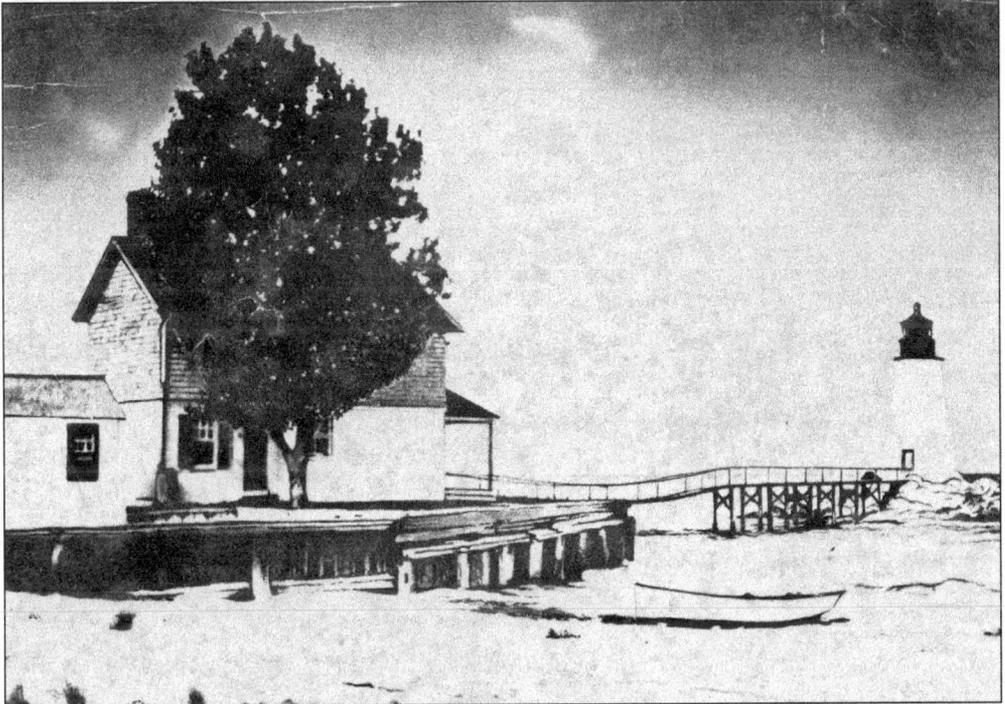

This old picture was taken of Back River Lighthouse and the cottage sometime after 1894 when the second story was added to the original structure to accommodate the keeper's growing family.

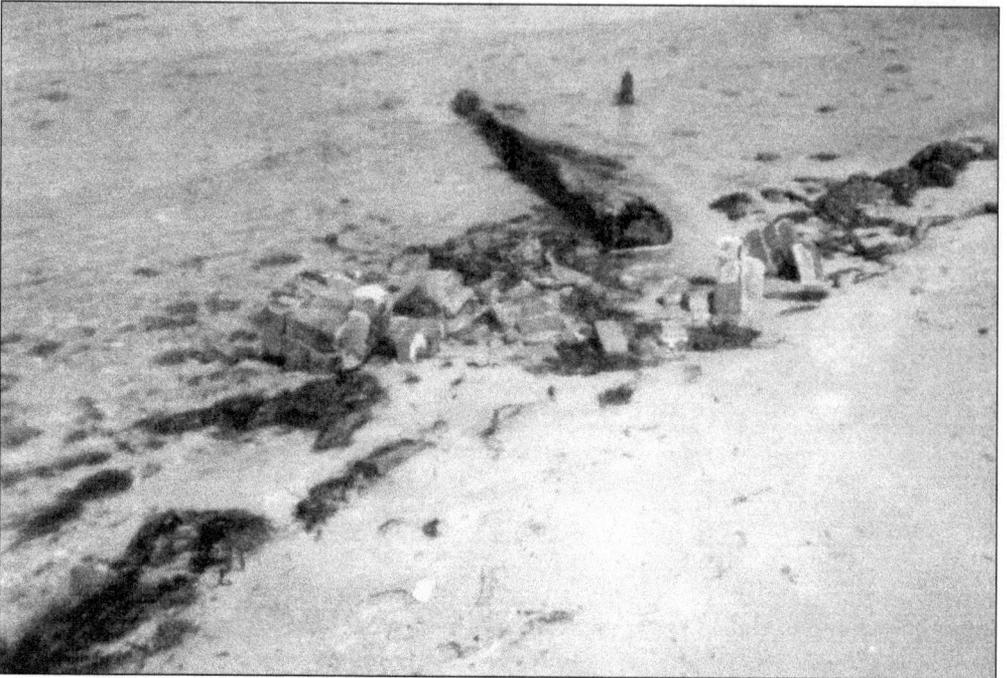

Factory Point is the northernmost part of Fox Hill. The peninsula of land extends into the channel of Back River from the Chesapeake Bay. There were jobs for factory workers and a convenient place for fishermen to off load their catch. Today its ruins have been revealed. To everyone's amazement, the factory was large and must have been quite a sight on that barren strip of land.

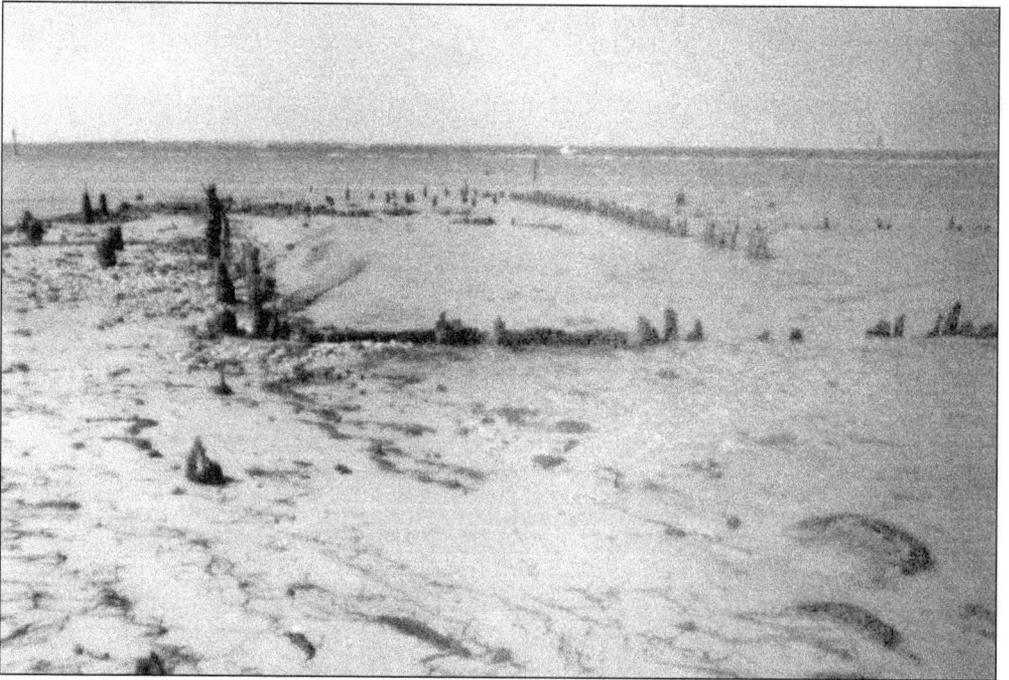

Two

Fox Hill Community

Fox Hill is a suburb of Hampton, Virginia, located on the Chesapeake Bay. It was once a fishing village. The Back River Lighthouse was built in 1829 and guided watermen and mariners for over 112 years. The light was abandoned in 1936. Then in 1956, it was destroyed by a hurricane. Now we'll drive down Beach Road.

27

The First Methodist is the oldest and mother church of the Fox Hill community. It dates back some 20 years before the War Between the States. The land was given by Mr. Henry Guy and his mother, Elizabeth, in 1844. They deeded it to seven trustees, whose names are given as R.A. Armstead, James Phillips, Jacob Ham, Major P. Bloxom, William A.G.W. Topping, John Cooper, and Henry Elliott. The building was located at the corner of Beach Road and Hall Road (upper end). First Methodist Church was torn down in 1974.

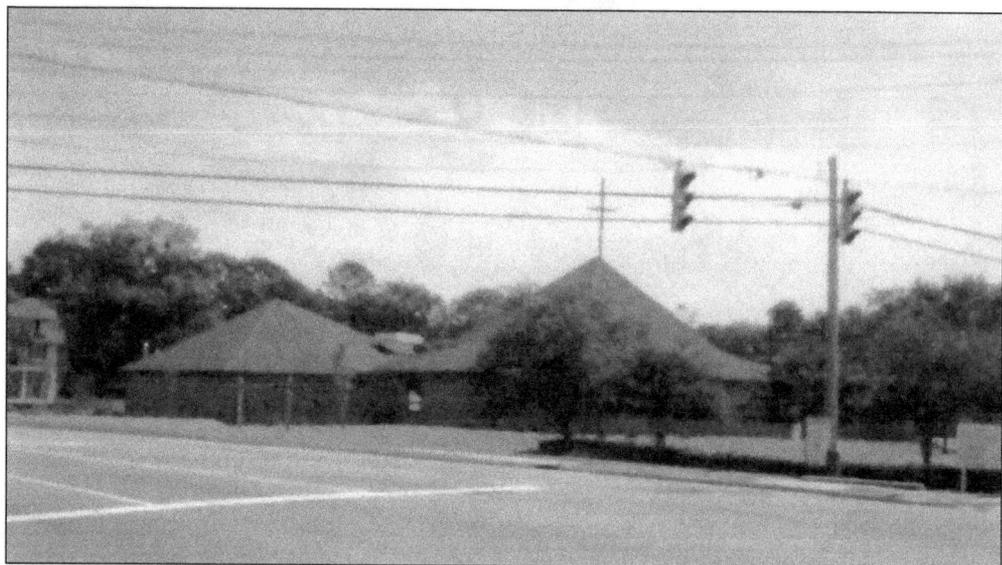

A new First Methodist Church was built about 1972 at Bloxom's Corner (where Old Buckroe Road, Fox Hill Road, and Silver Isles Boulevard intersect). The members built a new sanctuary and fellowship hall, which was completed in 2003.

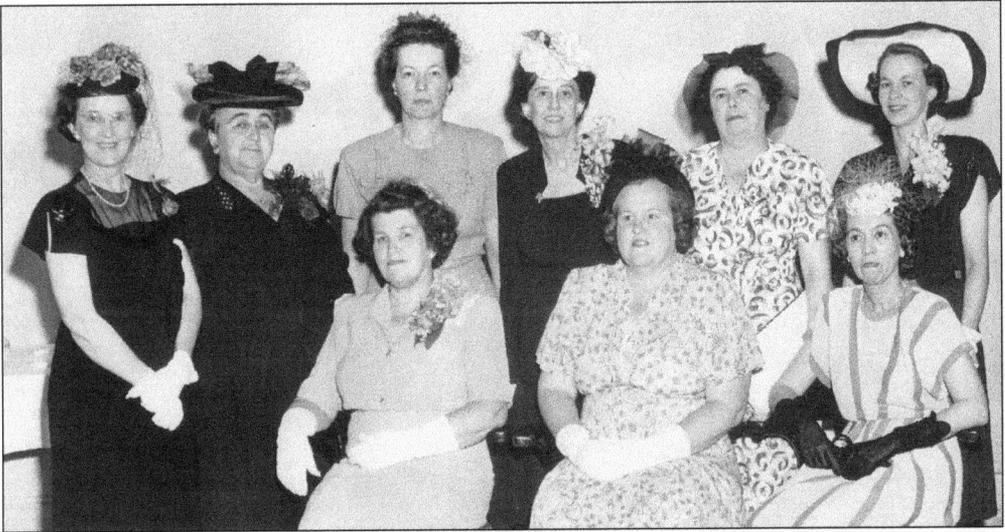

Mrs. Roxie Johnson was installed as the new president (1947–1948) of the Fox Hill Senior Woman's Club at its annual luncheon, which was held on a Wednesday night at the Hotel Chamberlin. The installing officer was Mrs. Manola Clark, far right standing, who is retiring president of Fox Hill Juniors. The officers, from left to right, are as follows: (front row) Mrs. Roxie Johnson, Mrs. Dorothy Todd, and Miss Margaret Smith, (back row) Mrs. Eunice Johnson, Mrs. Jack Clark, Mrs. Lucy Todd, Miss Fannie Routten, Mrs. Marguerite Mason, and Mrs. Manola Clark.

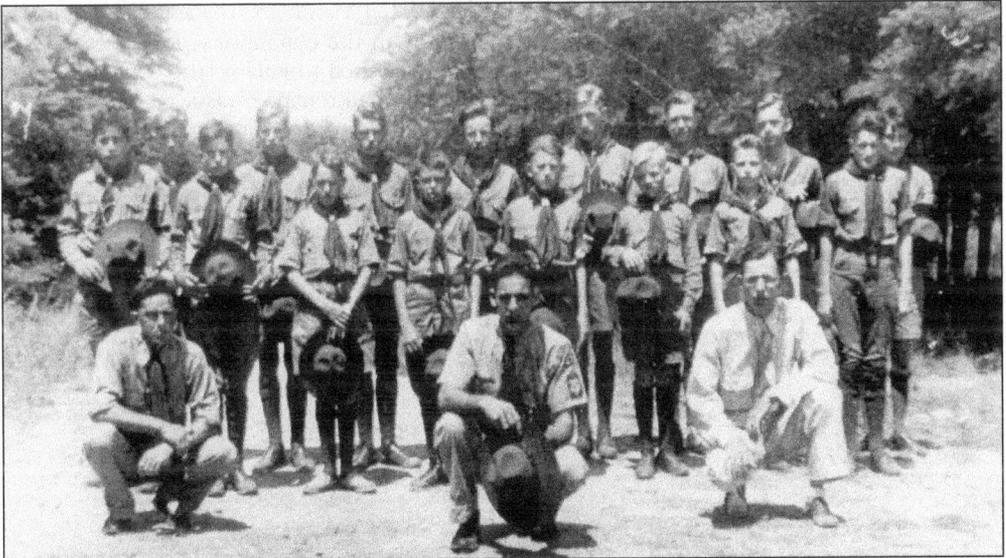

Boy Scout Troop 27 of Fox Hill, Elizabeth City County, Virginia, poses at Camp Okey, Gloucester Point, Virginia, July 1–4, 1939. This troop was sponsored by the Central United Methodist Church of Fox Hill. From left to right are (back row) Arthur Sharman, Amos Rowe, Irvin Lewis, Edgar Dixon, Phillip Routten, Matthew Elliott, Elvin Mason, David Wallace, David Johnson, Donald Johnson, Donald Dooley, John Spencer, Elwood Williams, Ernest Johnson, Victor Watson, and Charles Johnson, (front row) Arthur Cannon (Second Assistant Scout Master), Rufus H. Morris (Scout Master), and Harold D. Thompson (First Assistant Scout Master).

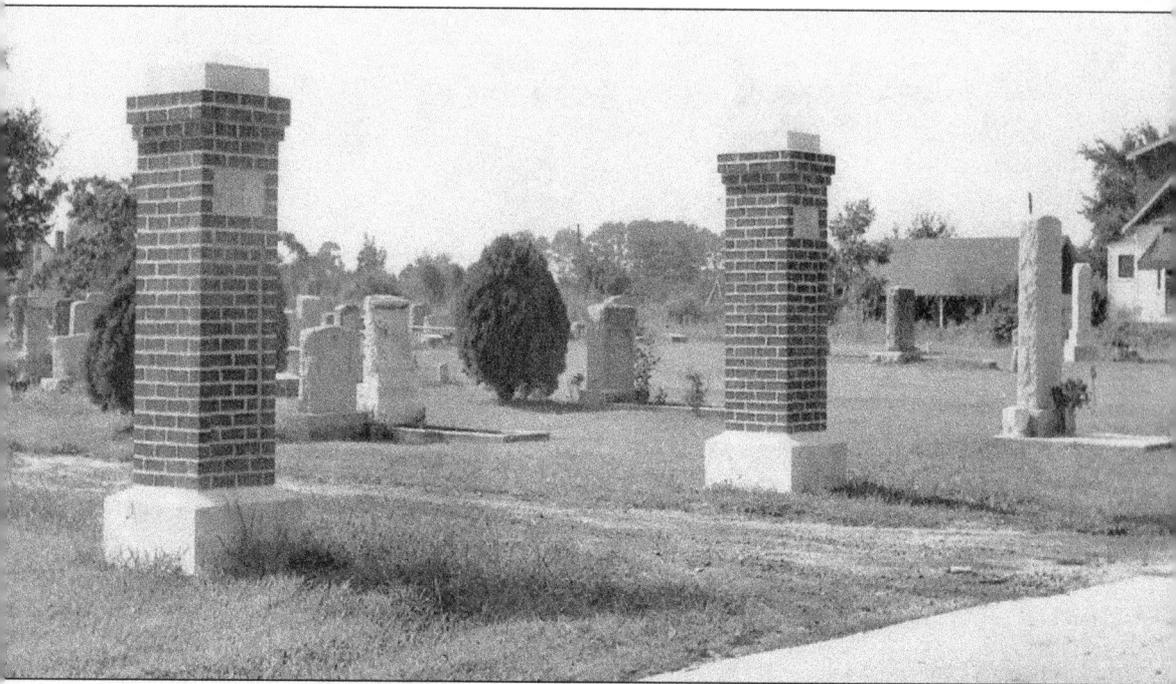

Clark Cemetery was founded in 1858 by John Henry Clark when his daughter, Margaret, died at age one and a half years. This site was the highest part of the 60-acre farm, which John Henry Clark purchased from Michael P. Guy by deed dated March 15, 1855. It was originally a family cemetery, but as the need for burial sites grew in the community, lots were sold to other families. In subsequent years, adjacent land was acquired to enlarge the cemetery to its present size of approximately 4.5 acres. Clark Cemetery maintenance was a major project of the Fox Hill Woman's Club for many years. The community realized the importance of having perpetual care for the cemetery. On November 12, 1985, the Clark Cemetery Perpetual Care Association of Fox Hill was formed. This association provides road and maintenance for this cemetery. Just about everyone buried in this cemetery is related.

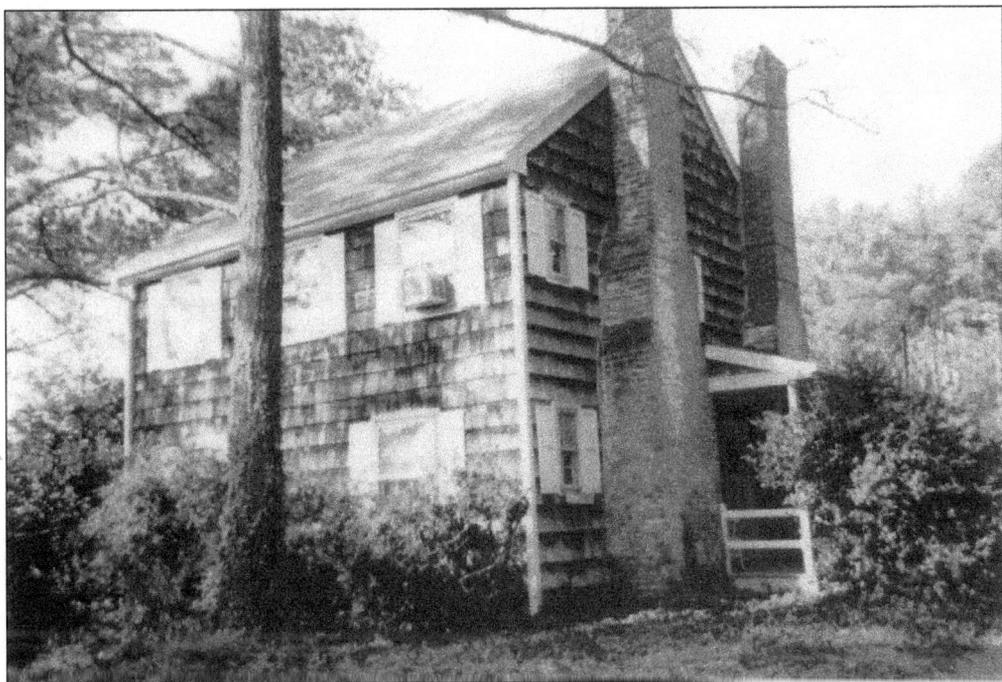

The Clark Farm house was built before 1830 and faces Harris Creek. It is believed to be the oldest standing home in Fox Hill. Over the years, it has gone through several renovations but retains its two double chimneys and wide (24 inches or more) floor boards. The Clark family no longer owns the house. This picture was taken in 2002 by Judy Clark Riss.

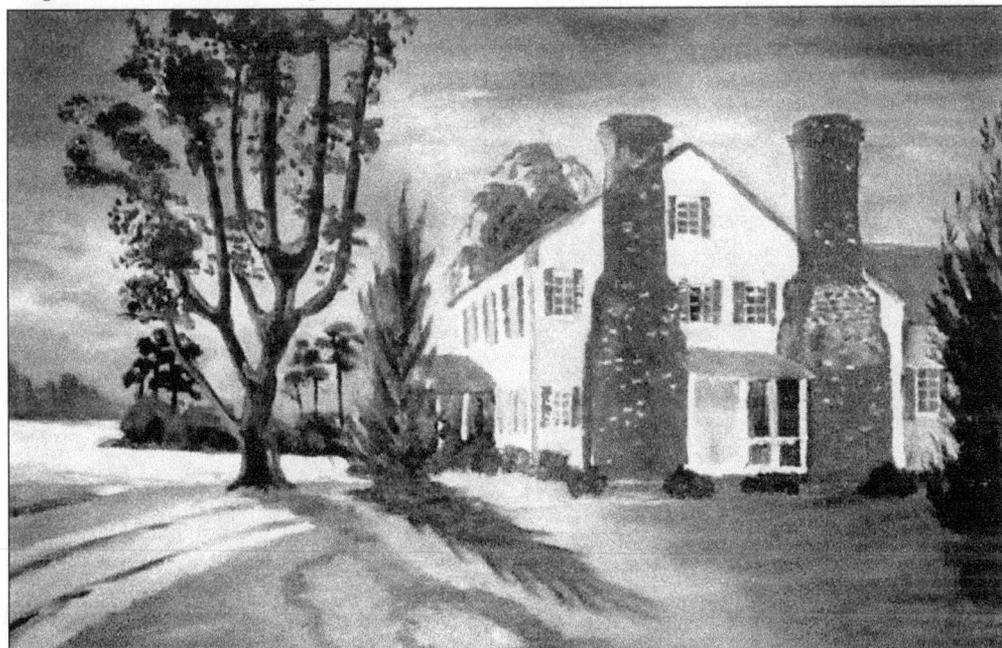

"Harp O' the Wind" is an oil painting of the Clark House by a local artist Frances Watson Evans. The name derived from the sound of the wind blowing through the trees, which sounded like a harp. Frances worked at Fort Monroe until she retired. Painting was her hobby.

This is a model T Ford that was used in the early 1900s to bus students from Harris Creek to Francis Asbury school in Fox Hill. Mr. Spencer drove the bus for many years. He also fired the furnace that produced heat for the school and cleaned the rooms after the students had left for the day. After Mr. Spencer retired, his stepson Billy Forbes drove this bus until a new yellow bus was purchased.

The bus had roll-up curtains for ventilation, and in bad weather the curtains would be rolled down to protect the children from rain or snow. It had wooden seats on each side. There was no heat in the bus. In this photo of the old bus, you can see the wooden door in the rear.

This is the Fox Hill School in 1915, which was located at 186 and 188 Beach Road (a private home). It was eventually outgrown as the community's population increased. Johnson Evans, who is 94 years old, said he remembered attending this school where two or three classes would meet in the same classroom.

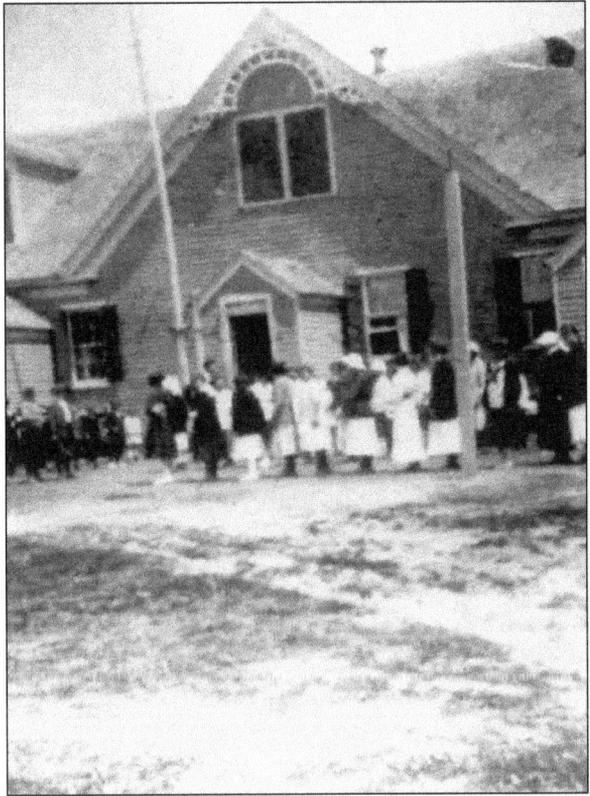

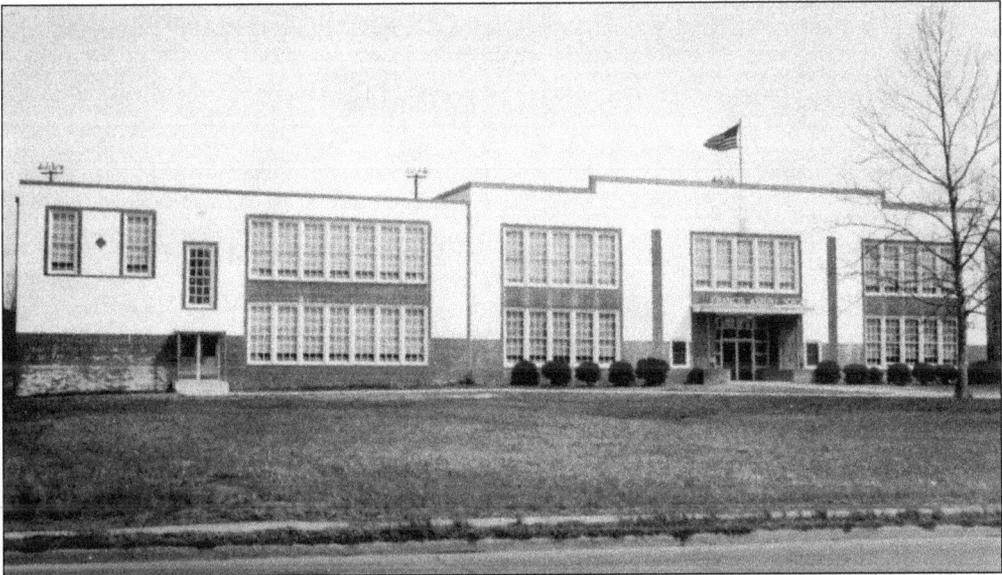

In 1917, a larger, up-to-date school was built at 140 Beach Road at a cost of $1,800. This new school was named Francis Asbury. In 1964, part of Asbury burned due to an electrical fire in the cafeteria. The newest part of the school (at that time) was the two-story section on the left, which is still used today. The original building had to be torn down and rebuilt.

FOX HILL ANTI-VACCINATION SCHOOL
Ripraps, Va.
1906-1907

Irving L. Llewellyn
Miss Lettie Wallace
Assistant

This is a graduation program for the Fox Hill Anti-Vaccination School. As the name implies, there were some families in Fox Hill that objected to vaccination for smallpox. They sent their children to a school that did not have a requirement for the vaccination.

PUPILS

EIGHTH GRADE

Vara Johnson	Pres.
Octavia Routten	Secy.
Hilda Holston	Treas.
Eunice Johnson	Poet
Effie Johnson	Prophet
Katie Johnson	Historian
Edith Johnson	Carlie Johnson
Stanley Johnson	

SEVENTH GRADE

Elroy Llewellyn	Pres.
Nora Mason	Vice Pres.
Bennie Johnson	Secy.
Gracie Gordon	Kuney Johnson
Clarence Johnson	Norman Dixon

SIXTH GRADE

Goldie Johnson	Pres.
Beckie Barron	Vice Pres.
Raymond Johnson	Secy.
Rosa Wallace	Nora Elliott
Virgie Routten	Laura Copeland
Fannie Routten	Aloma Holston
Andrew Mason	Emmet Holston
Sydney Johnson	

PRIMARY DEPT.

Mattie Oldfield	Mattie Barron
Dan Elliott	Jessie Lewis

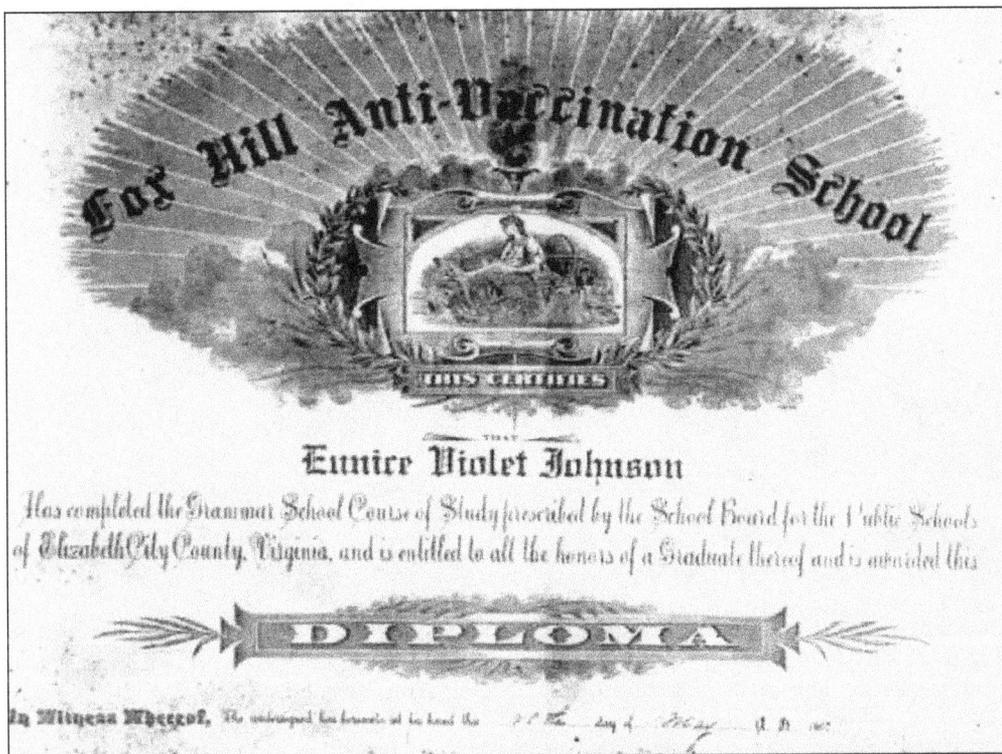

Fox Hill Anti-Vaccination School

THIS CERTIFIES

THAT

Eunice Violet Johnson

Has completed the Grammar School Course of Study prescribed by the School Board for the Public Schools of Elizabeth City County, Virginia, and is entitled to all the honors of a Graduate thereof and is awarded this

DIPLOMA

In Witness Whereof, The undersigned has hereunto set his hand the ___ day of ___ A. D. ___

In 1906–1907, the smallpox vaccination law was passed and Virginia school children were required to be vaccinated. As a student of this time related, "One day Mr. J.M. Willis, the school superintendent, came to the school and announced that all children would have medicine put in their arm with a needle." This was something that most of the people of Fox Hill had never heard of, so some of the children went running home in fear. This was the beginning of a new private school in the village. It was called the Fox Hill Anti-Vaccination School. The classes were made up of children from each grade whose parents were against the vaccination law.

The principal of the Fox Hill public school, Mr. Llewellyn, was also against th vaccination requirement. He left and became principal of this newly formed private school. The classes were held in the old Red Men's Hall located on Beach Road, near Johnson Road.

35

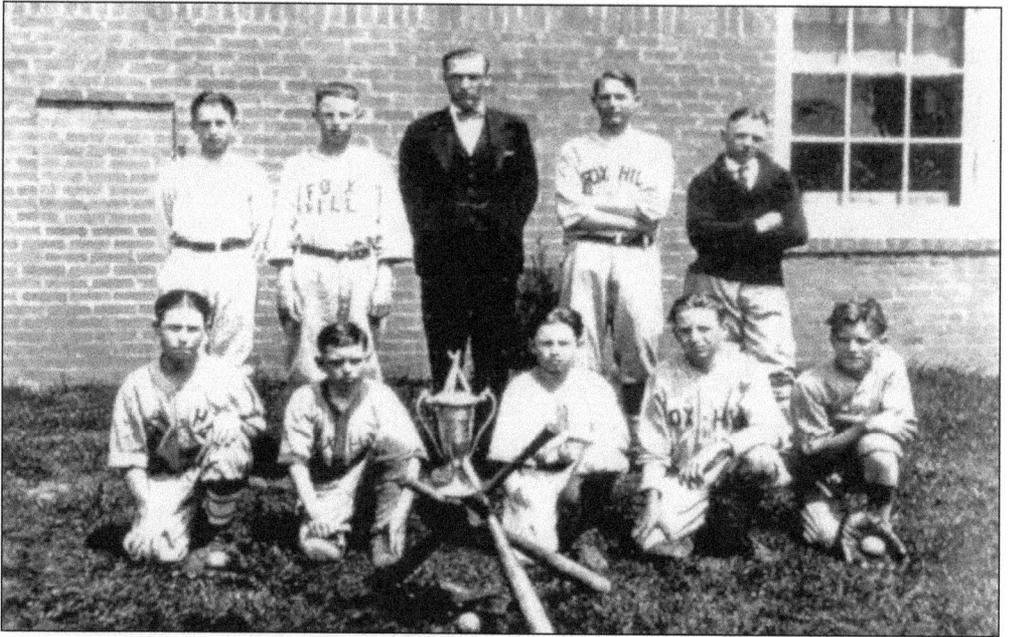

The 1927 Fox Hill School Baseball Team won the Elizabeth City County Grammar Grade Championship. The team is pictured, from left to right, as follows: (front row) Willams, third base; Bloxom, left field; Wallace, second base; Holston, right field; Rowe, short stop; (back row) Smith, pitcher; Johnson, center field; Eason, coach and principal; Wallace, first base; Decker, catcher.

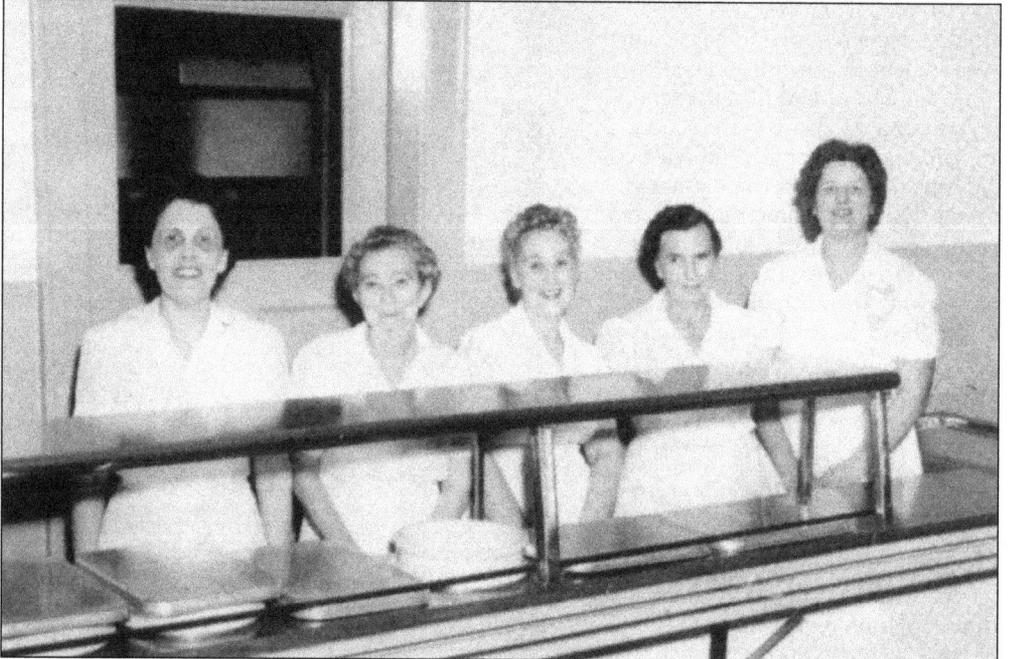

The Francis Asbury School cafeteria staff in 1956 included, from left to right, Marian Holston Malcom, Clara Rowe Lee, Frances Jester Johnson "Sassy," Maggie Johnson Quinn, and Louise Lewis.

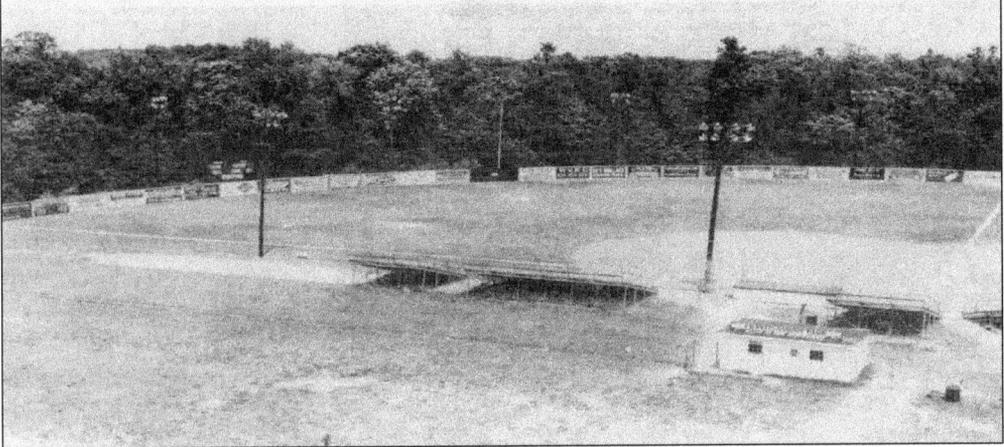

WELCOME TO
FRANCIS ASBURY PARK-FOX HILL
HOME OF THE PENINSULA ALL-STARS

Softball has been played and watched in Fox Hill for years. Francis Asbury Park was the home of the Fox Hill All-Stars until the team was disbanded, but not before establishing a national reputation.

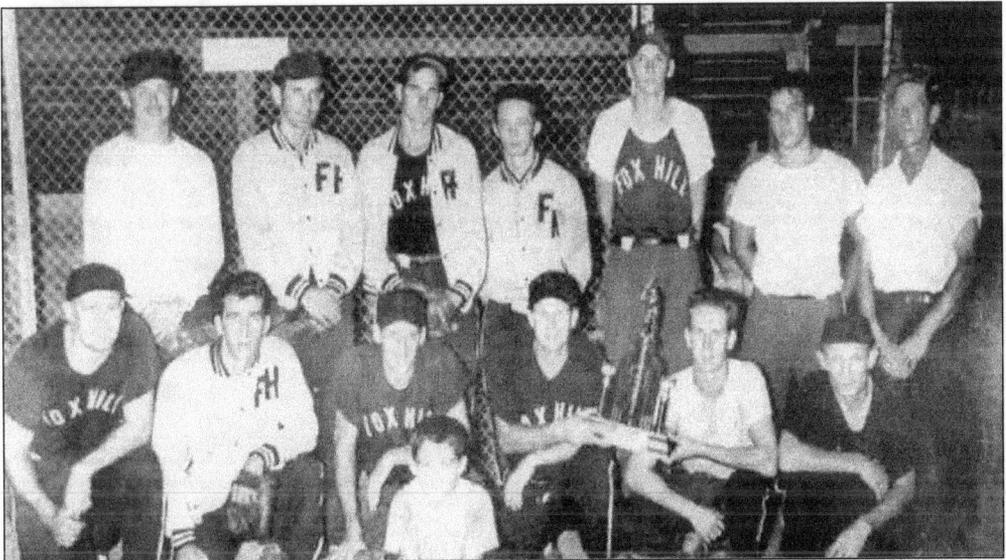

The 1955 State Champs—the Fox Hill All Stars—are the following, from left to right: (front row) Freddie Eubank, Nick Ferraro, Hoby Thomas, Buddy Bryant, Bob Saunders, and Frank Lonna; (back row) Skippy Cole, Hank Stewart, Dick Carneal, Charlie Lewis, Ronnie Weber, Billy Clark, and Harry Wallace, manager.

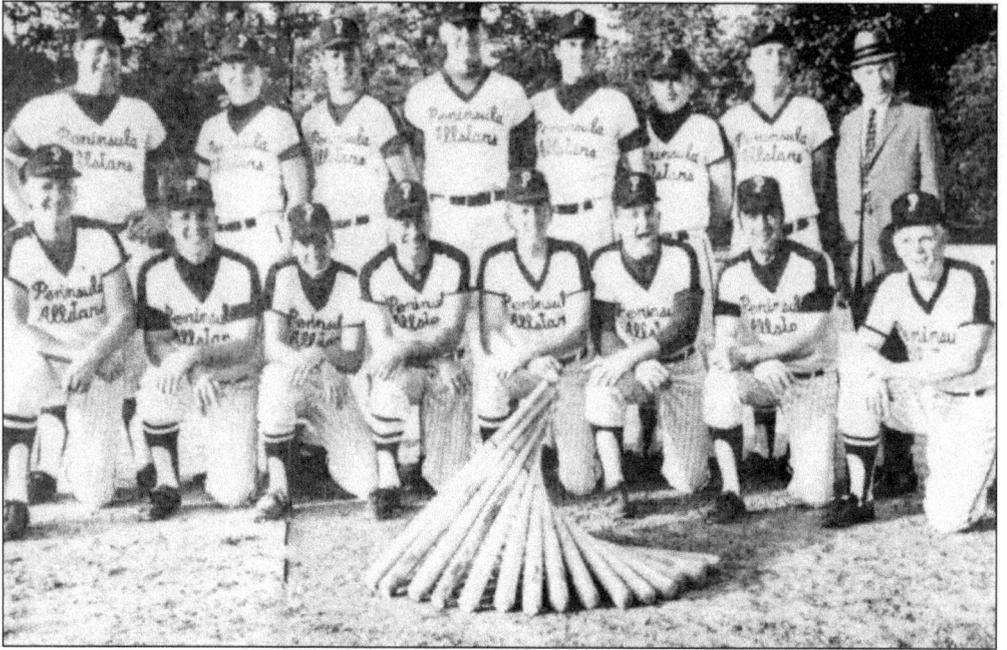

The 1969 Peninsula All-Stars, a member of the Atlantic Seaboard Major Softball League, Southern Division, are pictured here. They are, from left to right, (front row) Don Brandt, Don Winegrad, Jim Willman, Keith Goodson, Jesse Kersey, Bud Porter, Joey Lawrence, and Sam Winfrey; (back row) Trent Joyner, George Weikel, Billy Covington, Ron Peterson, Bob Wilson, Dick St. Clair, Jack Hull, and Business Manager Phillip Routten.

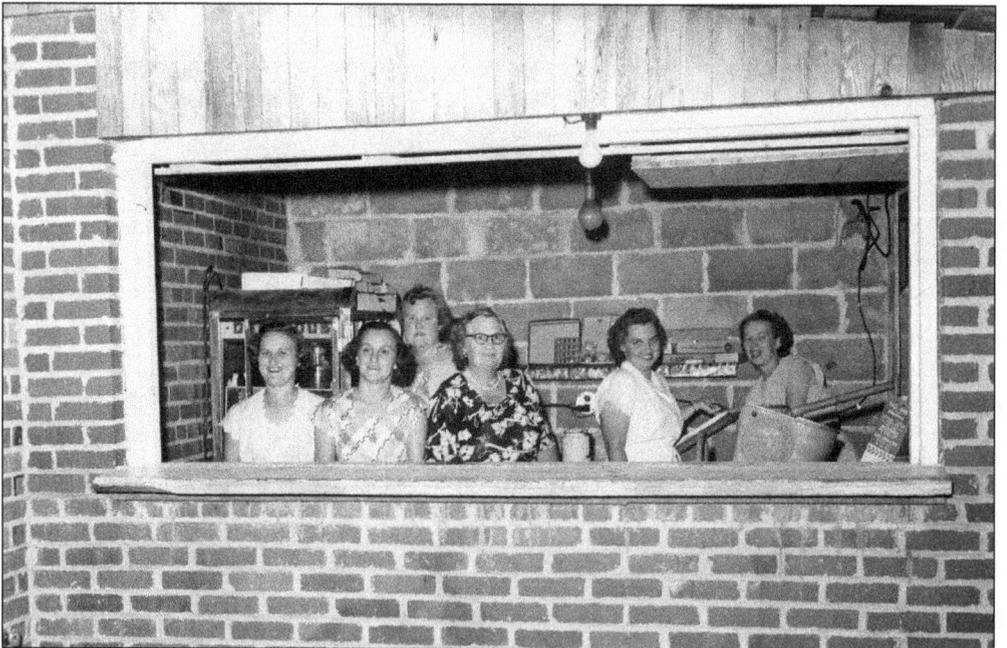

The Junior Woman's Club of Fox Hill serves refreshments at Francis Asbury Park. Pictured are, from left to right, Mary Smith, Anna Marie Smith, Dorothy Todd, Ethel Collie, Etta Hudgins, and Manola Clark.

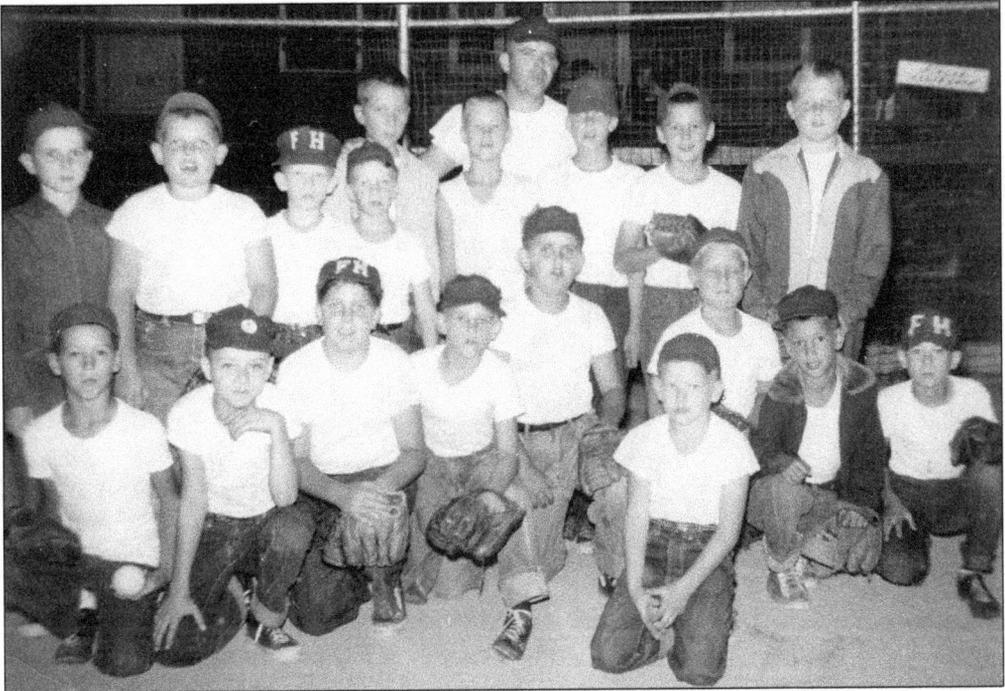

Baseball begins young in Fox Hill. Posing here are, from left to right, (front row) Wilson Hunt, Billy Van, two unidentified, ? Jenkins, Eddie Rideout, Ralph Joynes, Bobbie Bunting, and Charlie Wallace; (back row) Jake Evans, Henry Hudgins, Donnie Johnson, Tommy Evans, unidentified, Freddie Rowe, Thad Perry (coach), Jimmy Moore, Junie Routten, Dudley Moore, and Bobby Julian.

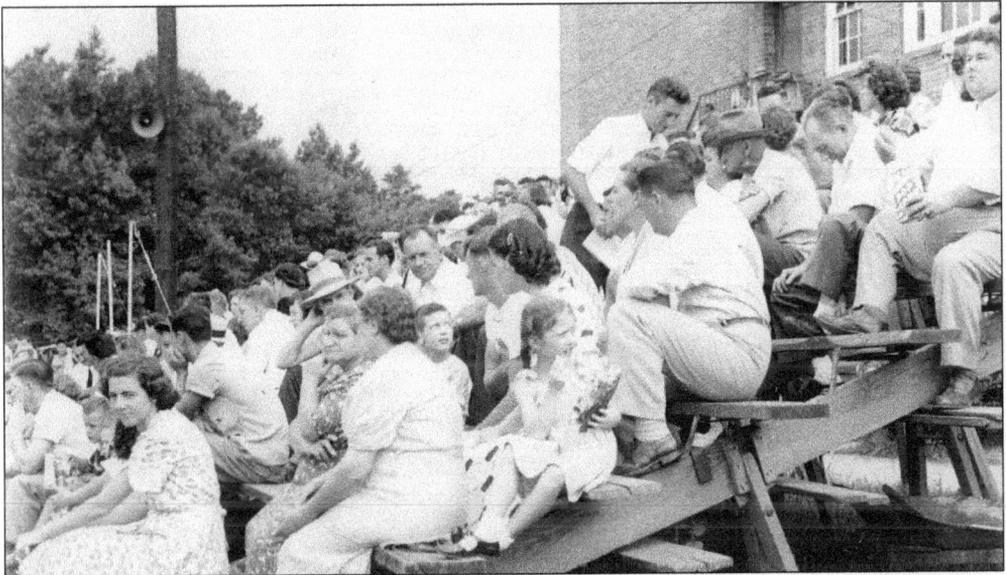

Ball fans are shown here at Asbury. Today, the park is used by the Kecoughtan High School Girls Softball team. This picture of fans watching the game was taken in 1955 by Howard Cole. Watching the game on the bottom row of the bleachers is Anne Firth and her son, Jimmy, and daughter, Annette. The little girl in pigtails on the third row is Anne Paige Decker.

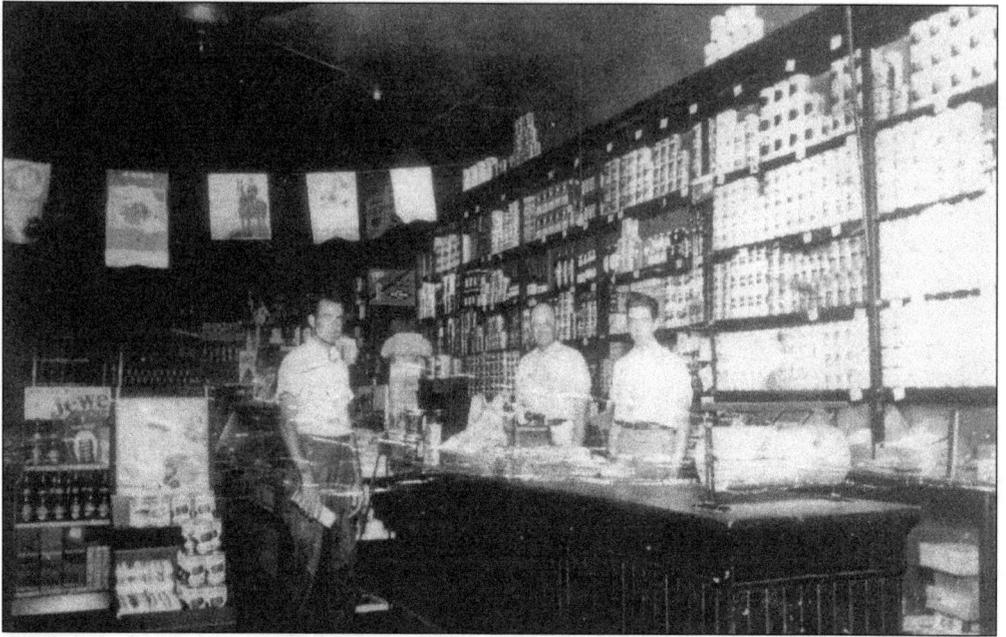

From left to right, Frank Biscoe, Henry Johnson, and Rufus Melson pose for a picture in Henry Johnson's grocery store around 1935. Early stores in the area sold everything from groceries, fishing supplies, and paint to appliances, feed, and grain. The penny candy case, which most children in Fox Hill were familiar with, is the one on the far right. During the hurricane of 1933, the water came in the building up to the counter top where the men are standing.

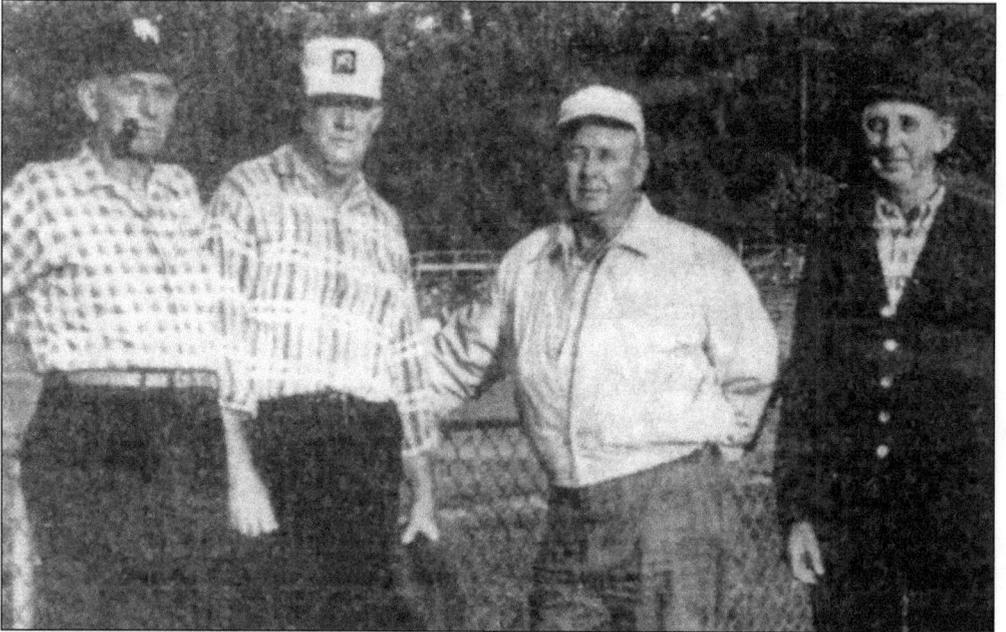

The people of Fox Hill have always enjoyed softball. In 1956, these four men helped to continue the Fox Hill tradition by working to build the fence at Francis Asbury Park. Asbury Park is one of the top playing fields on the East Coast. From left to right are Vernon Johnson, Hartness Firth (one of the leaders), Alonza "Babe" Clark, and Taylor "Slim" Forrest.

On Tuesday morning, October 31, 1934, a Fox Hill home was nearly demolished by the impact of a plane that had collided with another in flight. This plane struck the front porch of the two-story dwelling and entered the upstairs bedroom, leaving the wings and wheels in front of the home. The engine and fuselage traveled through the bedroom and hall way and exploded out of the rear of the home, leaving the gaping hole shown in the photo.

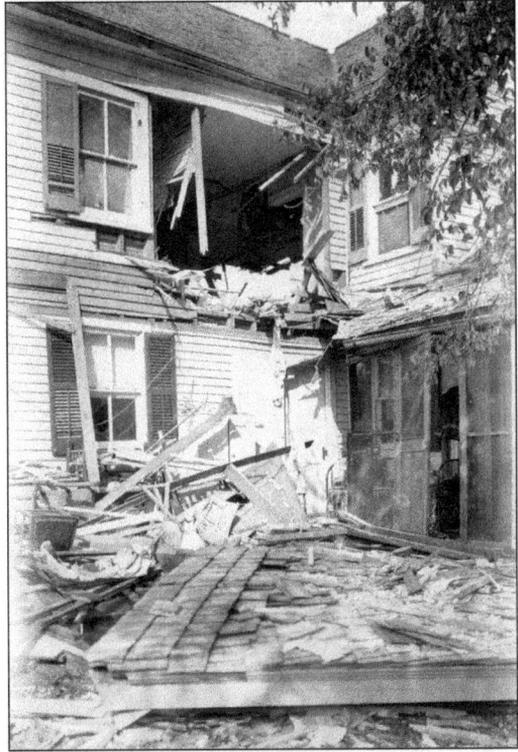

The plane crashed into the back yard, as you can see in this photo. On the right side of the photo stands Ms. Smith, the home owner, whose daughter was supposed to be married at 5 p.m. that day, but her wedding gown was taken out by the plane. The wedding took place as planned but at a different location. There were seven people in the home, but no one was injured. A thrifty neighbor, Brack Richardson, who was a local entrepreneur, got permission to salvage the airplane fuel. He decided to use it in his automobile—with disastrous results!

41

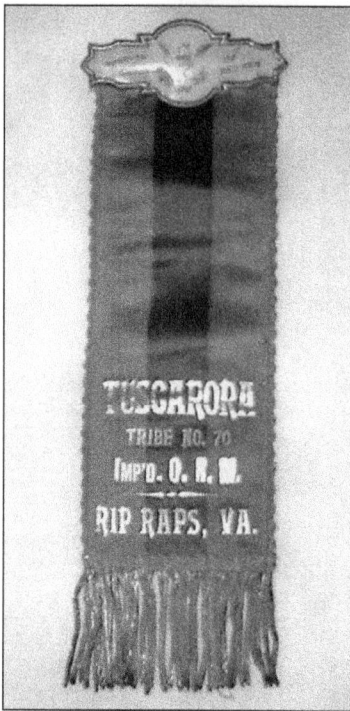

There were several fraternal orders represented in Fox Hill. Among these were Red Men, Degree of Pocahontas, Odd Fellows, Rebekahs, Woodmen, and Sons of Temperance. The Red Men's hall was located next to the soda shop in the 600 block of Beach Road. The Order of Red Men was founded in 1765 as the Sons of Liberty. The name change came after the American Revolution, and in 1834, it became the Improved Order of the Red Men. Today, their basic goals still remain: love and respect of the American flag and upholding the principle of free government and the democratic way of life. The lodge was Tuscarora Tribe 70, Rip Raps, Virginia.

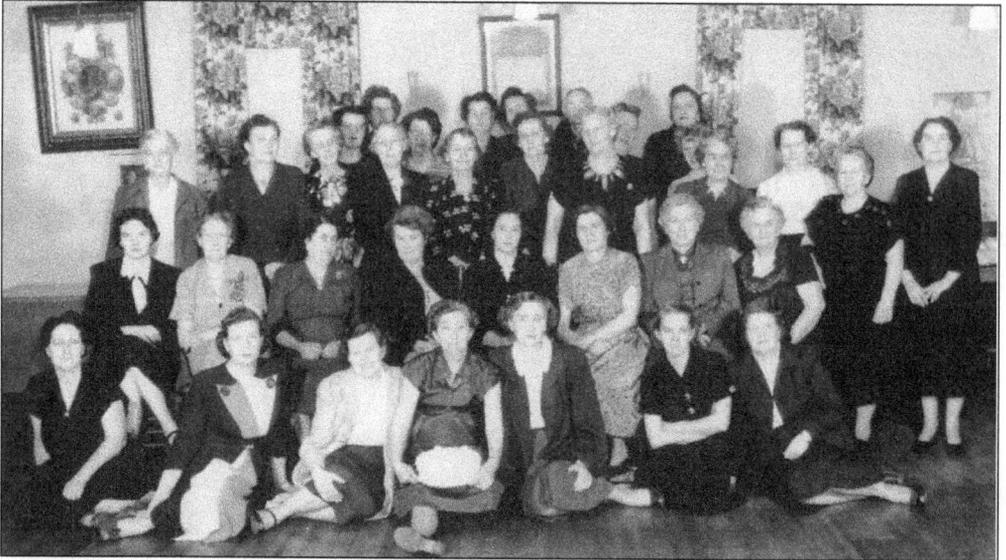

This is a group picture of the Pocahontas, which was one of the popular fraternal organizations in Fox Hill. Pocahontas supported community events. Pictured from left to right are (front row) Daisy Melson, Marie Hopkins Wallace, Margaret Brown Williams, Clara Rowe Lee, Gavin Rowe, Dot Raines Phillips, and Annie Decker; (middle row) two unidentified, Margarete Mason, Roxie Smith Johnson, Edith Rideout, two unidentified, Ethel Johnson Routten Collie, Henrietta Hamilton Guy, and Beatrice Oldfield Wyatt; (back row) Mal Weber Parham, Charlotte Horton Rowe, unidentified, Orie Wallace Guy, Christine Johnson Price, unidentified, Teal Johnson Williams, two unidentified, Clara Lee's mother, Edna Johnson Melzer, Myrtle Oldfield Lewis, and Tilly Williams.

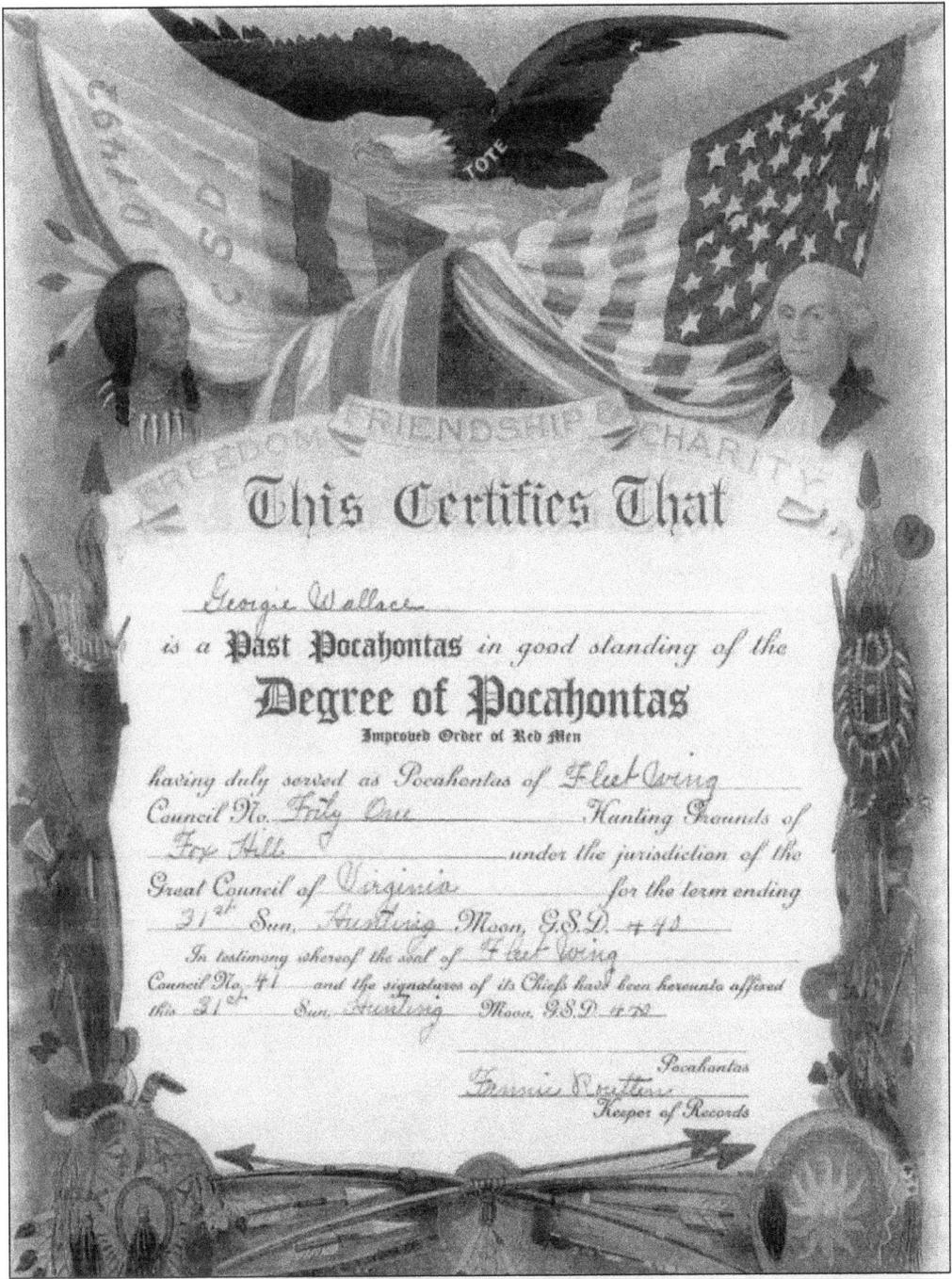

This is a copy of the *Degree of Pocahontas*, which is the Women's Auxiliary of the Order of Red Men. After joining, each member received this beautiful certification as proof of membership.

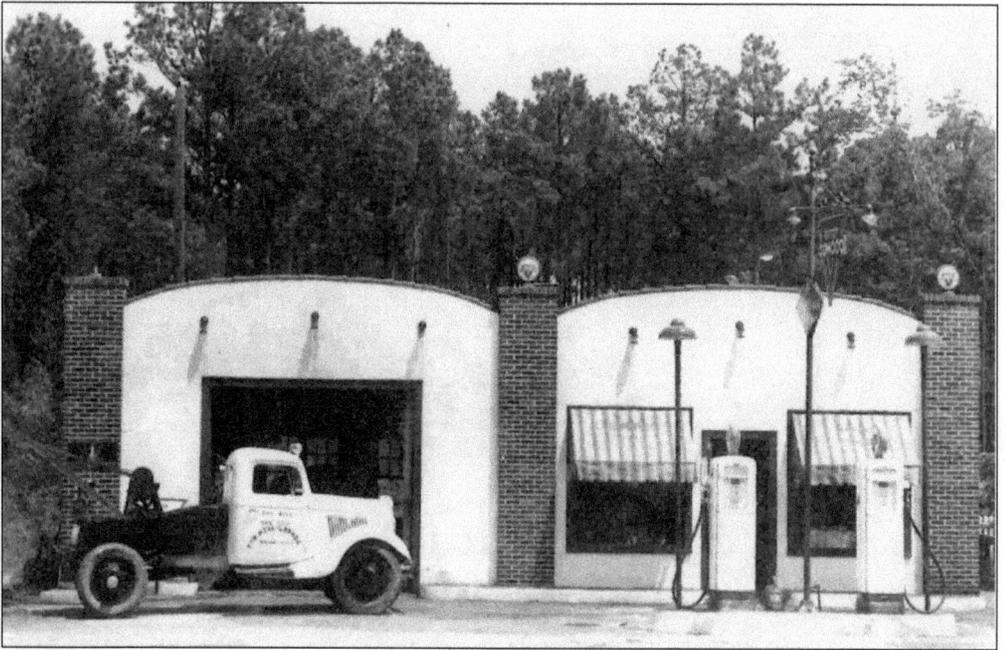

Clifton Lee Routten owned and operated the Fox Hill Garage from 1940 to 1970. The wrecker in this 1945 photo is a 1935 Ford truck with a weaver mechanical derick mounted on back.

Clifton Lee Routten ("Clif"), pictured here with his wife Florence Marshall Routten, was a real mechanic who could repair any vehicle. Actually he was gifted and could repair anything that had an engine (like lawn mowers, etc.). It was said he only needed a wire coat hanger to make repairs. What a mechanic!

44

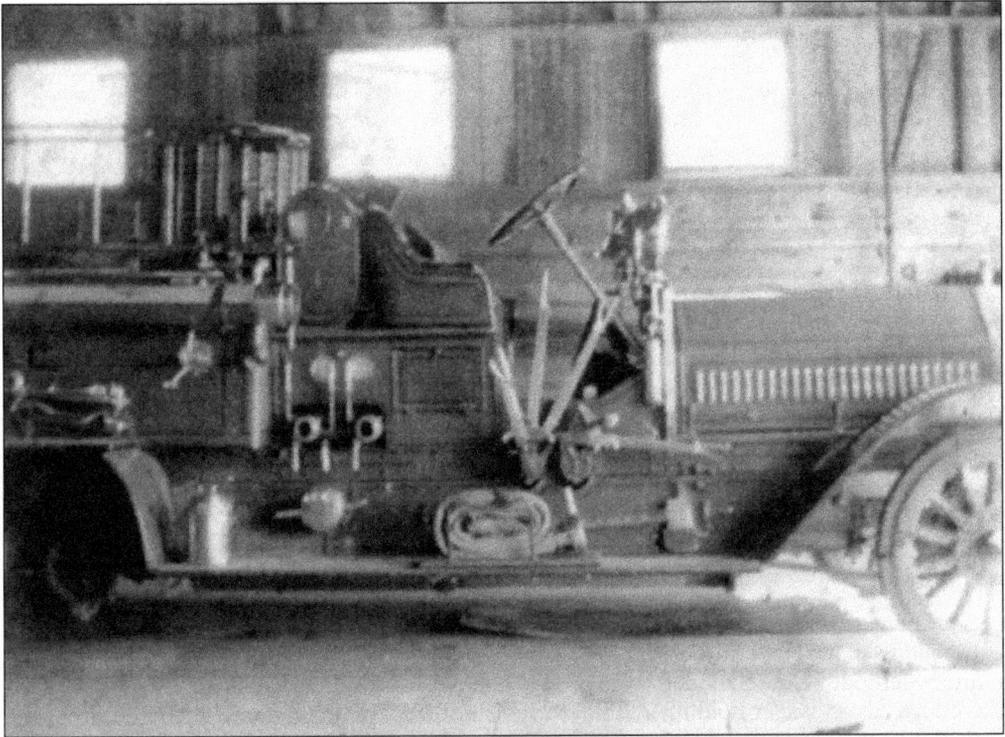

In 1922, Fox Hill Fire organized their first fire department with 14 members. The Model "T" Ford Fire Engine was purchased from the Wythe Volunteer Fire Company. It carried two 35-gallon chemical tanks, which were able to discharge soda and acid foam. This purchase was prior to the advent of city water in Fox Hill, so the water used was from rain barrels or deep water wells. Note the neat feature of the wooden spokes in the tires. The first fire house was built on land next to the Bank of Fox Hill with the funds raised from the sale of cook books and cakes.

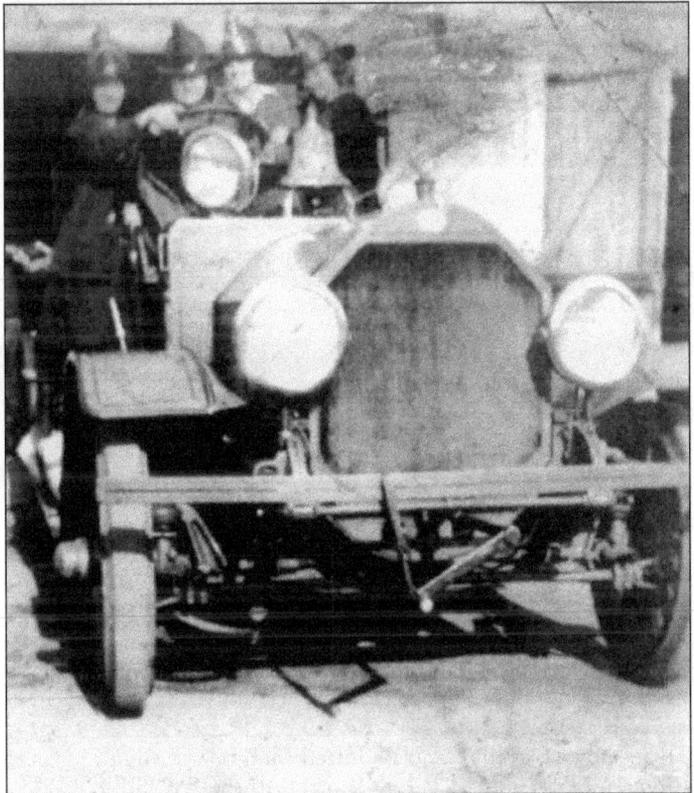

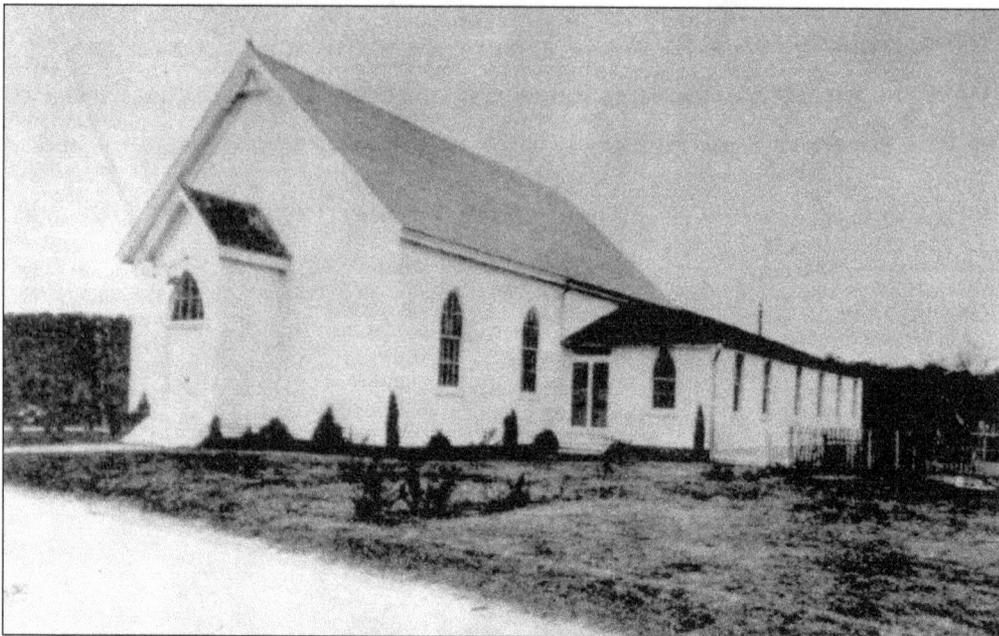

This picture shows Fox Hill Central Methodist Church in 1926. In the 1950s, Fox Hill Central United Methodist Church undertook a project to build a new sanctuary. To finance this project, the congregation began holding a "Friday Night Fish Fry." Everyone in the church, from the youngest to the eldest, would contribute in some fashion to make the dinners a success. They were held on the church grounds, with tables set up in the parking lot, and parking was any available space. The menu included fried fish, steamed crabs, cole slaw, potato salad, hush puppies, coffee, lemonade, and dessert. Several years of dinners helped finance the construction of the sanctuary, which is in use today.

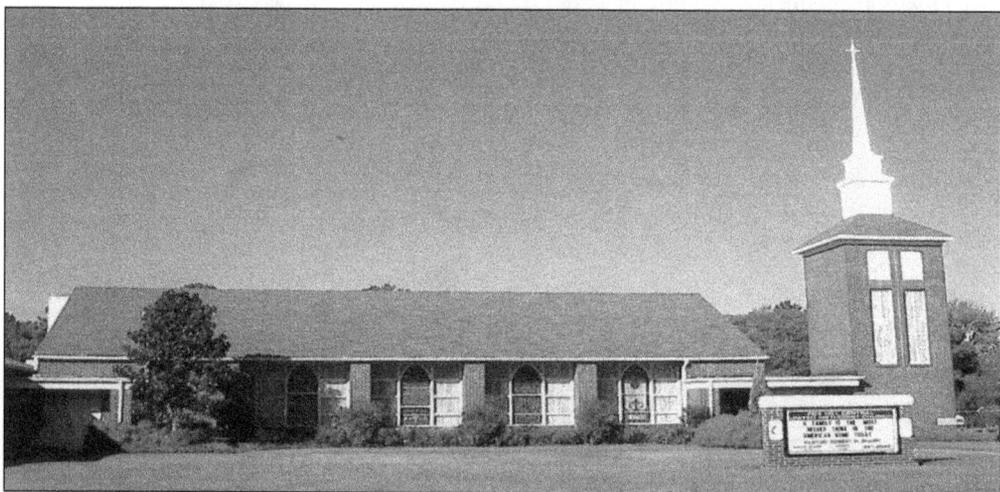

This is how Fox Hill Central United Methodist Church looks today. The youngest Methodist church in Fox Hill, it is very supportive of the Fox Hill Historical Society and community.

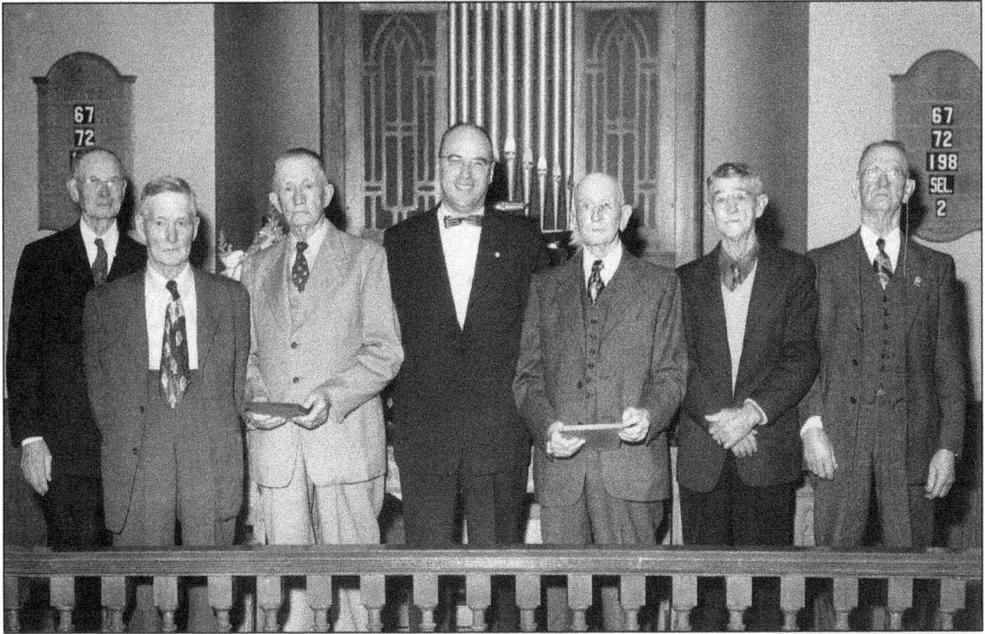

Fox Hill Central United Methodist Church was organized in 1899, and in 1951 it recognized its senior members. Those members are, from left to right, unidentified, Amos Wallace, George Johnson, Rev. James Clements, John W. Evans Sr., Moses Routten, and Harry Johnson. This picture was taken in the original sanctuary.

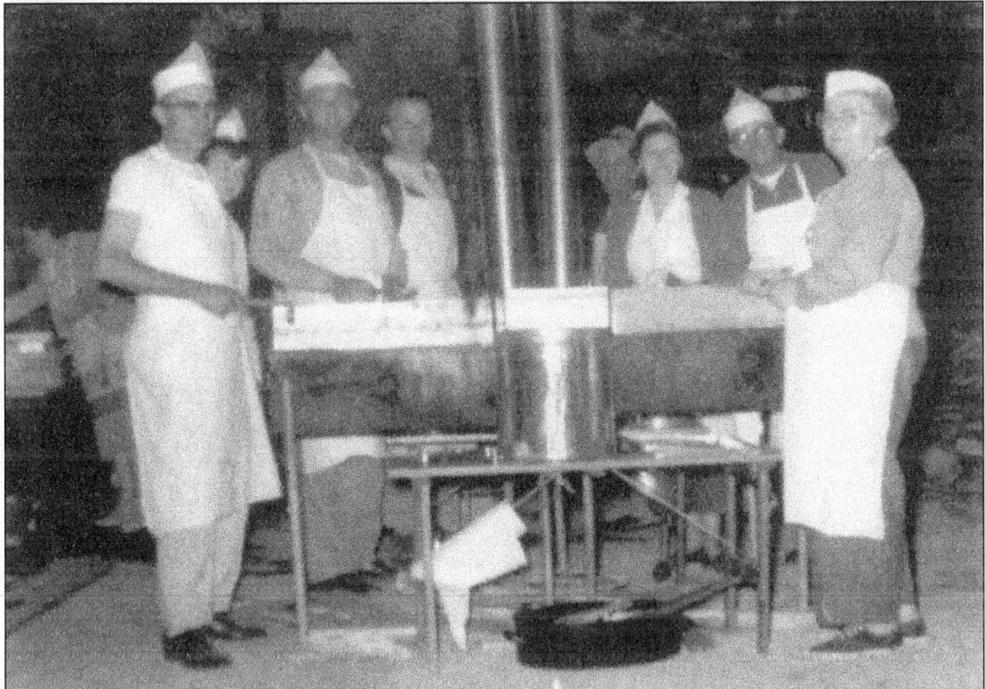

These Central United Methodist congregation workers are the hush puppy crew who worked in the fish fries. From left to right are Vernon Lewis Sr., JoAnn Johnson, Carroll Johnson, Marvin Smith, John Smith, Ilma Dixon Lewis, C.W. (Pat) Bloxom, and Jessie Dixon Bloxom.

47

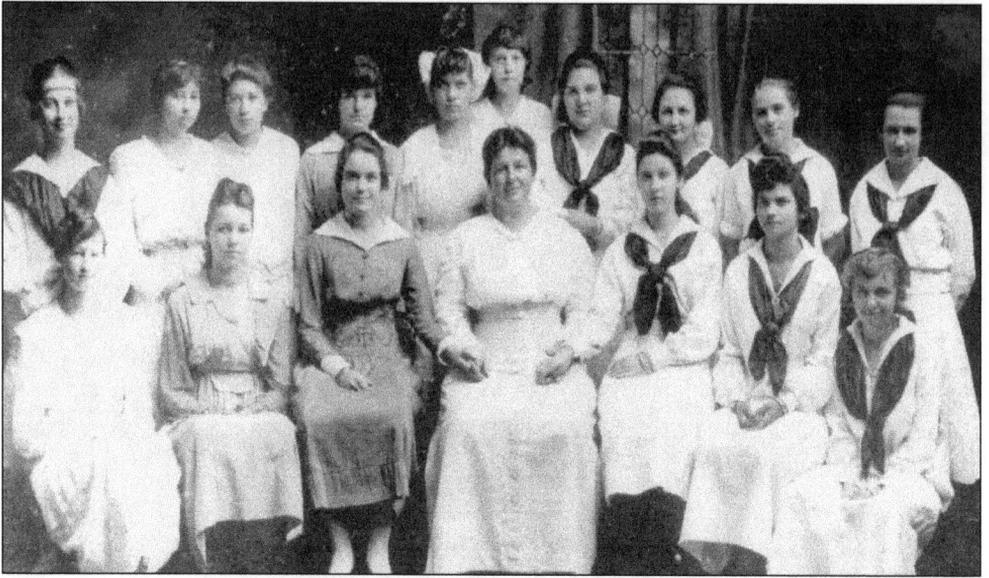

Mrs. Clara Messick's Sunday School class at Central United Methodist Church in 1916 included, from left to right, the following: (front row) Mary Evans, Lucy Smith, Mattie Clark, Clara Messick, Frances Jester, Louise Johnson, and Minnie Johnson; (back row) Mildred Wallace, Clara Rowe, Della Wallace, Mary Clark, Thelma Cole, Charlotte Wallace, Adeline Lewis, Lillian Johnson, Jesse Dixon, and Nellie Routten.

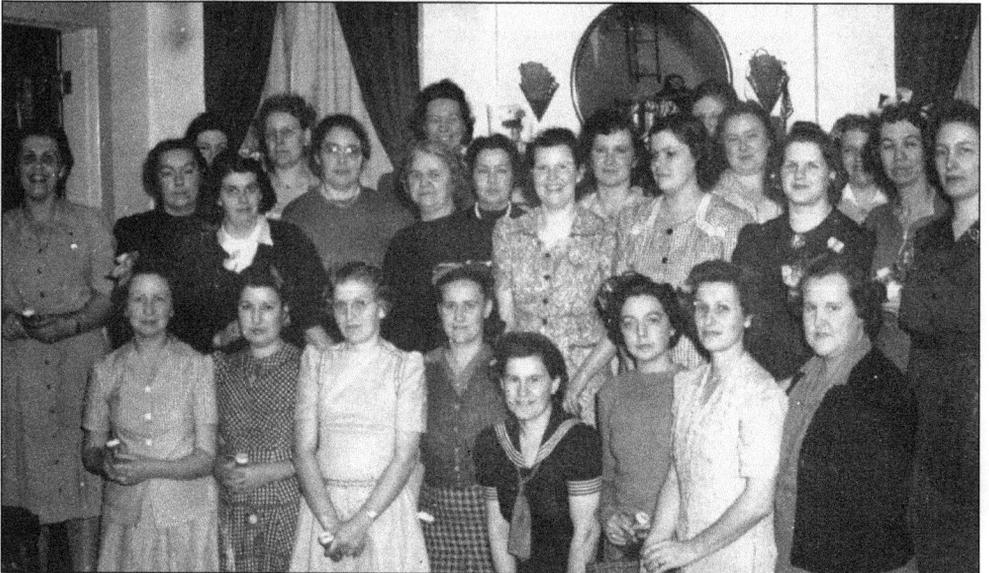

Fox Hill Central Methodist Church's Fedelis Sunday School class of 1948 consisted of the following, from left to right: (kneeling) Edith Evans Cole, Beulah Clark Watkins, Maud Rowe Odom, Cecil Drummond Wallace, Addie Richardson Freeman, Emma Wallace Collins, Ruth Evans Johnson, Dorothy Holston Todd; (standing) Marion Holston Malcom, two unidentified,, Helen Brunk Wallace, Mary Richardson Wallace Kastelberg, Mattie Clark Johnson, Evelyn Dixon Wallace Decker, Lucy Smith Todd, Annie Wallace Anderson, Margaret Brown Williams, Katherine Dunton Evans, Elizabeth Hunt Evans, Margaret Smith Wallace, Molly Shackelford Lewis, Margaret Smith, and Gladis Richardson Kelly.

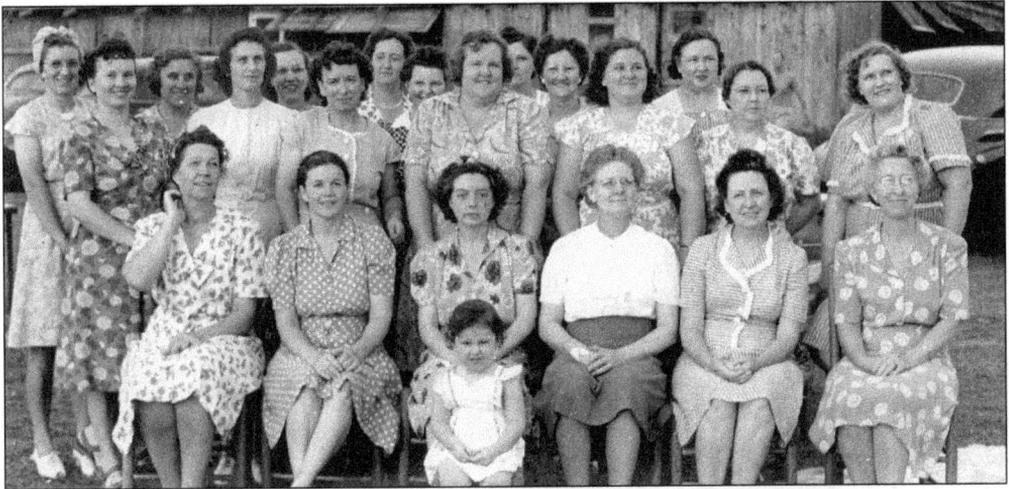

The Central Methodist Church Women's Fidelis Class Picnic of 1947 included, from left to right, (front row) Judy Evans Taylor; (middle row) Lucy Smith Todd, Nell Carmines Evans, Emma Wallace Collins, Mary Richardson Wallace Kastelberg, Edith Evans Cole, and Mrs. Reynolds (the preacher's wife); (back row) Maud Rowe Odom, Katherine Dunton Evans, Florence Routten Webb, Ruth Evans Johnson, Iva Wallace Elder, Mattie Hornsby Wallace, Grace Johnson Thompson, Margaret Warren Williams, Dorothy Holston Todd, Elizabeth Hunt Evans, Hazel Johnson Smith, Alese White Evans, Margaret Smith Wallace, Annie Wallace Anderson, and Molly Shackelford Lewis. Notice the old dance hall in background at beach. All of this has changed over the years.

Fox Hill Central Methodist Church held annual summer picnics at Grandview Beach in Fox Hill. In 1947, some of the children at the picnic were, from left to right, (front row) George Anderson, Katie Lee Evans, Norma Lee Todd, Judy White Evans, Jessie Kay Wallace, Kirby Ann Odom, and Lessie Jane Elder; (middle row) Betsy Kelly Evans, Betty Anderson, Hattie Collins, Patricia Collins, Amy Riggins, and Jean Evans; (back row) Ann Wallace, Barbara Ann Webb, unidentified, and Betty Sue Reynolds.

This 1930 photograph was taken in cold weather in front of Edward Thomas Wyatt's grocery store. Edith Mae Wyatt Councill and Ruth Lewis Martin are wearing sweaters and coats and there are no leaves on the tree. Notice the old model T delivery truck sitting beside the store and the old gas pump under the shaded roof on the front of the store.

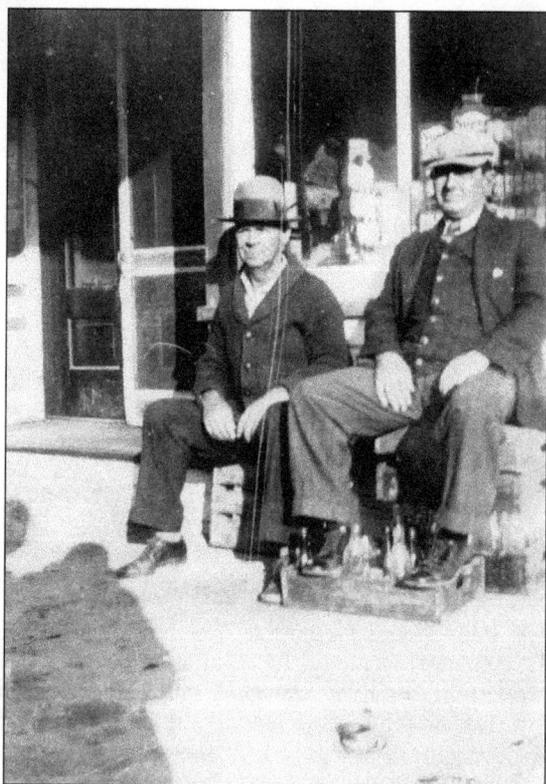

Notice the seats in this photograph: the men are sitting on old time wooden Coca-Cola crates. These gentlemen are wearing sweaters and coats as they take advantage of the winter sunshine.

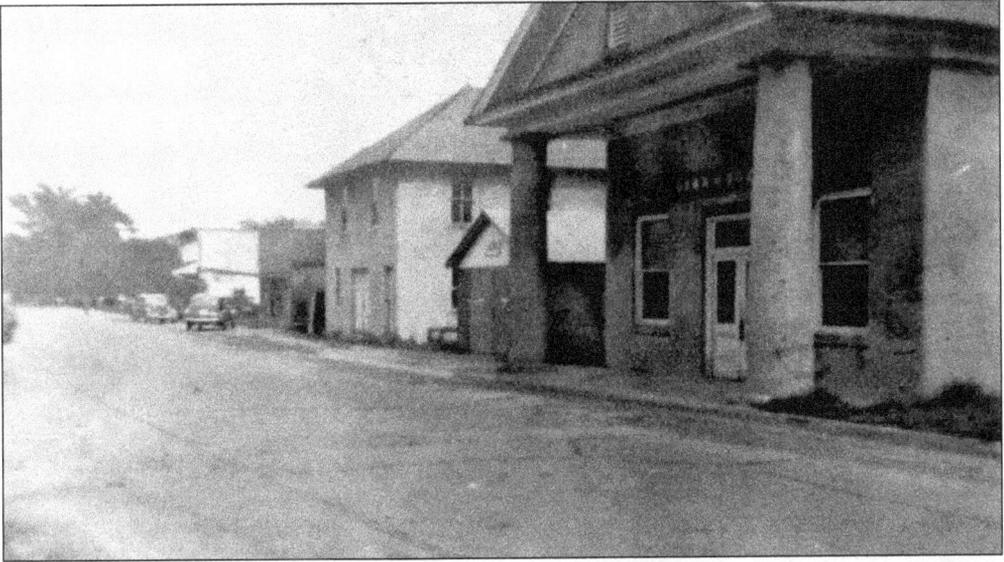

This image shows Fox Hill in the 1930s. This was part of the business district on the 600 block of Beach Road. The first building was the Fox Hill Bank, the next building was the first fire station in Fox Hill, and the next building is the Red Men and Pocahontas Hall. After that is the pool room, which later became a soda shop. Between the two buildings there was a barber shop. The last building was a grocery store owned by Mr. George Lewis and later by Royce Johnson.

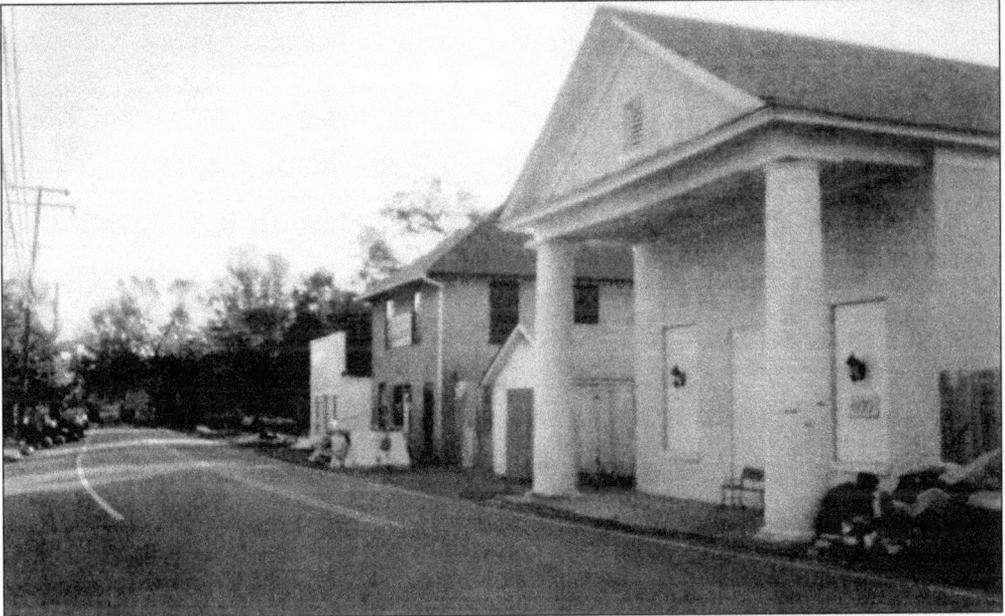

This image shows Fox Hill in September 2003. This is the business district as it appears today. The pile of trash in front of what was the Red Men's hall is the result of Hurricane Isabel, a category two when she hit the North Carolina coast. Many homes in Fox Hill were flooded and residents had no power or phone service for days. Many trees were uprooted and had to be removed. Weldon Firth worked very hard helping his neighbors to cut down the trees threatening their homes. He said, not entirely in jest, any birds returning to nest in Fox Hill had better call ahead for reservations.

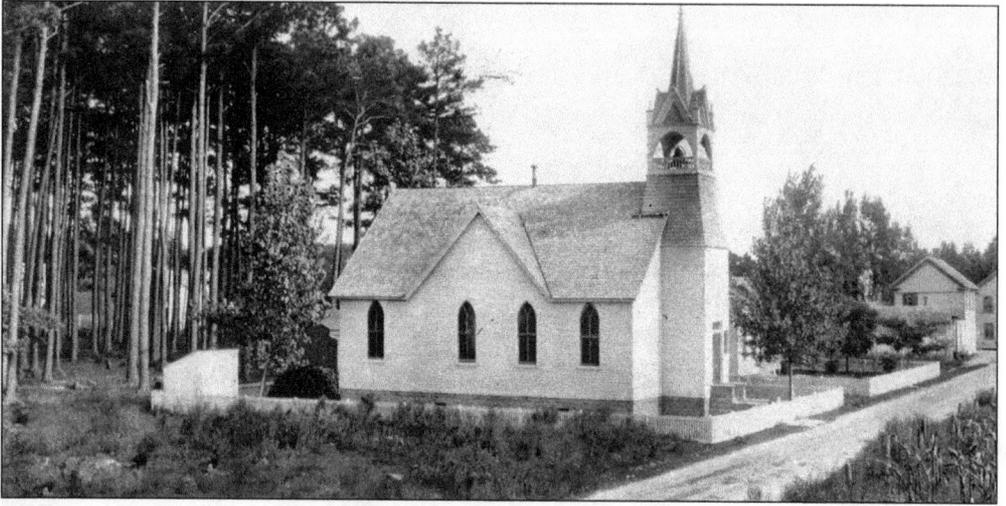

Wallace Memorial United Methodist Church was formed after 1895, when a group from First Church of Fox Hill decided to organize a church nearer the bay. They first met in the Knights Templars building located in the 400 block of Beach Road until a permanent location was secured. In 1895, Mr. William Parker Wallace gave a parcel of land for the purpose of erecting a church building. The corner stone to the church was laid in 1896. The original church organizers were J.H. Clark Sr., Mary E. Clark, J.H. Clark Jr., Diana Clark, B.F. Rowe, Susan A. Rowe, John Lewis Sr., G.T. Elliott Sr., Emmaline Elliott, G.T. Elliott Jr., Bell Elliott, J.W. Johnson Sr., Sadie Johnson, J.F. Johnson, Mary J. Johnson, George Johnson Sr., T.J. Johnson Sr., Betty Johnson, D.S. Johnson Sr., M.R. Johnson, M.V. Johnson, M.P. Wallace, and Martha V. Wallace.

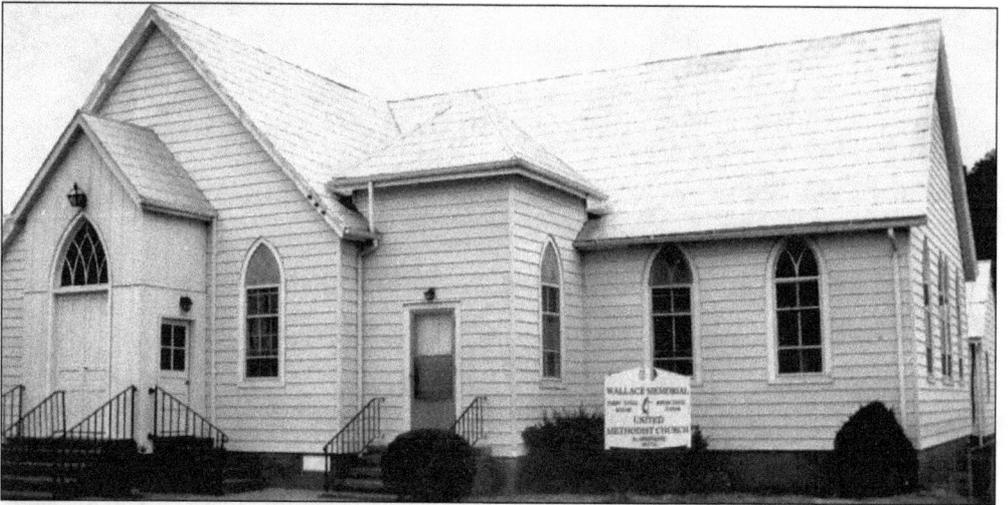

The Maryland Conference of 1897 accepted Wallace Memorial United Methodist Church, shown here in 2003, as a member of their Conference. The original church, Fox Hill M.P. Church, was accepted as a member and the Rev. George H. Stockdale became the first minister in 1901. In 1906, the church was named Wallace Memorial Protestant Church, but in 1939 the church became known as Wallace Memorial Methodist Church. In 1962 a parcel of land, adjacent to the church, was purchased for a parking lot and two on the west side of Johnson Road for a new parsonage. This building was dedicated in October 1962. The church is now Wallace Memorial United Methodist Church.

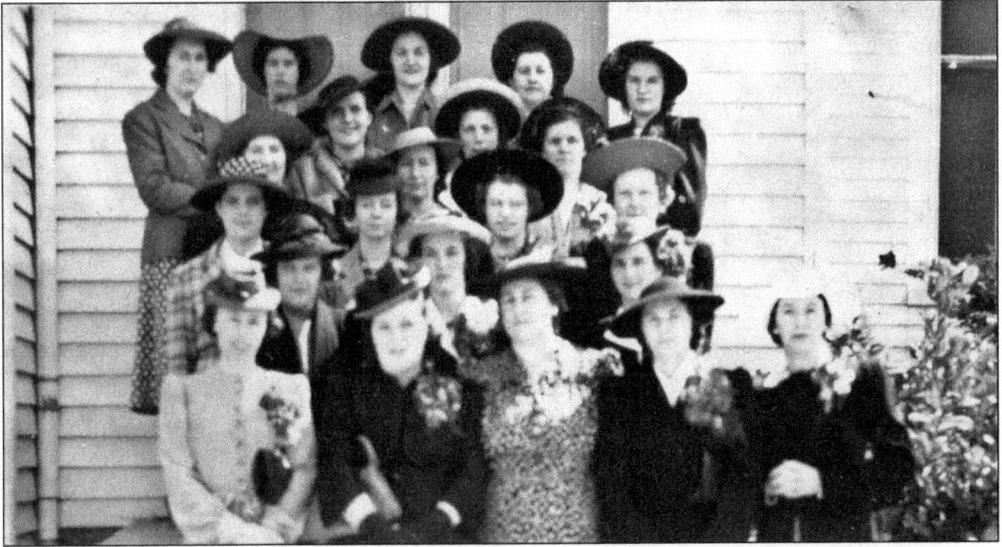

This is the Wallace Memorial United Methodist Church Dorcas Sunday School Class in a picture taken about 1940. The class is named for the biblical character, Dorcas, who was a judge. The members are, from left to right, (first row) Pearl Hollingsworth, Edna Melzer, Annie Hovey, Vivian Watkins, and Frances Watson Evans; (second row) Annie Decker, Rachel Williams, and Frances Holston; (third row) Marie Johnson, Betsy Hogg, and Kathleen Sydnor; (fourth row) Mabel Copeland Gage, Georgie Johnson, and Janie Copeland Spain; (fifth row) Lucy Hudgins and Mrytle Johnson; (sixth row) Rebecca Elliott, Rivers Johnson, Anna Lee Abbott, Esther Quinn Saunders, and Katie Harper

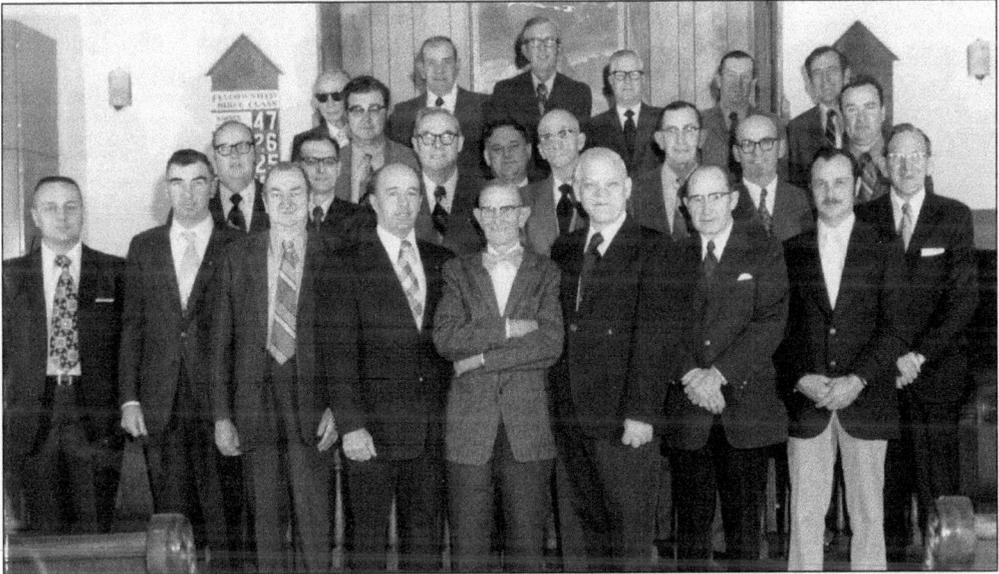

The Men's Bible Class (c. 1970) at Wallace Memorial United Methodist Church included, from left to right, (front row) Gaylord Ambrose, Earl Quinn, Elliott Johnson, Edward Powell, Wallace Elliott, Robert Cole, Walter Sears, and Neal Johnson; (middle row) Howard Williams, Meredith Ballard, John Stokes, Robert Green, David Cutshaw, Hunter Topping, Wilbur Johnson, Otis Powell, Chester Wishon, and Arthur Cardwell; (back row) Otis Price, Ben Johnson, Lewis Johnson, Ralph Joyner, Marshall Smith, and Jeff Johnson.

This building on Dandy Point was built in the 1940s by Joseph L. Wallace to be used by the community for dances and social events. It was one large room with a bathroom in the back. Later it was converted to a residence. At the time it was torn down, which was sometime in the 1980s, it was owned by Wallace Marina and used for storage of fish nets and crab pots.

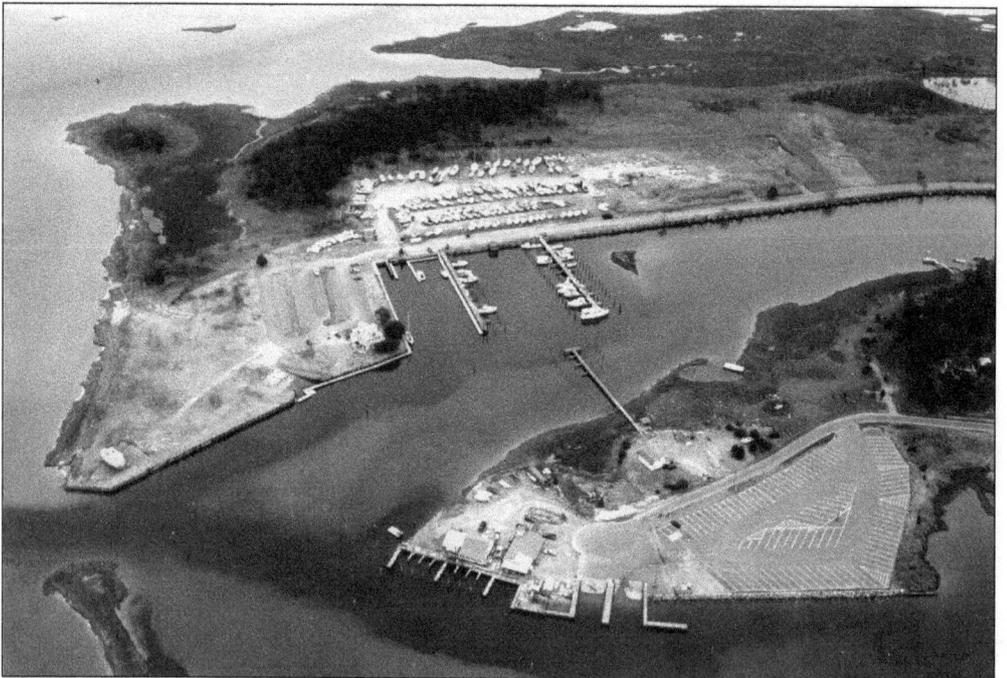

The two marinas pictured here are Dandy Point (lower right) and Bell Isle. It was at Bell Isle (upper left corner) where William Johnson came ashore with his infamous sea chest (pictured on page 84).

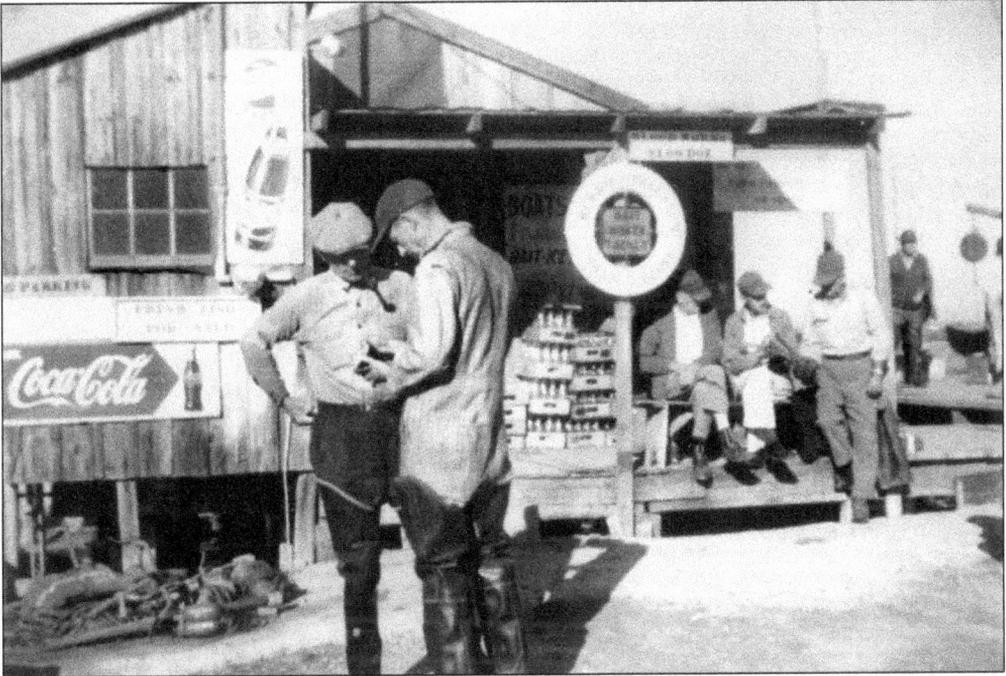

In Fox Hill, Virginia in the 1950s, fishermen return to Wallace's Marina on Dandy Point Road after a day's work, talk over their day's catch, and discuss a problem with a piece of equipment. From left to right are pictured Vernon Johnson, Harry Wallace, Sidney Johnson, Oden Wallace, and A.L. Johnson.

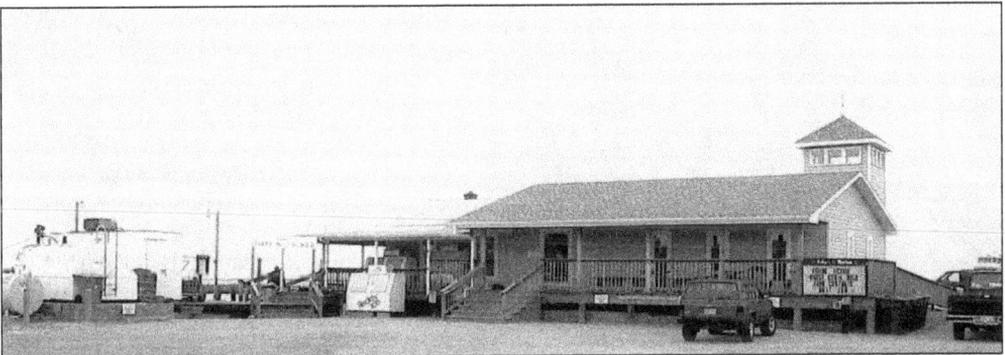

Wallace Marina in 2003 has changed over the years. It is at the end of Dandy Point Road and is one of the few public boat docks that is available to all citizens of the city.

Today, Beach Road is modern asphalt, but before 1923, the road was made from loose oyster shells. During the winter and rainy seasons, the road was full of holes and ruts. A man was appointed by the county government as overseer of the roads to keep them passable. This meant filling in the holes with shells, which he bought from local oystermen. He also hired local residents to repair the roads. The figures below are from the records of the Elizabeth City County Board of Supervisors' monthly meetings in 1905. These funds were paid to men of Fox Hill who lived in the Chesapeake District.

W.F. Wallace 1,200 Bushs. shells $36
W.F. Lewis 300 Bushs. shells $9
R.E. Johnson 500 Bushs. shells $15

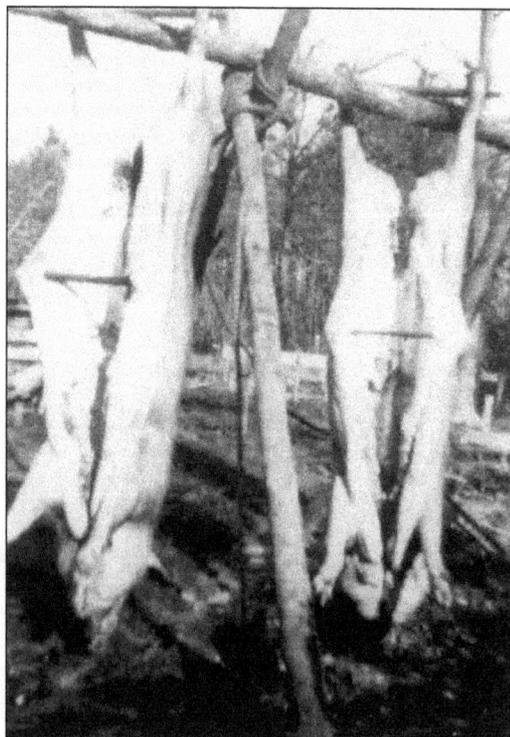

In the early days of Fox Hill, the people of the village raised their own pigs. They would grow to about 250 pounds during the summer. In the winter, the pigs would be shot and killed. The pigs would be shaved (scrapped using clam shells) of all hair and hung by their heels as shown in the photo. They would be butchered into hams, shoulders, and sides of bacon. The meat would be placed in what was known as smoke houses and smoked for several days to cure. Much of the meat was ground into sausage and then made into sausage links not unlike the ones sold today in grocery stores.

From Colonial days to World War II, the principal industries of Fox Hill were fishing and farming. Most of the farmers engaged in what is known as "truck" farming, which consisted of such crops as vegetables, strawberries, and sweet potatoes. These crops were primarily marketed to cities north of tidewater such as Baltimore and Washington, although some were sold locally to Phoebus and Hampton. One of the companies that purchased Fox Hill produce was Rowe & Jurney, Inc., of Baltimore, Maryland.

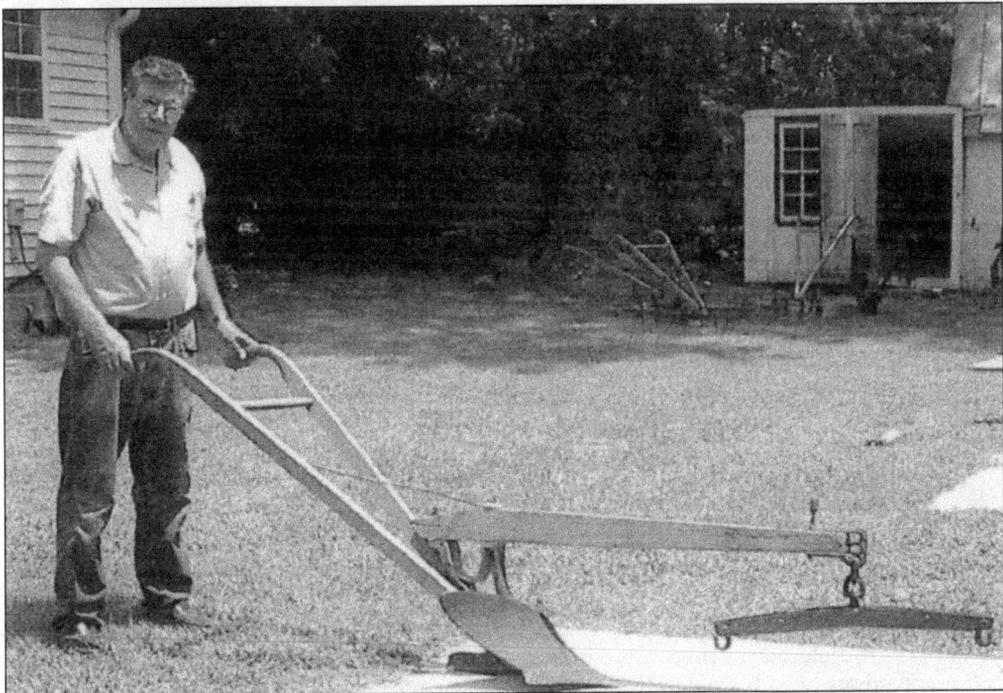

Two of the most profitable crops were early strawberries and fall lettuce. The demand for these crops was most likely due to the early and later growing seasons of the Virginia Peninsula, as opposed to the shorter seasons farther north. David C. Routten is standing here behind the Single Horse Plow. Sweet potatoes were grown by every farmer, not only as marketable produce, but as a domestic staple for the winter pantry.

57

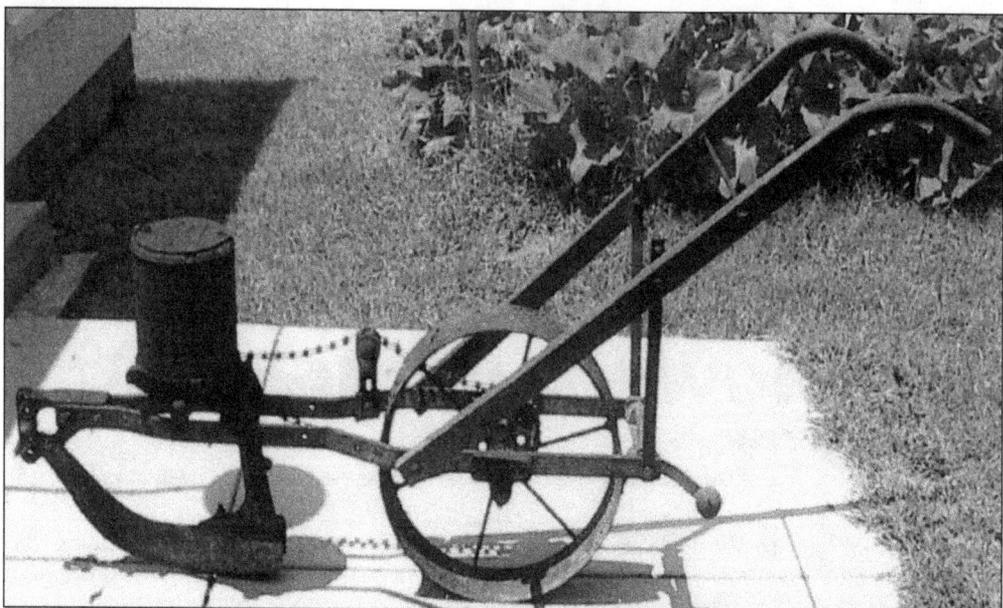

An adequately stocked corncrib and hayloft were required for the survival of a well regulated farm, since horses, cows, hogs, and fowl had to be fed. These supplies were needed for the winter.

In addition to field crops, there were gardens of assorted vegetables, a variety of fruit trees, and grape arbors, which produced food for domestic use. Nearly every farm had an acre or two of woodland from which dead trees were cut and used as fuel for cooking and heating. Another important by-product of the woods was pine straw, which was used as stable bedding for livestock. These small, well-managed farms enabled their owners to be substantially independent. Edward Routten, brothers Lawrence and Gordon Routten, and William Milliken operated three chicken farms after World War II.

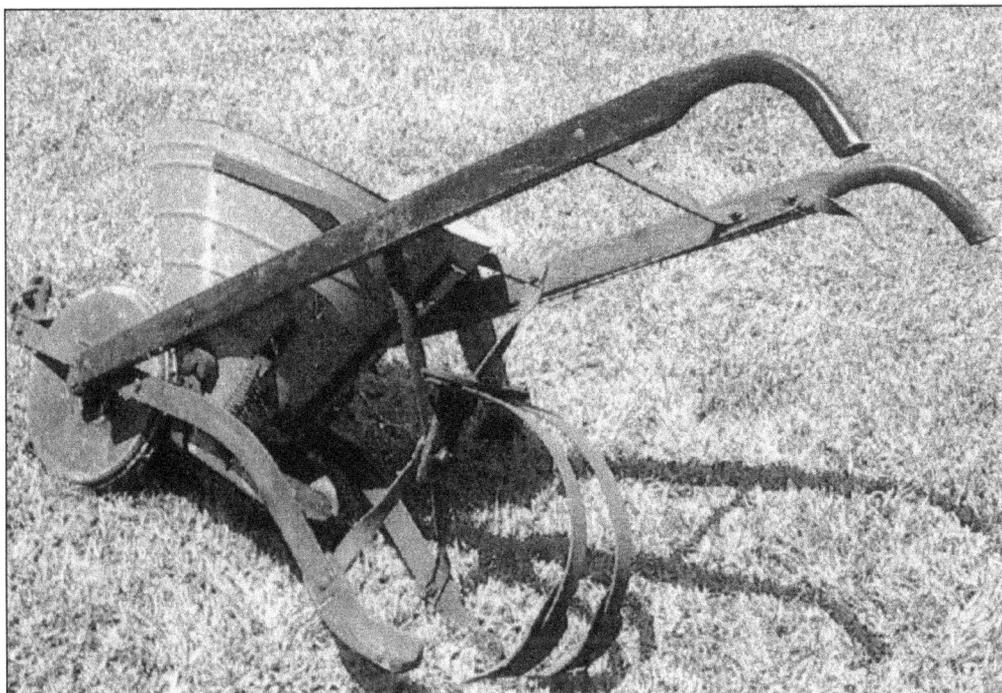

This is a guano distributor, which was used to fertilize the vegetables. Guano is bat manure, a favorite fertilizer in Fox Hill.

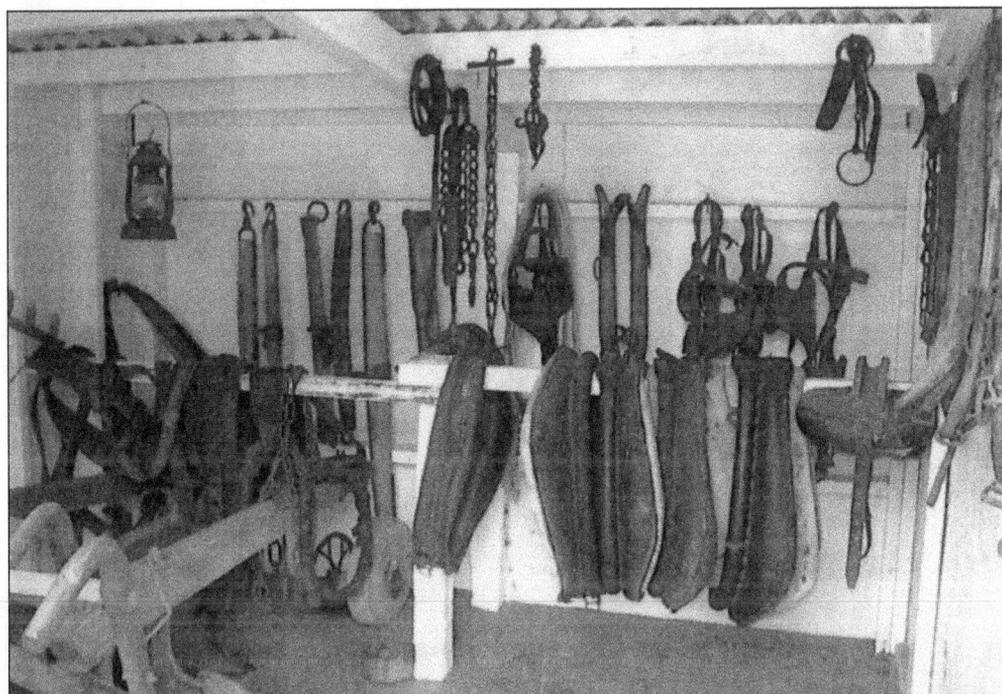

This is David Routten's extensive collection of farm equipment. Pictured are several horse collars, an oil lantern, and a plow. All were needed to work with animals in the fields of Fox Hill.

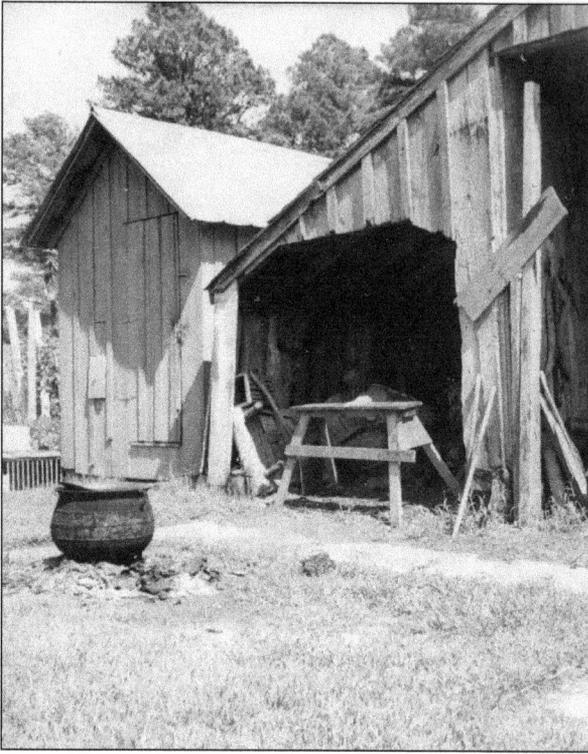

This is the smokehouse used for curing meat. Pig fat was cut into cubes and put into the cast iron kettle (iron pot in front of smokehouse) and when cooked, rendered fat into lard and kracklin. Lard was used for cooking and making lye soap. Kracklins were eaten or put into corn meal to make kracklin bread. Pigs were a main food source, along with seafood, for the families of Fox Hill.

The crops in the background of this photograph are corn. The shed was where the horse and cow were kept. The lane you see led to Granny Wyatt's home. Wyatt Lane is Horton Road today.

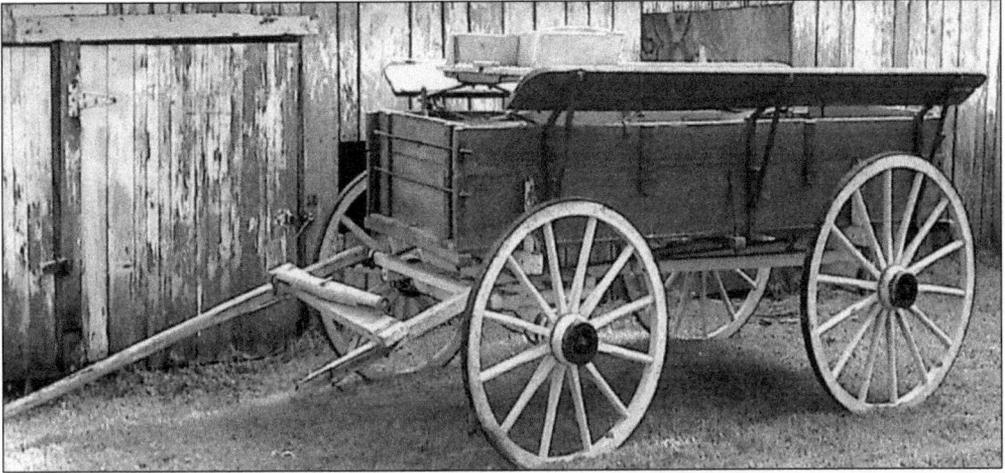

This is a single horse wagon with spadder boards and a spring seat. It was used for family transportation as well as hauling farm products, equipment, and other sorts of wares.

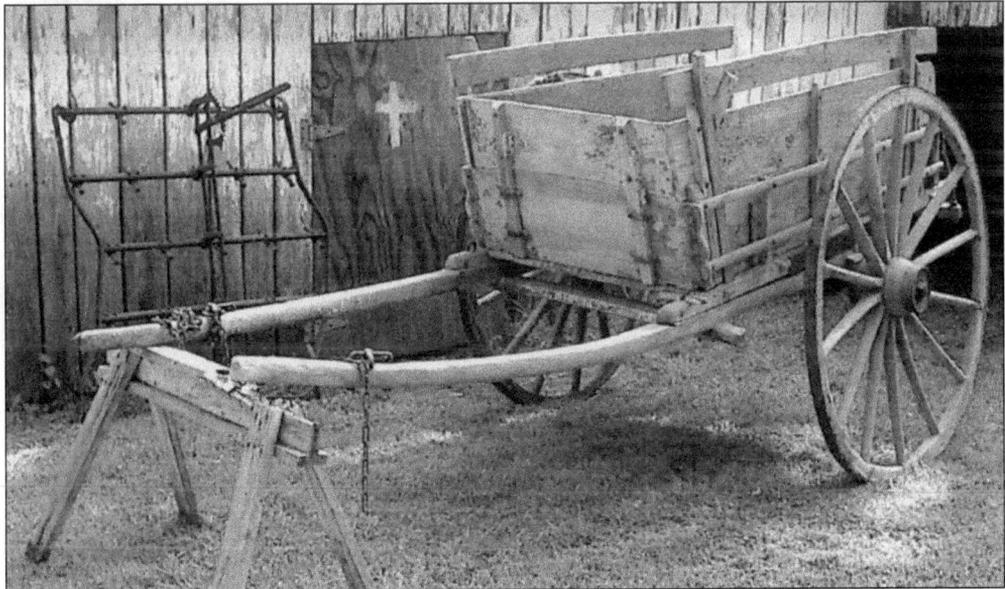

This is the single horse tumbrel cart, which is commonly called a tip cart. The tumbrel is the American version of the Welsh cart. Without being attached to a horse, it would tip over, rider and contents spilled to the ground.

This is the Missile Control Site on Wind Mill Point Road. In World War II, troops were quartered at the water tower on Beach Road. The local residents welcomed the troops by giving them homemade goodies like hot rolls. The soldiers might have been living in tents, but at least they were well fed! Military troops patrolled the area beaches south to Fort Monroe and north to Factory Point. These beaches included Buckroe Beach and Grandview Beach. There were pill boxes and lookout towers still in place after the end of World War II. Due to time and erosion these pill boxes and towers have long disappeared.

Here is the Nike Missile Site and Bomb Shelter on Grundland Drive. After World War II came the Cold War, and Fox Hill was touched like every other place in the United States. It was evidenced by two locations, Grundland Drive and Wind Mill Point Road. Nike missiles and a bomb shelter were located on Grundland Drive. In fact, the proper name is a community center, but the locals still refer to it as the "Nike Site." The Wind Mill Point location was the control site and is currently used by Hampton City Schools. The Grundland location is also used by Hampton for the Fox Hill Athletic Association and is where the Fox Hill Historical Society meets.

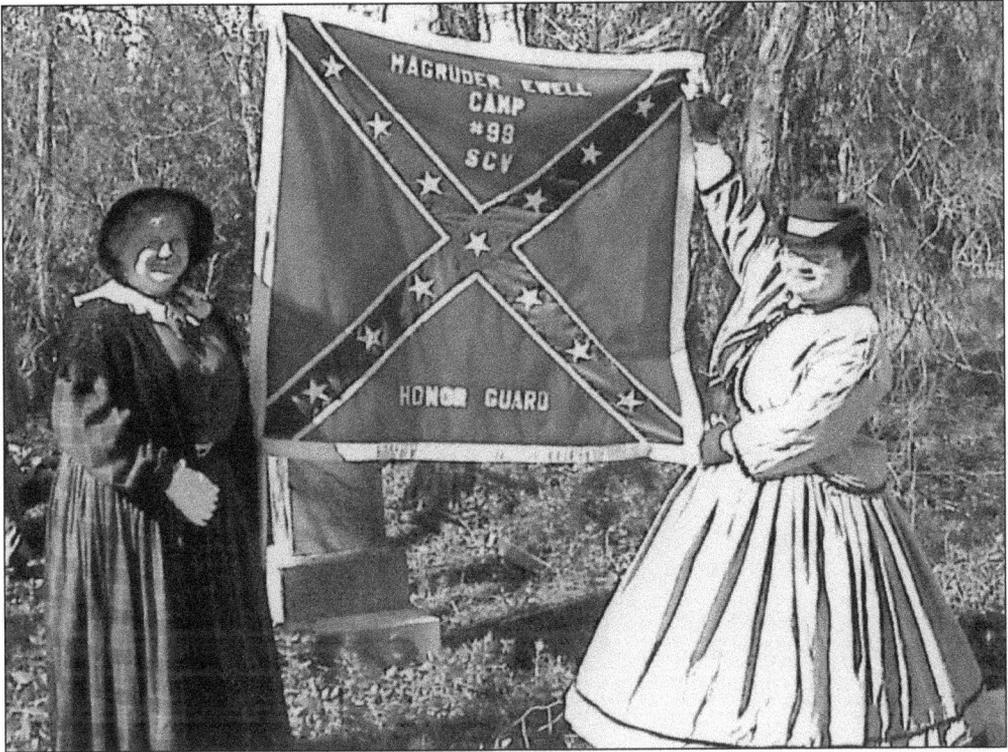

On April 12, 2003, members of the Fox Hill Historical Society remembered their Civil War dead by placing a bronze cross at the grave site of these men located on Grundland Road in Fox Hill. The grave behind the sign is Robert Samuel Johnson ("Dipper"). Dipper was the groom for Robert E. Lee's horse, Traveler. Pictured are Melodye Ballard (great-granddaughter of Benjamin and Harriet Copeland; granddaughter of Mabel Cathleen Copeland Gage and Clinton DeWitt Gage; and daughter of Marjorie Gage Ballard and Meredith William Ballard) and Rosemarie Arredondo Kidd (great-great-granddaughter of John W. Evans and Mary Wyatt; great-granddaughter of John W. Evans Sr. and Katherine Virginia Johnson; granddaughter of John W. Evans Jr. and Nell Carmines Evans; and daughter of Katie Evans Arredondo and Robert Arredondo).

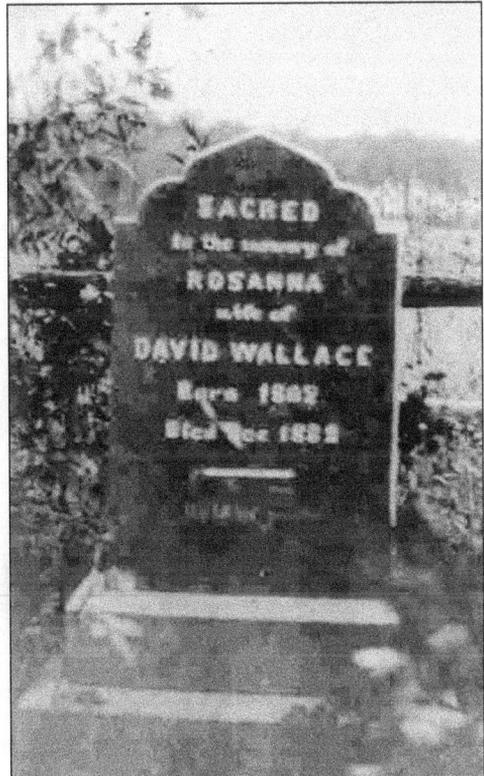

This is the tombstone of Roseanna Wallace, who was the wife of David Wallace. She is buried in the Wallace-Johnson Cemetery on Grundland, which is the same cemetery as the location of the Civil War ceremony.

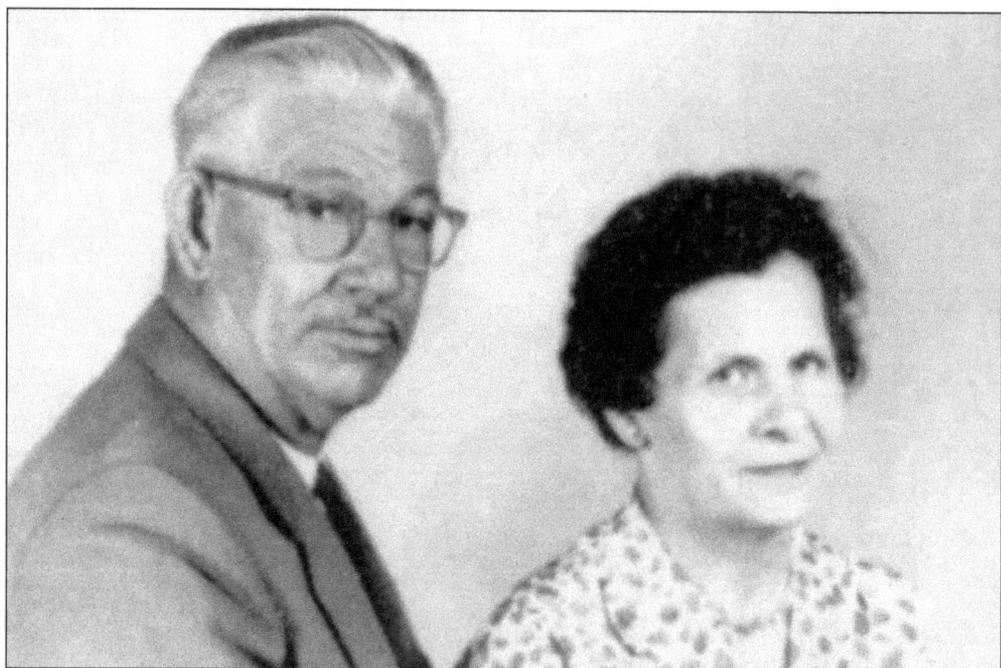

Clifton Lee Wallace Sr. is Jack Wallace's son and Johnny Wallace's brother. Clifton poses here with his wife, Rosalie Belle Henry Wallace.

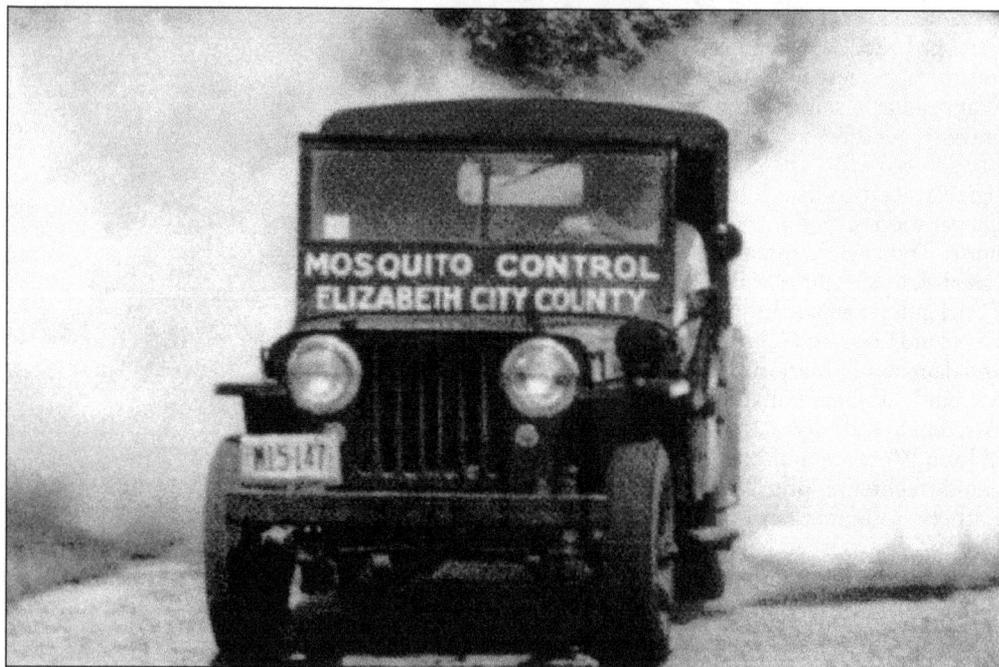

Fox Hill is located on the Chesapeake Bay where the bay flows into the Atlantic Ocean. In the summer months there are a lot of mosquitoes. Clifton Wallace worked for Elizabeth City County, Virginia and is shown here in a World War II Jeep, spraying DDT for mosquitoes. Notice the white fog as he drives along the back roads of Fox Hill during the 1940s, before they knew that DDT was dangerous to use.

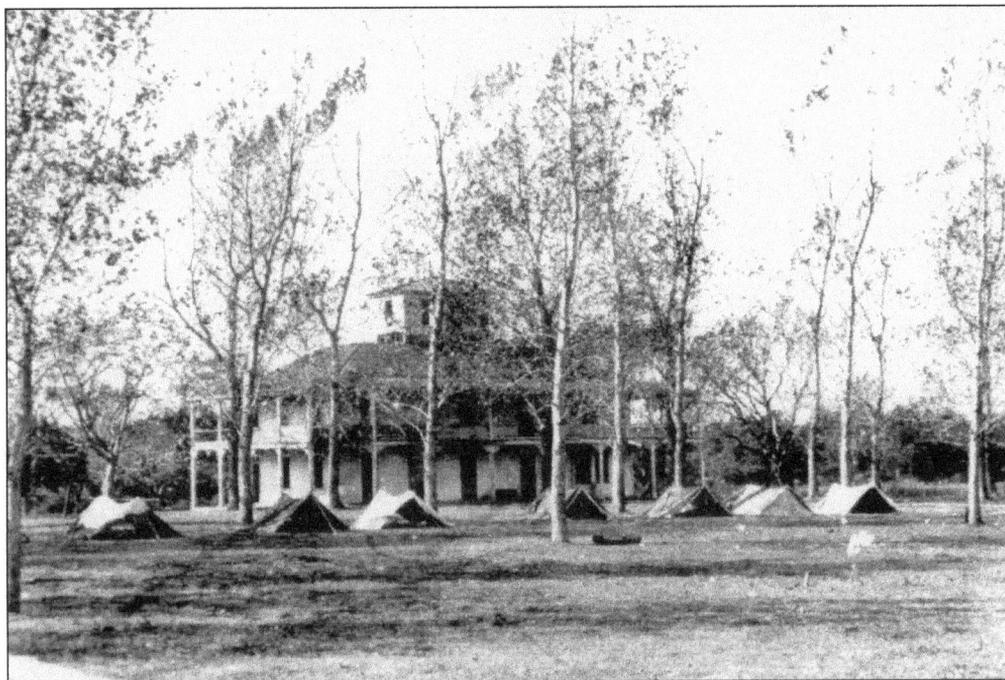

During World War I, troops were quartered at Grandview in front of the Hotel Annex. The popular trees are long gone, as is the land on which this hotel was built.

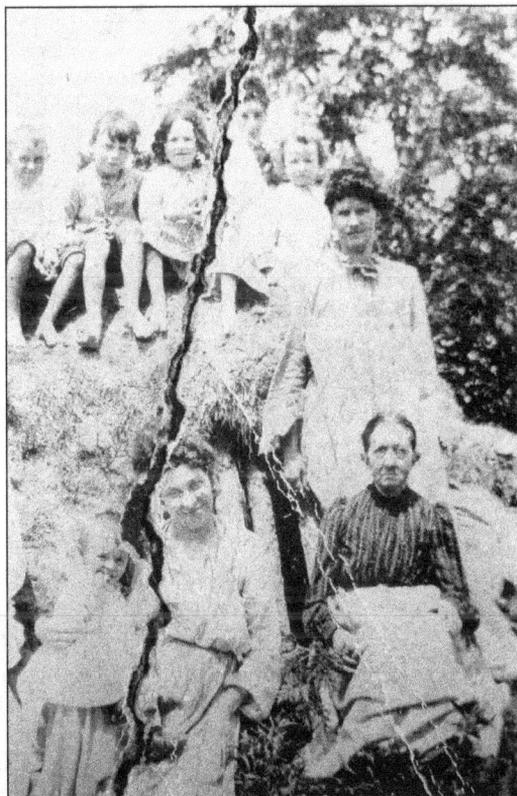

Seated in the lower right corner, Susannah Bekke Johnson (born January 6, 1828 and died September 7, 1910), the daughter of William and Elizabeth Wallace Johnson. Susannah married John Saunders Wyatt in 1845. Their first child was Mary Elizabeth Wyatt (Mrs. John Evans). Susannah smoked Blue Bonnet clay pipes. Catherine Virginia Johnson (Mrs. John Evans Sr.) is standing. Upper left children are Mary Evans, Erma Evans, unknown boys. In the lower left is Lulie Johnson, who was Catherine's best friend.

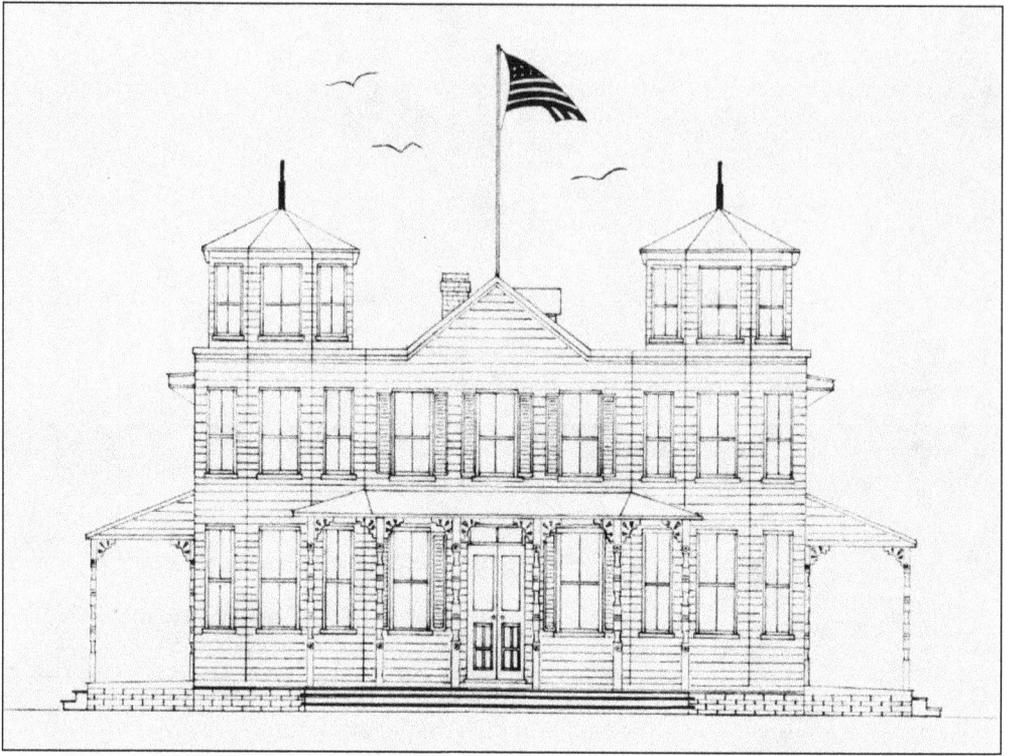

This is what the hotel looked like in 1890. Grandview was a very popular place during that time in history. There have been several dance pavilions in the area over the years, but time marches on and Fox Hill is no exception. The hotel has long disappeared and a housing project now stands on its location. This drawing of the hotel was made by Mr. Charles F. Elliott.

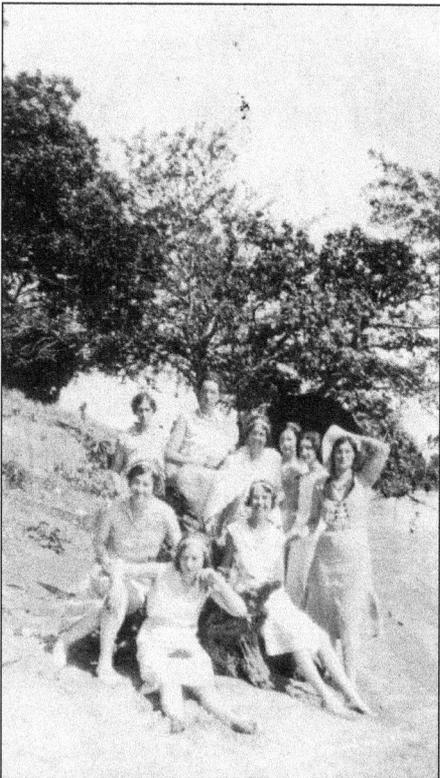

The girls pictured here are, from left to right: (front row) Iva Wallace Elder Rideout; (middle row) Gracie Johnson Thompson and Ruby Smith Morris; (back row) Clara Smith, Lucy Smith Todd, Margaret Smith, Edith Evans Cole, Mabel Jester Wallace, and Ruth Evans Johnson.

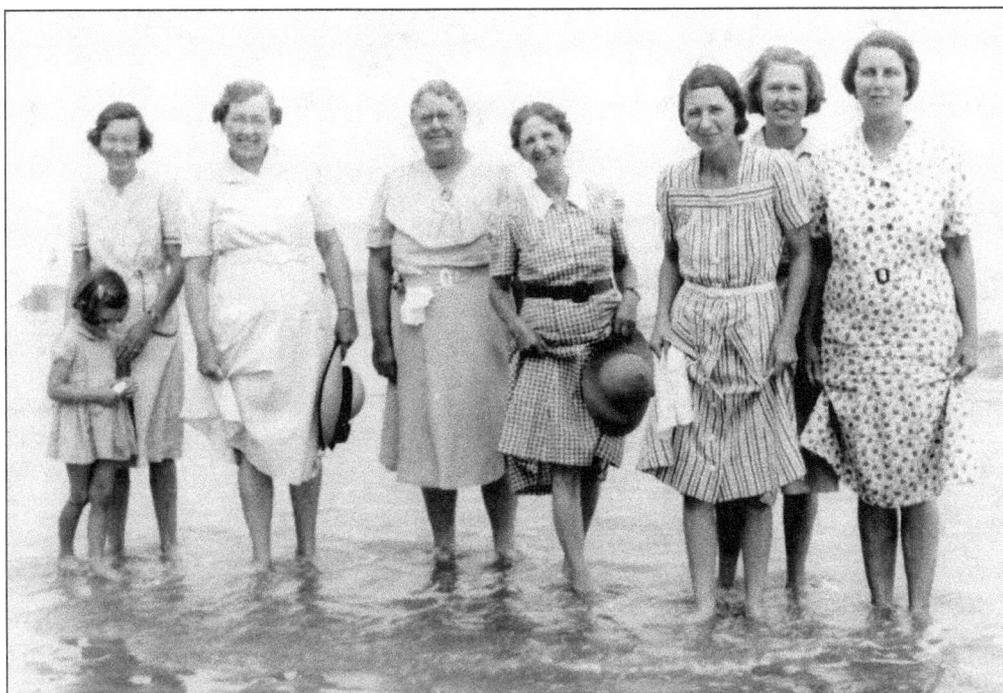

Fox Hill ladies take a stroll in the warm waters of the Chesapeake Bay on a warm spring day at Grandview Beach in 1931. They are, from left to right, Linda Decker (child), Myrtle Johnson, Lelia Johnson, Katherine (Sissy) Watson, Hattie Johnson, Vivian Watkins, Martha Mason, and Virginia (Vergie) Elliott.

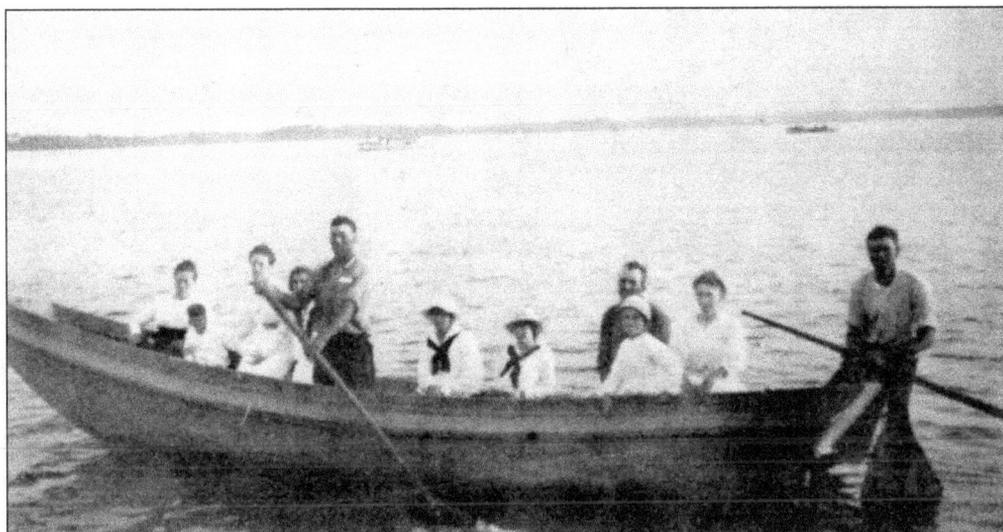

From left to right, Mary Rowe Johnson, Billy Wallace, Vera Wallace, unidentified, Johnson Rew, Harry Mansfield, Edna Johnson, Fannie Routten, Edith ?, Richard Johnson, Aunt Sing, and Peter Wallace, spent this Sunday afternoon on Back River.

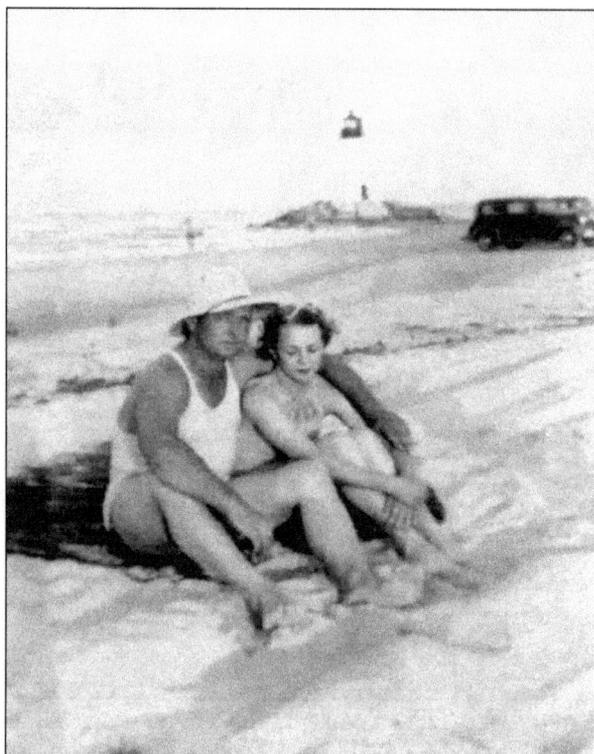

Alonza "Babe" Clark and Manola Patterson Clark enjoy a warm sunny day at Grandview Beach, Fox Hill during their honeymoon in 1939. In the background is the Back River Lighthouse.

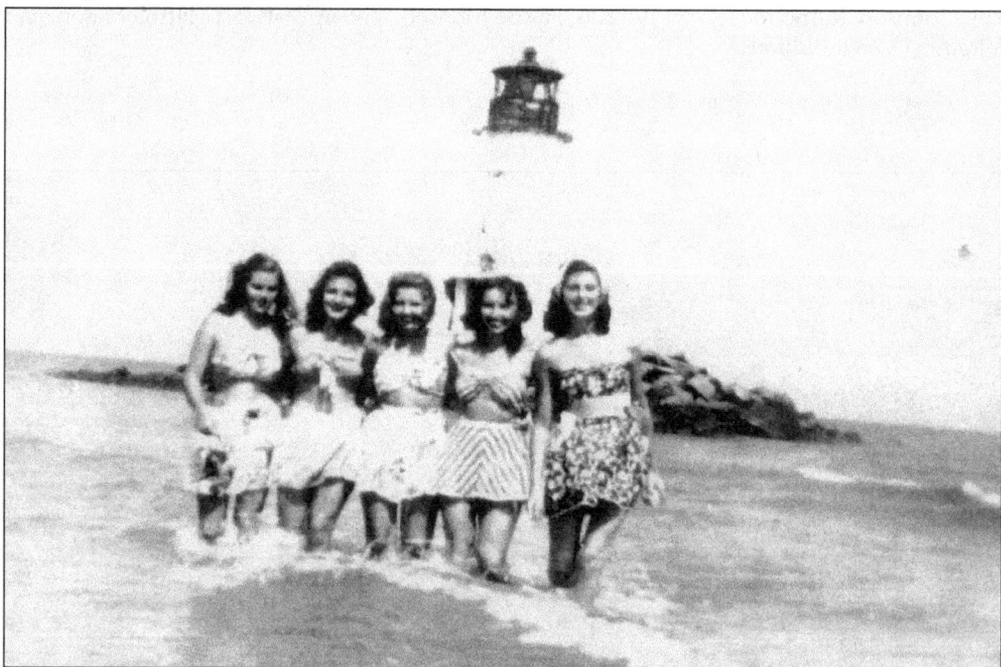

With the Grandview Lighthouse as a background, these women take time for a photo opportunity as they enjoy a warm day at the beach in the summer of 1942. From left to right, they are Joyce Johnson Hunt, Doris Rudd Porter, Carolyn Johnson Lingenfelser, Shirley Mason Green, and Jackie Elliott Wilson.

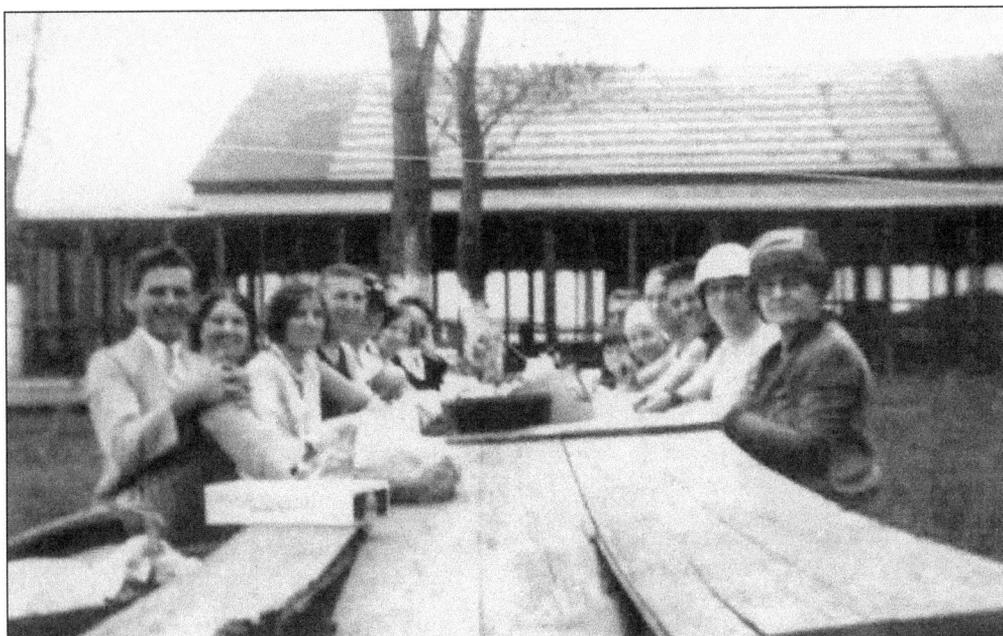

The Jones family has a picnic at the beach on a warm sunny afternoon in the 1930s. The beach was very popular during this time. The old Grandview Dance Pavilion is seen in the background. Many famous bands have played here over the years.

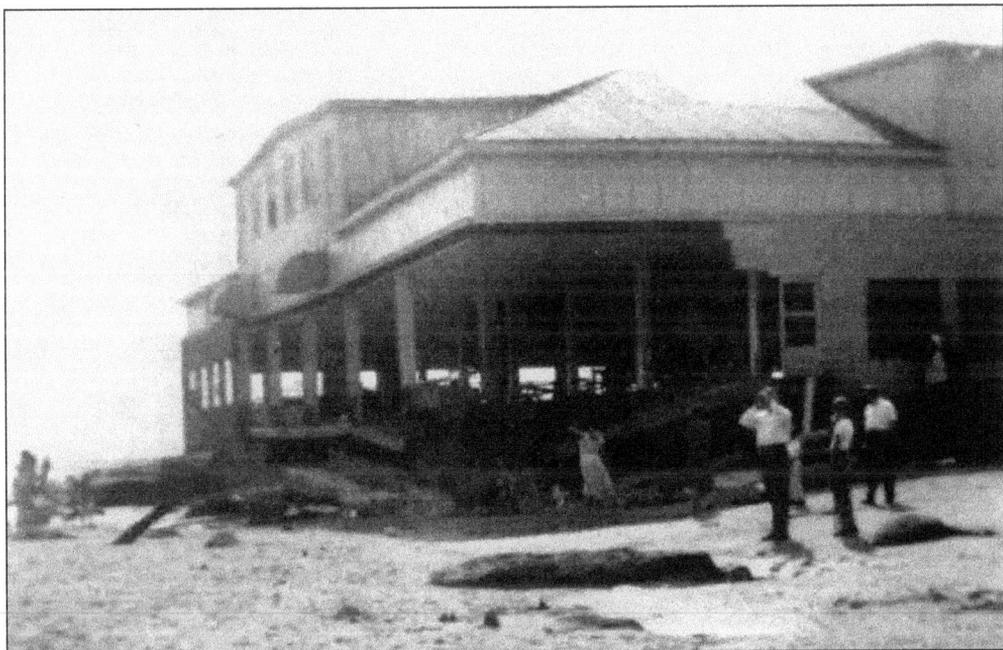

The Grandview Dance Pavilion was said to be one of the largest dance pavilions in this part of the tidewater. The dance floor would accommodate about 300 couples. The pavilion was badly damaged in 1954 by Hurricane Hazel and later torn down. The land area of Grandview has eroded about 1,500 feet since the 1890s. In the time since, erosion has taken a toll on this area and what you see here is now under water and part of the Chesapeake Bay.

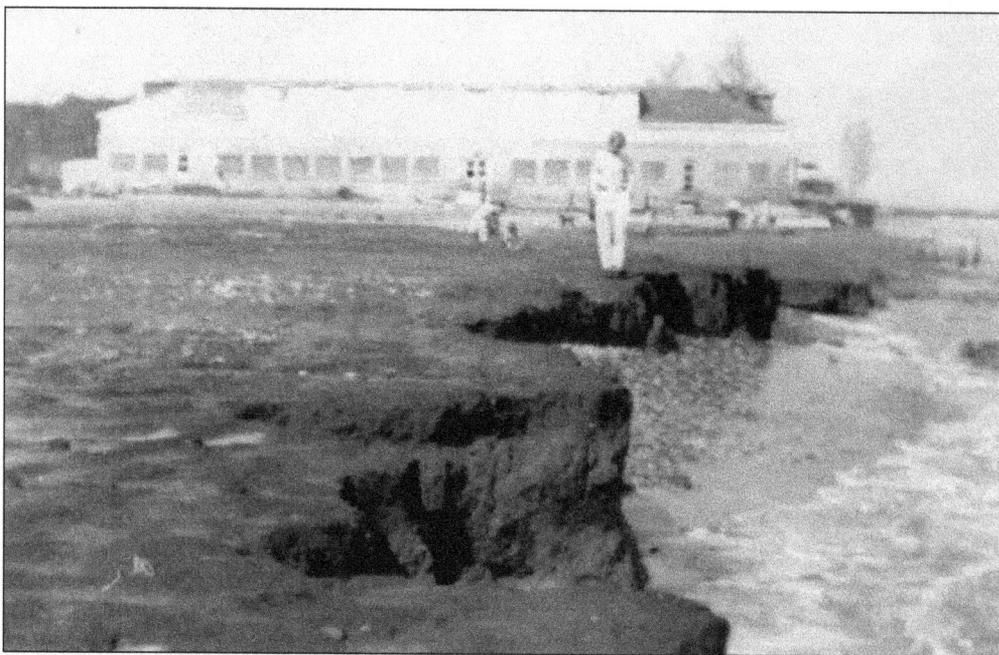

Mr. Charles F. Elliott walks along the shoreline after Hurricane Hazel did its damage in 1954. The Grandview Dance Pavilion is pictured in the background.

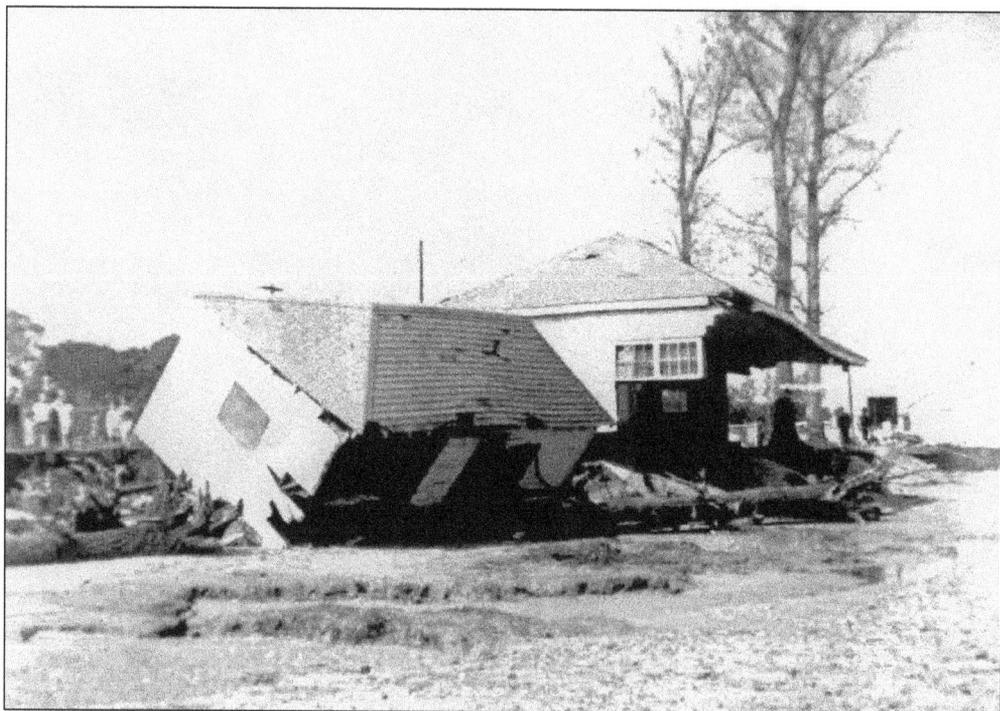

This is an example of the power of a hurricane. In 1954, Hurricane Hazel damaged several buildings on Grandview Beach. Hampton High School held the last prom in this pavilion in 1954, shortly before it was destroyed by Hazel.

Three

FOX HILL FAMILIES

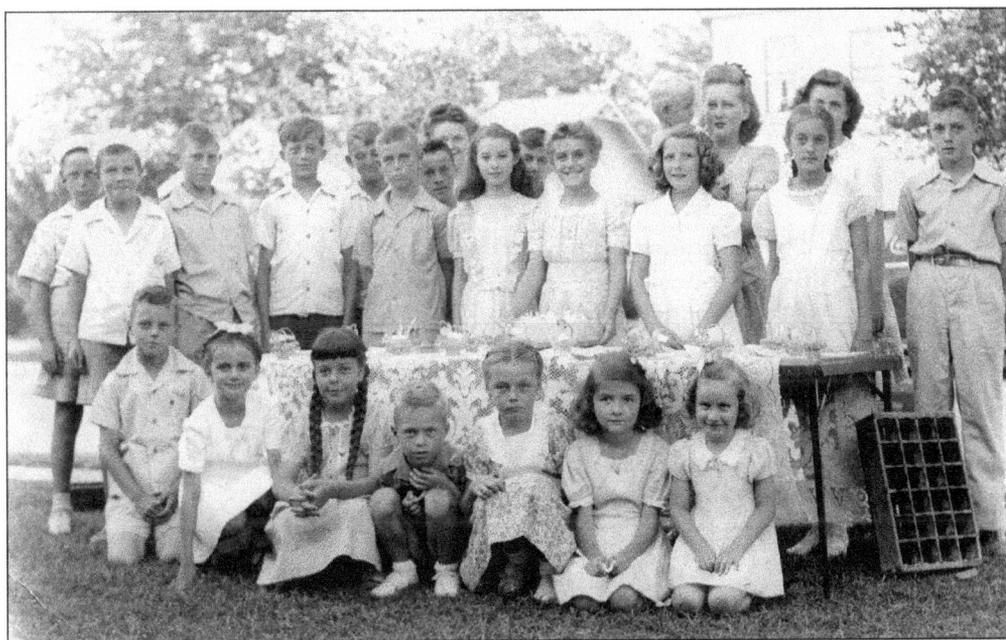

Pictured at Nancy Routten's birthday party about 1941 are, from left to right, as follows: (front row) Duncan Stewart, Jean Evans Raines, Betty Westcott Hoard, David Stewart, Barbara Spencer Price, Amy Riggins Johnson, and Betsy Evans Griffith; (middle row) Jack Clark, Robert Deal, Gene James, Eugene Griffith, Charles Ray Lewis, Skippy Cole, Dickie Wallace, Durwood Jones, Janet Rowe, Nancy Routten Quinn, Peggy Routten, Carolyn Lewis Dorst, and Wallace Ray Spencer; (back row) Dora May Kastleberg, Mildred Rowe Wise (holding Hartwell Routten), and Eleanor Alligood.

Charles Francis Elliott was known as the "beachcomber." He was born July 15, 1928 and is the son of Tom Elliott and Sarah Zander Elliott. His interest in researching local history led to writing and publishing several books, including *Fox Hill: Its People and Places*, *The Back River Lighthouse*, and *The Son Of A Fisherman*. He wrote articles that were published in the local paper, *The Daily Press* (Newport News, Virginia). Charlie was also interested in wood carving. He died June 25, 1998. Some of the information in this book is from the pages of Elliott's book *Fox Hill: Its People and Places*, courtesy of his widow, Marian K. Elliott.

Manola Patterson Clark and Virginia Johnson Clark are two local historians who started working on Fox Hill history in the early 1950s. Manola and Virginia worked together to complete a map of Fox Hill with most family residence locations along with many landmarks included. Manola compiled a history of Fox Hill, which was published in local newspapers and available in local libraries.

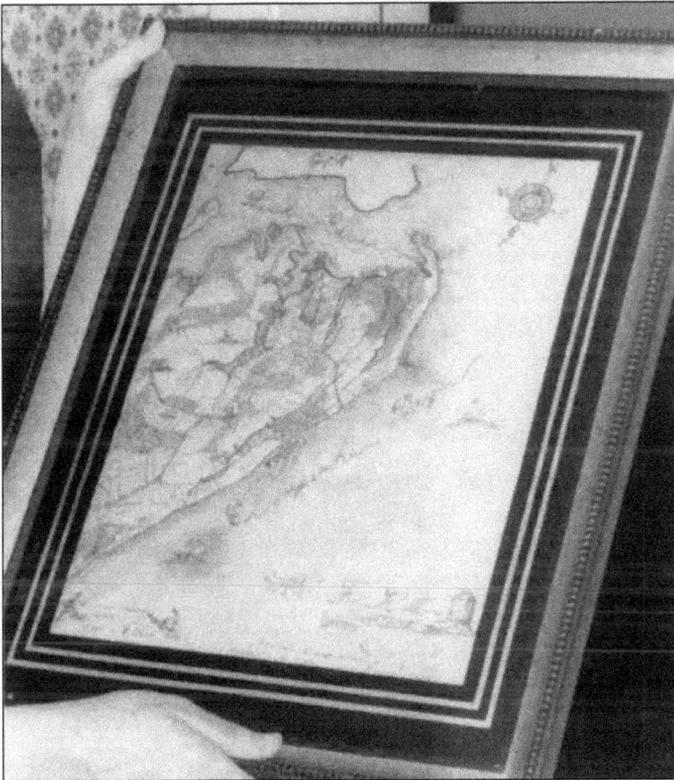

This is the map of Fox Hill that was drawn by Virginia Johnson Clark and Manola Patterson Clark in the early 1950s.

This photograph of Benjamin F. Burge and his wife, the former Ada Virginia Johnstone of Hampton Town, was taken in 1896. Benjamin Burge, who delivered ice to many of the homes and businesses in Hampton, was born in Fox Hill in 1874. He was the grandson of William H. Abdell, keeper of the Back River Lighthouse from 1863 until his death. He was also the grandson of William Burge, an early 19th-century settler in Fox Hill. According to stories he told his grandchildren, the original William Burge was from a well-to-do family in England. He was kidnapped and impressed into the British Navy. He escaped overboard when his ship went aground off Fox Hill during the War of 1812 and settled in Fox Hill, where he later married Kesiah Evans Lewis and earned his living on the water.

Laura Wallace Abdell was born August 28, 1867. She married Levin Payne Mason on August 15, 1883. Here she is shown with two of her 13 children. She is holding Virginia Elizabeth Mason, who was born September 30, 1913 in Elizabeth City County, Virginia. Virginia died in 1951 in Newport News, Virginia. The daughter standing is Laura Blanche Wallace Mason, who was born April 18, 1910 in Elizabeth City County.

There was a terrible influenza epidemic in Elizabeth City County in 1918. The month of October alone saw 135 people die from it. Fox Hill was not spared from this dreadful epidemic. The first cases in the county occurred there. Charles F. Elliott was one of the first to contract flu; he died from it, the first flu victim from the county. Schools were closed that fall and winter while churches were asked not to hold services because the buildings were needed as hospitals for the many who contracted the flu.

John Henry Clark Sr. (1831–1916) came to Fox Hill around 1832. He was a carpenter by trade and passed this tradition on to his sons. He served as a second lieutenant with the 115 Virginia Infantry, Company A, under the command of General Magruder at Yorktown, Virginia, in 1861. He bought or built the house at 137 Beach Road, which is known as the Clark Farm and is one of the oldest homes standing and occupied in Fox Hill today. Clark Cemetery was founded by him when he and his wife, Mary Elizabeth Porter, selected the site to bury their third child, Margaret, who died when she was one and a half years old; Margaret was, therefore, the first person buried in the cemetery.

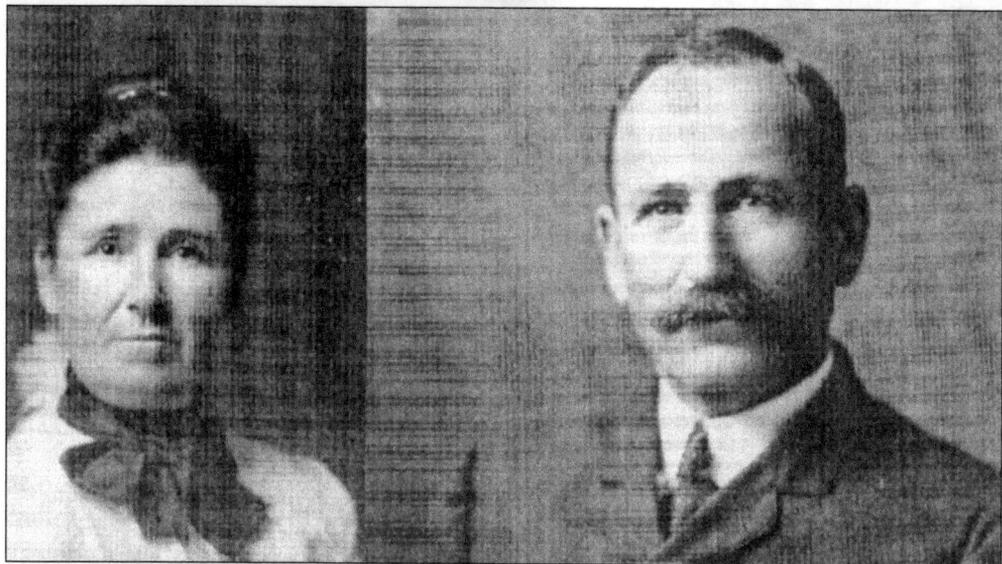

John Henry Clark Jr. (Papa Clark) is pictured here with his wife Diana Elizabeth Dawson. Papa Clark was born May 6, 1855 in Rip Raps (Fox Hill) and died November 20, 1925, five days after being paralyzed by a stroke. He was 70 years old when he died and is buried in Clark Cemetery. Papa Clark was a carpenter by trade, belonged to Wallace Memorial Methodist Church in Fox Hill, and was also a member of the Tuscarora Tribe #70 of Red Men and the Bay View Lodge of Odd Fellows. He married Diana Elizabeth Dawson (Mamma Dia) on March 25, 1878. She was the daughter of James Dawson and Diana Hopkins and was born in York County on March 7, 1859 and died January 6, 1935 at the age of 76. She is buried in Clark Cemetery next to Papa Clark. Diana was a charter member of Wallace Memorial Methodist Church. John and Diana had nine children: Eppie (Epia), Diana Elizabeth, William Thomas, Vera Wray (Adella), John Henry, James Porter, Edwin Layton, Granville, and Daisy.

John Henry Clark III ("Jack") owned and operated Clark Brothers Construction Company in Fox Hill and built many of the homes there. He and his two sons operated the business, following in the footsteps of his father and grandfather. He served as Superintendent of Public Works for Elizabeth City County, as well as serving on the School Board for Elizabeth City County. Sue Wyatt Clark was very active in community affairs. She was a member of the Pocahontas, the Fox Hill Woman's Club, Community Chest Board, the Red Cross Board, and the Public Welfare Board. She was president of the Woman's Club for 12 years and instrumental in the formation of the Fox Hill Junior Woman's Club. During the 1930s, she was chairman of the Distributing Commodity Board. Sue was the first woman selected as a jury commissioner in the State of Virginia.

Mary Tabitha Clark (Polly), daughter of William Clark and Margaret White, was born in 1821 in Elizabeth City County in the Brown House on Harris Creek (behind the cemetery). Mary married Samuel Copeland from Philadelphia, Pennsylvania. Samuel was born on December 10, 1814 and came to Virgina to work in the Ordnance Department at Fortress Monroe as a blacksmith during and after the Civil War. When he met Mary, he said she was the most beautiful girl he had ever seen. They were married on April 9, 1843. They lived at Ft. Monroe for a short time, and their first child was born there. Mary died August 22, 1884 and Samuel died on November 20, 1890. Both are buried in Clark Cemetery. Samuel and Mary had 12 children: Margaret Jane (Peake), Samuel, Mary Anne (Reese), Hannah Frances (Brown), Anne Elizabeth, John Henry, William Andrew, Joseph F., George Washington, Benjamin Lee, Charles Thomas, and Annie Laura (Bloxom).

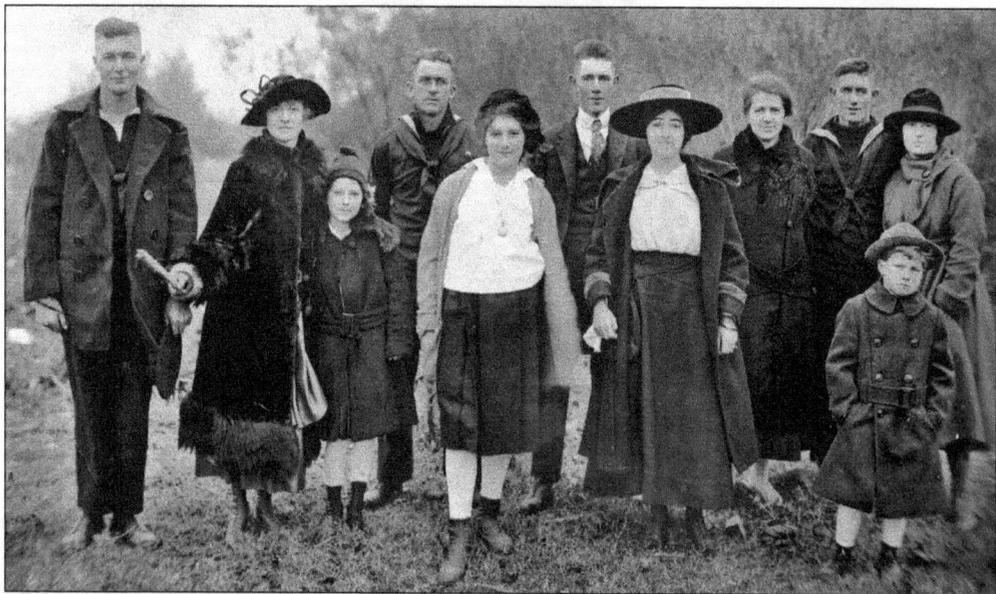

The following people posed for this 1918 photo in Fox Hill, from left to right: (front row) Tom Elliott, Emma Elliott, unidentified child, Mabel Copeland Gage, and Mary Copeland; (back row) unidentified sailor, unidentified, Annie Laura Copeland Rowe, Samuel Copeland, unidentified, and unidentified child.

Benjamin Lee Copeland was the 10th child of Samuel and Mary Tabitha Clark Copeland. He was born on February 13, 1862 in Elizabeth City County. Ben was a fisherman at the fish camp in Buckroe and also a farmer. Harriet Anne Elliott was born September 5, 1865 and was the daughter of George Thomas and Emmaline Lewis Elliott. Benjamin and Harriet were married on April 30, 1884 and built the family home on Beach Road in 1886. Harriet died February 10, 1935, and Ben died April 7, 1949 at 87 years of age. Both are buried in Clark Cemetery. They had seven children: Mary Tabitha (July 22, 1885), Margaret Rebecca (November 4, 1886), Howard Lee (March 14, 1892), Annie Laura (September 2, 1893), George Samuel (December 13, 1896), Robert Marshall (December 11, 1900), and Mabel Cathleen (May 6, 1906). Benjamin, Harriet, and Mabel Cathleen pose for a picture c. 1911.

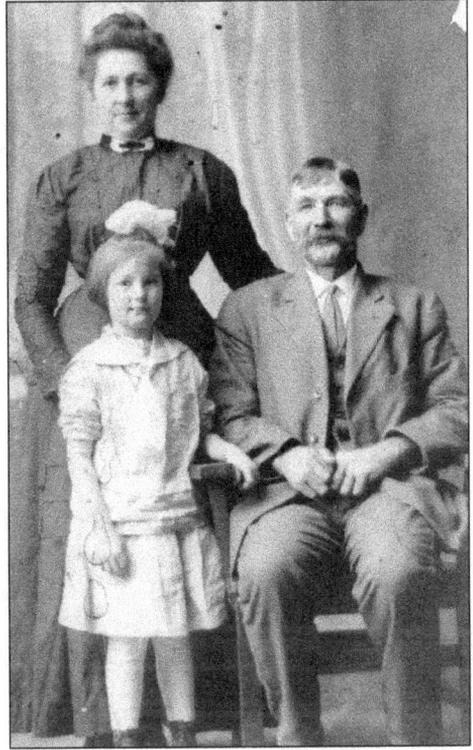

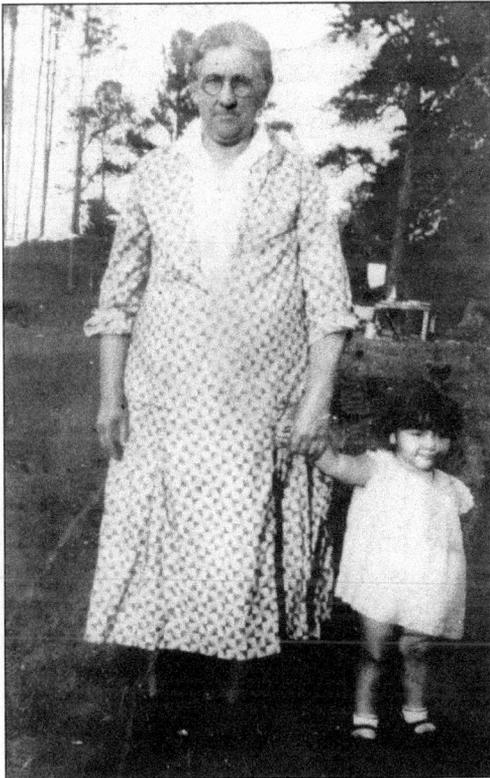

Harriet Anne Elliott Copeland and her granddaughter, Marjorie Anne Gage Ballard (daughter of Mabel Cathleen Copeland Gage and Clinton DeWitt Gage), are pictured here c. 1930.

There was a gate at the entrance to Fox Hill. Since the "open range law" was in effect, the purpose was to allow cattle to roam freely but not leave the Fox Hill area. A fence ran from the water's edge of Harris Creek on the west to the Chesapeake Bay on the east. The "Gate" was a unique iron gate installed on Beach Road, which opened automatically when a horse-drawn cart drove over the trigger mechanism placed in the road. A trigger on the opposite side would close the gate. The gate was located near Mr. William Holston's house. Cousins Mary Guy and Florence Holston (William's daughter) pose in the front yard of Holston's home.

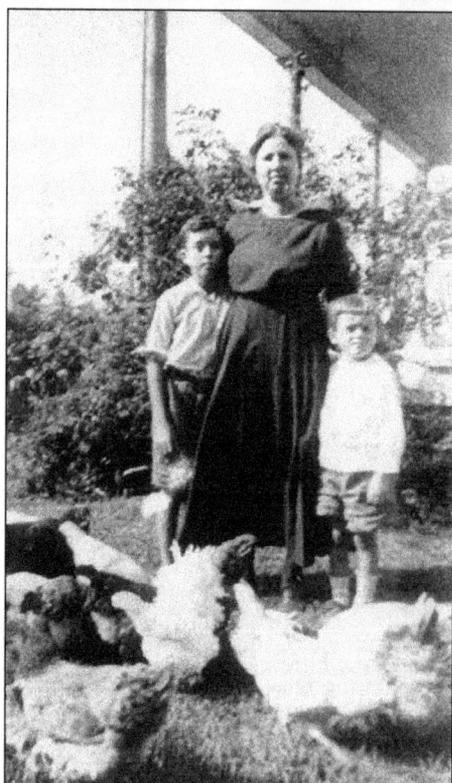

Vera Clark (Mrs. Charles Rowe, 1888–1958) stands with her two sons, Edward and Milton Rowe, in the yard of their Fox Hill home where the family's chickens were allowed free range.

Madison Monroe ("Matt") Holston was probably the youngest son of Elizabeth Johnson and John Holston (one of John's 26 children). He was born on January 18, 1856. Sarah Virginia Wyatt was the daughter of Susan Bekke Johnson and John Saunders Wyatt Sr. She was born on February 6, 1858. Matt and Sarah were married in Hampton Baptist Church on January 14, 1875 by the Reverend Adams. Matt was in the net fishing business and was prominent in the business and civic circles of Fox Hill. They were both active members of Central Methodist Church in Fox Hill.

This tintype features Sarah Virginia Wyatt Holston. Sarah wrote for the church paper, the *Church Voice*. She and Matt had eight children between 1875 and 1898. They were Eva May, Betsy Ann, Lina Estelle, Nettie Virginia, Thomas Hendricks, Pauline Madison, Hilda Ernestine, and John Carroll. Sarah Virginia died in 1910 and Madison died in 1932. They spent their entire lives in Fox Hill. After Sarah died, Matt operated the rides at Buckroe Beach Amusement Park in Hampton, Virginia.

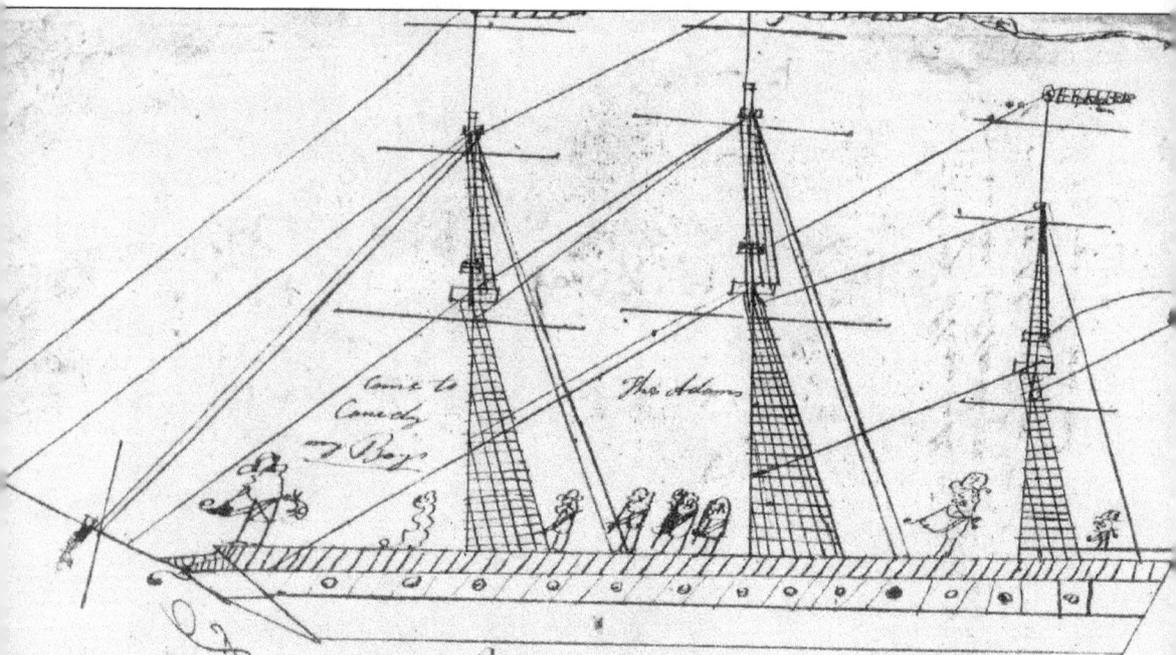

There is some mystery as to whether the first William Johnson to settle in Fox Hill jumped ship from a British frigate during the War of 1812 or came ashore on an American ship. He was a master mate or navigator on the gunboat *Adams* as shown in his log, which was passed down to his youngest son, Samuel Johnson, and on to his youngest grandson, Claude C. Johnson. There is also a question as to how the mariner got his wooden seaman's chest to shore had he jumped ship. The logbook journals a voyage from London to Madiera dated April 12 through May 1795 (which indicates he was only 12 years old at the time), showing that the seaman was probably studying his nautical lessons of latitude, longitude, logarithms, and the reading of a compass with observance of the polar star. There are also comments on the weather and payments or "prizes" received, which lead some to believe the first Fox Hill Johnson was a privateer. William Johnson was born in Lancashire, England in 1783. There are references in the log to Piccadilly and Southampton as well as Hampshire and Isle of Wight, which are on the southern coast of England. He received his U.S. citizenship papers in March 1815. His descendants were upstanding citizens of Elizabeth City County, Virginia: hardy fishermen, oystermen, and farmers at the mercy of the elements. Besides his role in the War of 1812, a number of his children, grandchildren, great- and great-great-grandchildren served in the War Between the States, World War I, World War II, as well as the Korean and Vietnam conflicts and the Gulf Wars. William Johnson died in 1853 at the age of 70. He left an interesting legacy.

William Johnson settled in Fox Hill about 1814. He is the ancestor of all the Johnsons who live here today. Johnson was a ship's navigator in the U.S. Navy in the 1790s, early 1800s, and in the War of 1812. All seamen during this time had big wooden sea chests for their clothes and personal belongings. This chest was passed down to his grandson, Claude C. Johnson, who is pictured here, and then to his great-grandson, Col. Robert S. Johnson.

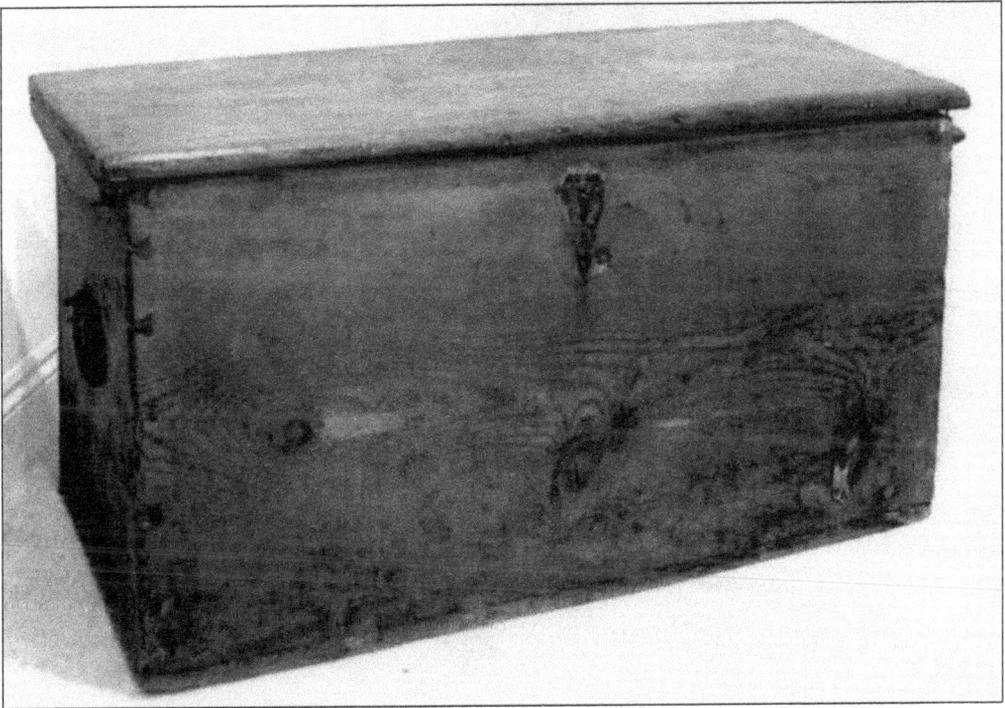

This is the sea chest that William Johnson brought with him to America. He bequeathed it to his grandson, who then left it to his son, Col. Robert S. Johnson.

Theresa Holston was the daughter of John Augustus Johnson (who was the twin of Susannah Bekke Johnson). The children of Theresa Holston, pictured here from left to right, are Charlie Holston, Eula Holston Johnson, Theresa Johnson Holston, Beatrice Holston Johnson, Clara Holston Horton, and Ellis Holston. There was another son, Carlys Holston (not pictured, deceased).

Ann and Henry Johnson Jr. (great-grandchildren of Mrs. Martha Viana Ward Wallace) dressed as Martha and George Washington for the May Day Festival (in 1933) at Francis Asbury School in Fox Hill. Ann Johnson married I.V. Behm and Henry Jr. married a cousin, Betty Frances Johnson.

Martha Viana Ward was born in York County on April 15, 1834. She married Capt. William P. Wallace of Fox Hill on April 8, 1853. Martha and William had eight children. Roseanna was their second child and was the grandmother of Ann Johnson Behm. Martha Viana wrote lovely poetry, as evidenced by the poem on the next two pages. She died in May 1923 and is buried in Clark Cemetery, Fox Hill.

Composed and written by Mrs. M.V. Ward Wallace

The writer has been requested
To write a sketch of her personality in poetry.
Now this seems like the first lesson.
As for twelve months the writer has not had a line of poetry in her possession,
Yet I find myself with some recollection
And quick to understand incidents that passes.

And at the age of 81 can see to read and write, without the aid of glasses.
My nationality the writer doesn't scarcely know,
Her father came from Eastern Shore.
My mother's father from Richmond came.
Tailor by trade, Watkins by name.
In York County, on Back River, The writer first saw the light of day.

When in my teens, I married Capt. William P. Wallace Rip Raps sailed away.
Rip Raps is in Fox Hill, which extends in a radius from Buckroe to the Oyster Rock.
There in its waters they catch the shad, hog fish and spot,
In a district where we have the rural and electric light,
No wonder the writer feels a little tasty for some-thing to right.
One can come to Fox Hill and they can quickly understand.

For miles and miles a negro don't own one foot of land.
Even here the writer need not stop
In the whole district one won't find a whiskey shop.
There was not any free school eighty years ago.
Therefore, education had to be obtained with quite a high price.
Although nothing was known better in the Country than a log schoolhouse.

Times have changed since then.
The writer used no other than a goose quill pen.
Although the writer never lived in a rented
Or unplastered house in all her born days,
And before the civil war was mistress of a few slaves.
Obedient slaves, ther's where the trouble came in,
No wonder the south was willing to give and die for them.

There wasn't one in the Southern Confederacy
Who did more for the South than my mother according to her ability.
She gave her timber by the acre
To General Magruder to build winter quarters on Back River.
She had a son who belonged to the Hampton Grays,
When he joined he thought it no more than play.

But in the first encounter,
It's likely he had rather be home with his mother.
Antietam was the first
To the front he had to go
Because he belonged to the ambulance corps
Many and many young men out of that battle went by the board.

To lose then the South could little afford.
Magruder was all to blame,
Because he marched over into Maryland.
This in 1916 yet two of that battle with us remain (Samie Johnson & Thomas Cain)
Harper's ferry said my brother.

He did his best to drive the enemy further,
But after the live ones were driven away, the dead ones were not any company.
He and his chumes made up their minds,
To rob the dead next day of gold watches and all the money they could find.
But after he saw their gruesome faces his heart failed him,
And the only penny worth he brought off the battlefield was a first class violin.

That old war relicle at Newport News,
And W.W. Wallace would much money for it refuse.
Mother said he can play it to beat the band,
And he never has forgotten the old tune, Dixie Land.
My Brother was quite a favorite after the
War, with Democrats around and in Hampton
They visited him by the hundred.

More than once with band of music Back River crossed.
Waking up the population as well as the horse.
There they had the oyster supper.
And enjoyed what they called a Democratic Rally.
All of those good old soldiers have passed away.
That was in Colonel Jeff Sinclair's and Baker Lee's day.

My brother too had to go
And leave his wife and nine children here below.
Captain Wesley Ward was Storekeeper and farmer.
The most of his occupation was on the water.
Out of the war he did not get this title,
But by being Captain of his own vessel.

He was an indulgent husband and father, and that wasn't all
He died a Christian and expected to answer to his name up yonder at the general roll call.
He was fifty-one years old when the died.
The writer was present at his bedside.
With a radiant smile said my brother,
Sister I will be waiting for you at the river.
His beautiful obituary the writer has kept for twenty years in her Bible.
It's been a solace to her in many troubles,
While the sands of life are sinking fast
Sister, through a vision can see the lovely bow in the east.

This was taken from a copy made on June 30, 1978, by Anita Ross Hehl Howell, great-granddaughter of Capt. Wesley Ward and daughter of Anita Ward Godsey. It had been copied and handed down through many generations of the family, including Sarah Elizabeth Ward Freeman, Rebecca Freeman Dryden, and Betsy Freeman Croswell Kersey.

Roseanna Wallace Johnson, known as "Grammie," was born in Fox Hill on October 17, 1857. Her parents were Martha Viana Ward of Poquoson and William Parker Wallace (who donated the land for Wallace Memorial Church). Grammie was four years old when the War Between the States started and remembered the incidents that affected her and her family. She was a wonderful storyteller and loved to entertain family and friends with her stories. When the Federals were in the area during the war, Grammie and her brothers and sisters were taken to Poquoson by boat for protection. Those experiences were uppermost in her mind for the rest of her life. She and Robert Eugene Johnson were married in February 1873 and had 12 children. She lived to be 98 years old, died November 4, 1955, and is buried in Clark Cemetery.

Robert Eugene Johnson was the third child of William Johnson and Sara Mary Topping. He was born in Fox Hill, February 22, 1856, and lived his entire life in that community. He was a farmer and a waterman, and he sold seafood to organizations in and around Hampton. The Veterans Administration was probably his largest account. No matter what the weather, fresh seafood was delivered on a regular basis to the "Soldier's Home" (later the Veterans Administration). He owned a 65-foot schooner, the *Bozeman* (pictured on page 22), that was used to transport seafood around the bay. Robert was the father of Henry Johnson, a local merchant whose store is pictured in this book. He died February 14, 1915 and is buried in Clark Cemetery in Fox Hill.

Miss Elizabeth Kelly Wallace (Betsy Kelly) was born July 8, 1848 in Elizabeth City County. George Lennon Johnson was born May 6, 1846. Betsy and George were married March 23, 1865 by the Rev. Mark Chevers, rector for St. Johns Church in his quarters at Old Point Comfort, Virginia. When the Civil War began, the Town of Hampton was burned by the Confederates to prevent Yankee occupation. St. Johns Church had also been burned, so the rector was at Fort Monroe, Virginia. Betsy Kelly died August 23, 1921 and George died June 6, 1917. Both are buried in Clark Cemetery.

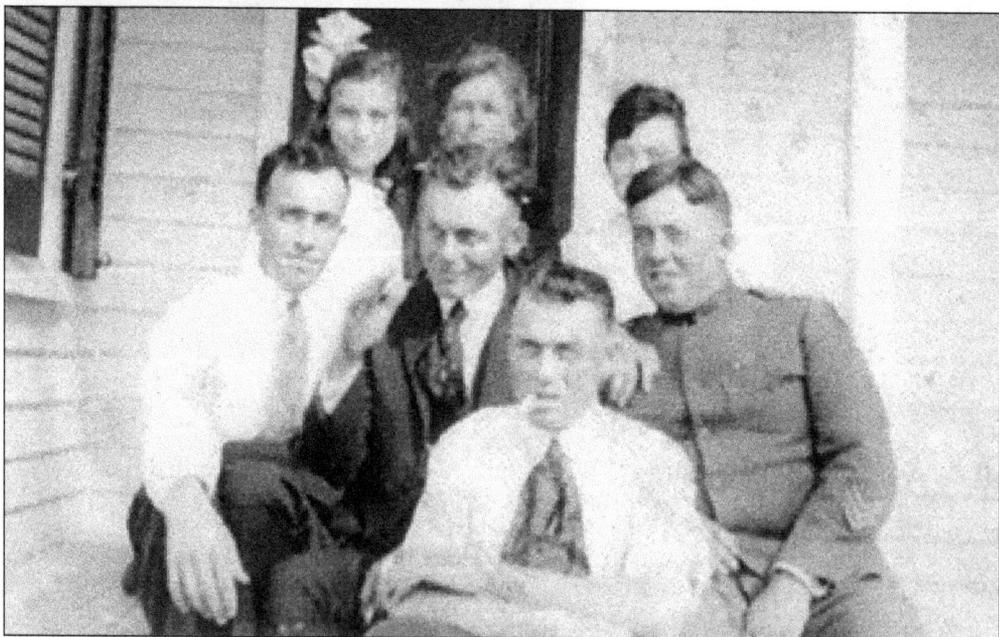

Mrs. Mary Susan Evans Rowe Guy (known as Sis or Mom Sis) lived from 1869 to 1937. Mom Sis is on the front porch of her home with her six children: Charles Rowe, Lois Guy, Frank Guy, Herb Guy, Mary Guy, and Allen Rowe. Mr. Benjamin F. Rowe died young from typhoid fever. Mr. Benjamin F. Guy dropped dead in his fishing boat. Life was not easy but families stayed together and were strong.

David Johnson ("Reddy") was the oldest son of Betsy Kelly Wallace and George Lennon Johnson. He was born October 5, 1869. Reddy was the treasurer of Elizabeth City County, Virginia and was an excellent speaker. He died April 20, 1932. He was married to Sally Horton. They had four sons: Marion, Joe Raymond, Ernest, and David.

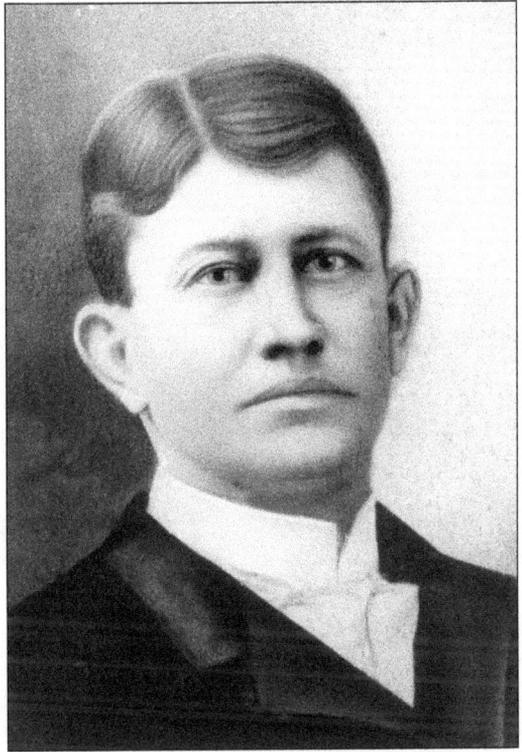

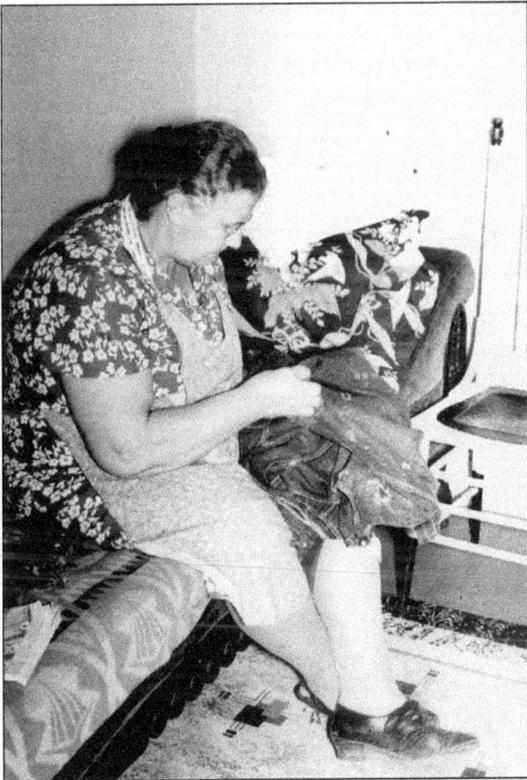

Mrs. Johnny Evans (Katie), a fisherman's wife, is mending work overalls in the kitchen of her home. The kitchen was the heart of this home. There was a wood burning cook stove that heated water too. She bathed her children in front of the stove and cooked delicious meals for family and friends. Katie is the daughter of George Johnson and Betsy Kelly Wallace. She was the mother of nine children and seven grew to adulthood. She loved flower gardening. This picture was taken in 1940 by Howard Cole.

Long Creek is a prominent body of water, which runs north to south in Fox Hill. No one actually knows when and why the name was changed to Grundland.

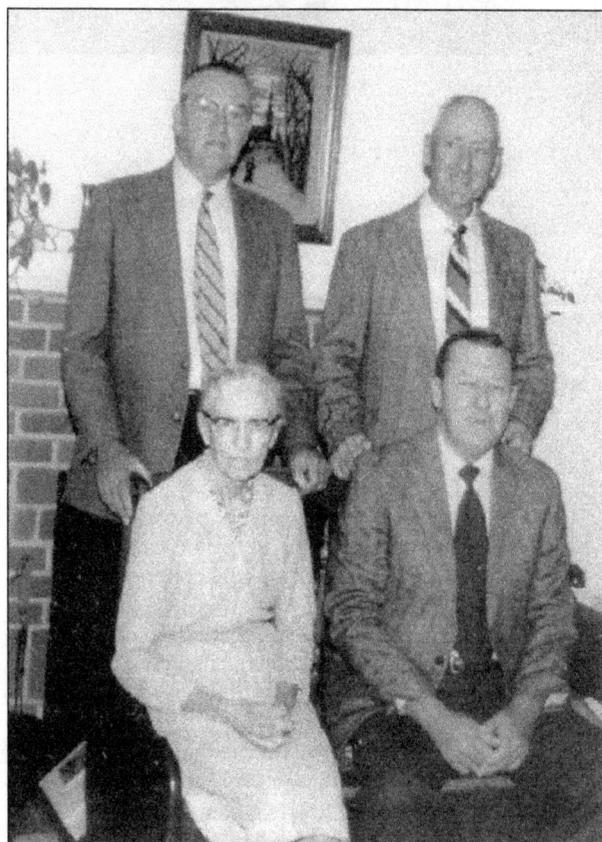

Vera Johnson Wallace is pictured with her three sons: (front row) Irving Wallace; (back row) Benny Wallace and Billy Wallace. Benny Wallace was the owner of Wallace Marina.

The following salutatory address was given by Vera Johnson at the Anti-Vaccination School of Fox Hill on May 27, 1907.

"Ladies and Gentlemen:

It is my most agreeable duty to welcome you to the exercises of this hour. It is not only a duty which I cheerfully perform, but I consider it a rare honor and a high privilege to stand here before you in the cause of education. The class of '07 extend to you a most cordial welcome. With the close of today we will have reached that goal towards which we have been striving for eight long, get seemingly short, years. We must now enter upon the greater field of life which lies stretched out before us. We must cast away our school privileges and pleasures, only to hold them with the firm grasp of our memories, and assume those graver burdens which beset us as we leave the threshold of the school so dear to us. Our equipment is good, our armor strong, so let us meet our worldly battles face to face, remembering that a nation looks to her schools for men and women of brains. The time is now at hand when it is necessary for us as a class, to part; but we can defy those circumstances to arise which can weaken these ties of friendship so dearly formed by us during our school course. In future years, in both prosperity and disaster, they can be but a source of the greatest pleasure and comfort to us. Let confidence and truth abide with us forevermore. We go forth as members of a large family, to meet again when occasion offers always ready to help one another, and never forgetting to honor our Anti-vaccination School. Let this evening be the brightest and happiest of our school course, and although we have but few hours while we still have them with us. As we pause today upon the dividing ground between two periods in our lives, and look back over the varied experiences of our school life, with its cheerfulness and its pleasures, its rivalries and ambitions, its duties and generous friendships, we cannot avoid a feeling of sadness that comes with the thought of parting. The influence of our school days has left a lasting impress upon our minds and hearts. It pervades the inmost recesses of our natures. It has become a guiding principle on our lives. It molds our character. It shapes our destinies. Our life work lies before us. A life of the highest endeavor can alone repay the debt we owe to our school. As we go from this hall into the battle tumult of the world where our mission is to be achieved and our rank among men decided, she bids us take up the line of advance into the future, and press with earnest purpose to noblest aims. In after years as we pursue our respective courses in the great arena of life there will yet come to us thru the enriching haze of time our teacher's kindly words of advice and counsel. The lofty ideals of life and character that he has sought to implant in our minds and hearts will then be appreciated and realized as they have never been before. Inspired and guided by these ideals we will the better be enabled to fulfill the duties of life, to over come the temptations that beset our ways and to hasten the march of man onward to the glorious realization of the Universal Brotherhood of man. This I firmly believe to be the trend of humanity. We are about to take our place in the great van of life to help it ever onward to this goal of supreme perfection. Ours the opportunity, ours the task and ours the duty to perform. And in the performance of our duty what sweet pleasures, what infinite joy what laurels await our brows only the discerning eye of time have knowledge of. How true are the words of Ruskin when he wrote:

'How near is grandeur to our dust
How near to God is man
When duty whispers low thou must
And youth replies I can.' "

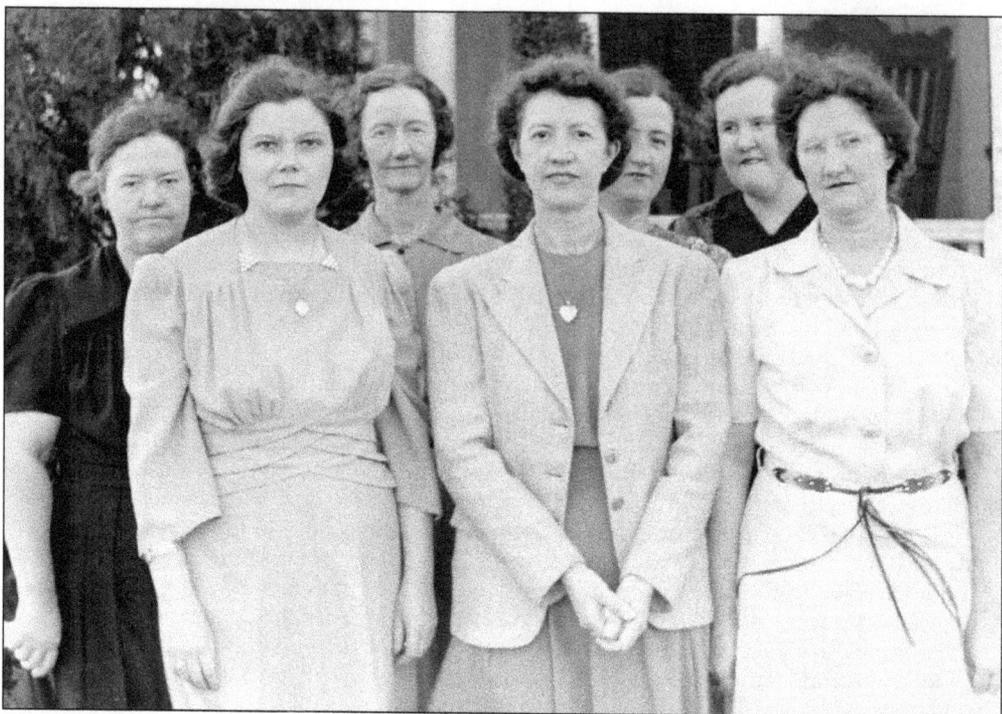

The Johnson sisters pose with other family members on a Sunday afternoon. They are, from left to right, Elizabeth (Biddy) Hunt (who is a married to a cousin, George Evans), Lina, Hazel, Irma (first cousin), Ethel, Gracie, and Dorothy Holston Todd (cousin).

The Evans cousins are in front of the barn at 208 Beach Road on a snowy day in 1965. They are, from left to right, Johnny Evans, Jake Evans, Joe Evans, Tommy Evans, and a friend, Clifton Rowe.

Jennings Johnson ("Red") was the son of Zacheus and Vashti Johnson. He was born June 21, 1908 and died January 23, 1960. As you can tell, he was a great baseball player and played on the Fox Hill team. Red worked for Newport News Shipyard. He was fun to be around and loved to tease Betsy Evans.

Seated on the left is Alfred F. Johnson, who was born January 1, 1887, and died October 24, 1950. He was the son of James F. Johnson. His wife was Ellen Virginia (born November 14, 1892 and died June 23, 1949), and their daughter is Virginia Johnson Clark, our renowned historian. Seated next to Alfred is Jeffery "Jetty" Johnson (September 13, 1886–February 27, 1908), the son of Sam Johnson and the brother of Claude Johnson.

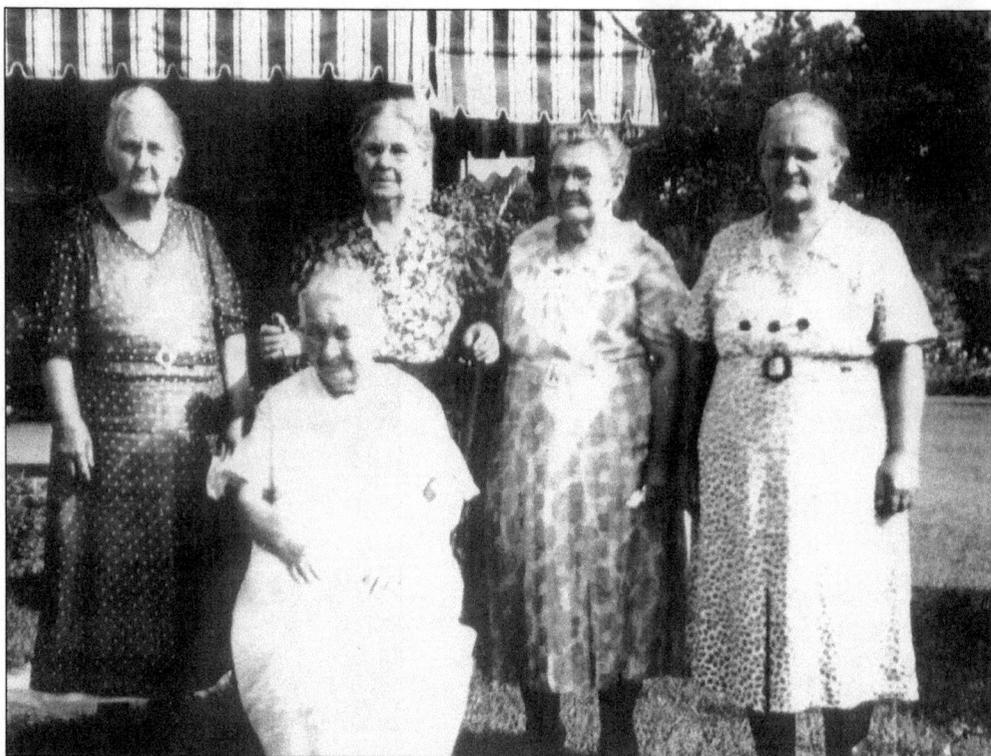

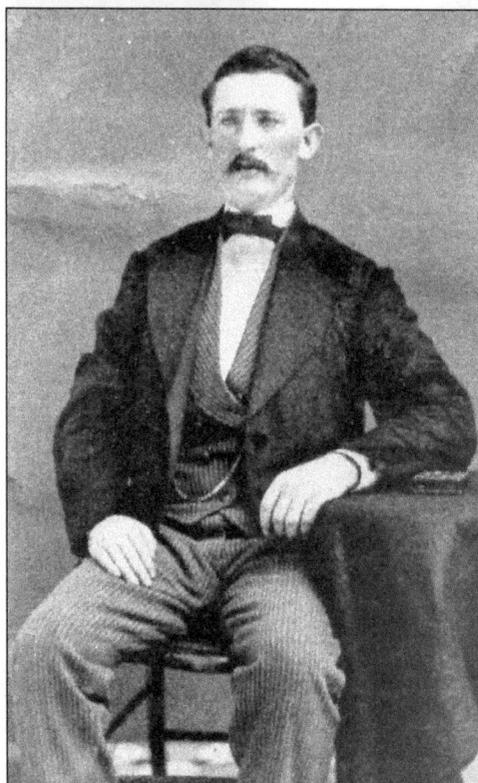

James ("Tank") and Teresa Hubbard Johnson ("Tootsie") had 10 children: William, Bud, Lipscomb, Joseph, Molly, Lonnie, Lula, Annie, Virginia, and Gertrude. Standing from left to right are the following: Virginia Johnson (May 23, 1865–December 26, 1946), Mary Elizabeth Johnson "Molly" Wyatt (January 12, 1870–November 5, 1952), Annie Laurie Johnson Lewis (November 7, 1872–February 26, 1942), Gertrude Johnson Roberson "Gertie" (1878), and Eleanor Lenorah Johnson Woodley "Lonnie" (1860–1945).

David Wallace Johnson was the son of William Johnson Jr. and Mary A. Topping ("Sara"). He was born June 2, 1857. He married Virginia Teresa Johnson, the daughter of James "Tank" Johnson and Teresa Hubbard Johnson ("Tootsie") in 1883. David died June 27, 1920. His children are Jane Johnson Johnson (married A.L. Johnson), Ethel Johnson Routten Collie, Margaret Johnson Routten, Herbert Johnson, and James "Beanie" Johnson.

Richard C. Topping, known to all as "Brownie," and Pearl V. married in 1921, pictured here in June that year. He was 29 and she 22. They had two daughters, Mary Elizabeth and Helen Knewstep. A son, Richard Jr., died soon after birth. They were the proud grandparents of four; one granddaughter they raised. Brownie was a self-employed carpenter/contractor, working for Fort Monroe and building many homes in Buckroe, Phoebus, and Hampton. He loved people and a good time. He called square-dances at the Grandview Dance Hall in Fox Hill and could sing all of the old hymns with sweet justice. He fished all of his life and had a great reverence for the water. He built a boat every winter, which he'd sell come spring.

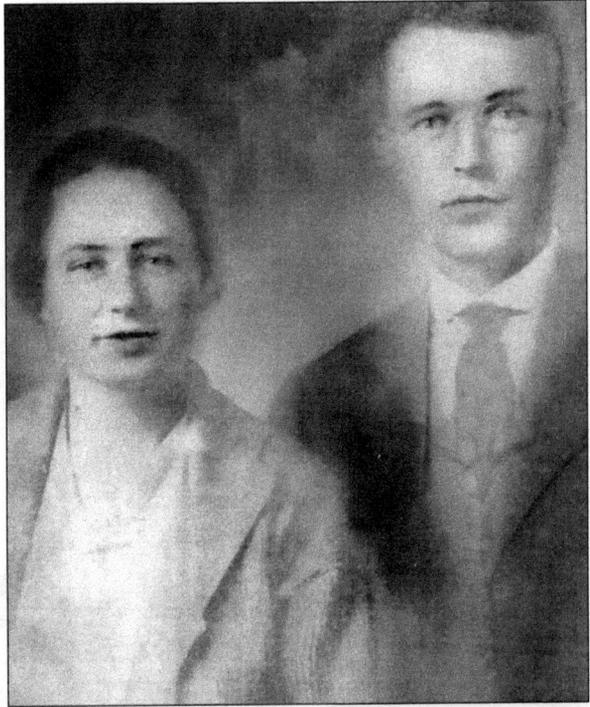

Pearl Topping was resultant, resourceful, and remarkable, a multi-talented, extremely intelligent lady. She raised chickens and sold the eggs to the military bases. When the granddaughter she raised was old enough to go to school, Pearl went to work for the Maida Developing Co. until she retired. If Pearl wanted a new table, she simply took what tools of Brownie's she needed and built one. If she wanted to have a lovely scarf, she made herself one. Pearl had a lifelong love of automobiles. She knew them inside and out and mechanically. She liked her cars fast and flashy. Deeply rooted in their own religious upbringing, neither Brownie nor Pearl were strangers to hard times or hard work. They are sorely missed. Shown here at Easter in 1942, from left to right, are Brownie, Pearl, Elizabeth, and Helen.

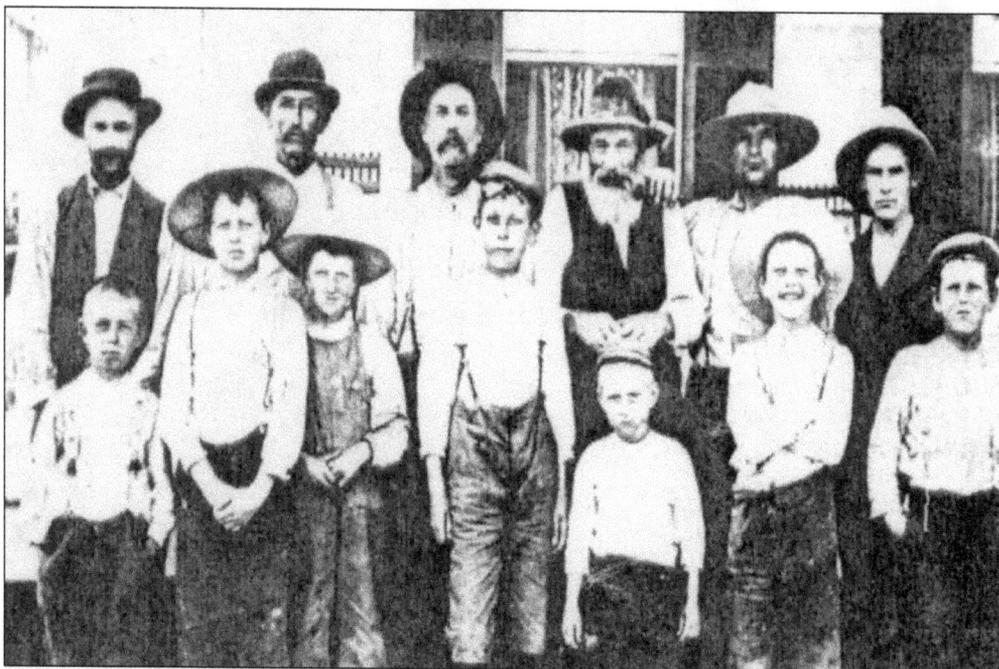

This picture was taken about 1908 in front of the residence of William F. Wallace, Wallace Road in Fox Hill, Virginia. Shown here, from left to right, are the following: (front row) Earl Wallace, Howard Lewis, Vic Watson, Andrew Cole, Paul Routten, Elmer Wallace, and William Routten; (back row) William F. Wallace, George Watson, Martin Lewis, Charles T. Wallace, George Oldfield, and Emmett Holston.

This is a typical fish shanty, which was the workplace for fisherman and where they ate and where their equipment was stored. This shanty, at the end of Dandy Point Road, was owned by Callie Wallace. Pictured is Callie with his wife, Lottie Johnson Wallace (on left) and a friend.

Joseph Severn Wallace and his wife, Rosa Watson Wallace, celebrated their 50th wedding anniversary in 1927. Joseph Severn Wallace was the son of John Thomas Wallace and Elizabeth Kirby Patrick. Rosa Watson Wallace was the daughter of Mary Francis Wallace and Thomas Teagle Watson and the granddaughter of David Wallace and Roseanna Fitchett.

This 1909 wedding photo is of Jesse Lee Wallace and wife Georgie Hornsby Wallace. Jesse Lee Wallace was the son of Joseph Severn Wallace and Rosa Watson Wallace. Georgie Hornsby Wallace was the daughter of Calvin Hornsby and Nellie Thurston Shields.

99

William Parker Wallace was born in Fox Hill on February 21, 1829 and lived here all of his life. He made his living on the water. He owned a sloop he sailed to Baltimore to take fresh seafood for sale in the city markets. On his return trips, his cargo consisted of household goods only available from large cities, and he operated one of the few general stores in this area. During the Civil War, on a patrol visit, the Federals stopped by the Wallace Farm only to find Captain Wallace in bed sick. The doubting officer asked to see him and when taken to "Grandpa's" room, he saw Captain Wallace was indeed a sick man. Medicine was sent from Fortress Monroe that possibly saved his life. William Parker and his family attended First United Methodist Church, a distance of about three miles from where they lived. William P. Wallace gave a parcel of land for the purpose of erecting a church building. This new church became known as the Wallace Memorial Methodist Church and is still a very active congregation today. Mr. Wallace was 75 years old when he died October 13, 1904 in Fox Hill; he is buried in Clark Cemetery.

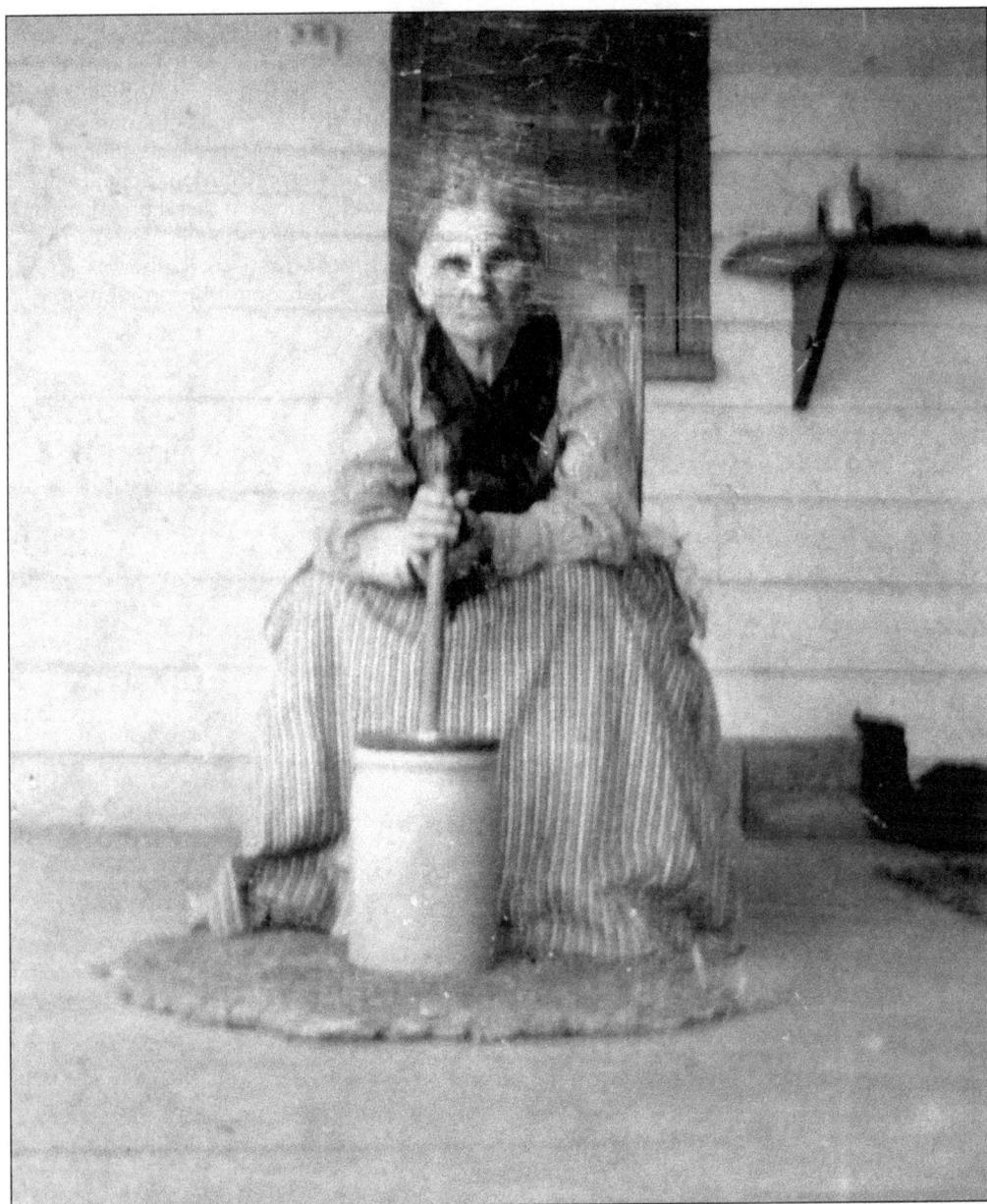

Mrs. Roseanna Fitchett Wallace (1802–1882), wife of David Thomas Wallace, is seated in front of her butter churn on the porch of her home in Fox Hill. Roseanna was from Somerset County, Maryland. She was the mother of nine children and was her husband's second wife. Elizabeth Kelly Wallace ("Betsy Kelly") was her youngest child. One son, Robert Wallace, was one of the Back River Lighthouse Keepers. Another son, William Parker Wallace, was the founder of Wallace Memorial Church. When Roseanna died in 1882, she was buried next to her husband, David (born August 10, 1799 and died July 8, 1875) in the Wallace and Johnson Cemetery on Grundland Road in Fox Hill.

Mary Rowe Johnson is holding Mildred Rowe Wise. Mary was born in 1858 and died September 16, 1935. She married William James Johnson. They were the parents of Andrew, Thomas Jefferson, Vera, Mary Agnes Johnson Wallace, Vashti Johnson Johnson, Edna, Joseph, and Marvin. Vashti Johnson first married Zacheus Johnson and after he died, she married William "Pitch Will" Johnson, so she was technically Vashti Johnson Johnson Johnson.

Cordellia Wyatt ("Delia Ann") married William "Bill" Holston on December 29, 1863. They had 12 children. Delia Ann was born February 9, 1849 and died December 29, 1923. She is the daughter of John Saunders Wyatt and Susannah Bekke Johnson. Bill was born October 28, 1844 and died April 4, 1929. He is the son of John Thomas Holston and Elizabeth Ann Johnson. Bill was a blacksmith.

John Evans (1832–1875) came with John Saunders Wyatt in a sailboat at the age of 13. He was a sailor and boatman all his life and was listed in the census as a sailor. He married Mary Elizabeth Wyatt Evans, the daughter of John Saunders Wyatt and Susannah Bekke Johnson and older sister of Sarah Virginia Wyatt. She was a widow at age 28 and died the same year. Their home was located in Fox Hill on Harris Creek where John docked his schooner (*The Spray*). They had four children—Tom, Johnny, Mary, and Rosa. Their descendants continue to live in Fox Hill.

Mary (1846–1875) was a beautiful woman who died too young. She was born December 15, 1846. Her children were raised by her parents and siblings, but unfortunately, like most orphans, their childhood was difficult and troubled without her care and love. Mary and John are buried in unmarked graves in the Johnson Cemetery off Grundland Road in Fox Hill. Their grandson, Johnson Evans, said they are buried on the western side of the cemetery. This is probable because Mary's aunts and uncles are buried in that part of the cemetery (David Thomas and Rosanna Fitchett Wallace and David Samuel and Catherine Elizabeth Stores Johnson).

William Thomas Wyatt was born in 1855 at what was known as Black Jack, where Langley Field is today. Amelia Ann Routten, born in 1859, married William Thomas on December 7, 1876. He was a member of the Tuscarora Tribe #70 of Red Men and Bay View Lodge of Odd Fellows; an oyster and fisherman, a successful businessman, and a splendid citizen. He was a member of the Methodist Church and was known for his fine character. He was justice of the peace of Elizabeth City County in 1895. "Papa Buck" and "Aunt Melie" had seven children, including one set of twins. Amelia joined the church at the age of 12 and became a Sunday School teacher at the age of 20 while a member of First Church, Fox Hill. She taught Sunday School until the age of 92. Her life was characterized by her graciousness, kindness, sincerity, and her love for God.

William "Bill" Thomas Wyatt Jr. was the senior member of Wyatt Brothers firm, becoming head of the firm in 1936. He was the son of Amelia Ann Routten and W.T. Wyatt. Bill was born August 6, 1888. He died November 17, 1946 and is buried in Clark Cemetery. Bill was a man of sterling qualities and extremely popular with everyone who knew him. He was a member of the Hampton Baptist Church and the Hampton Lodge of Elks.

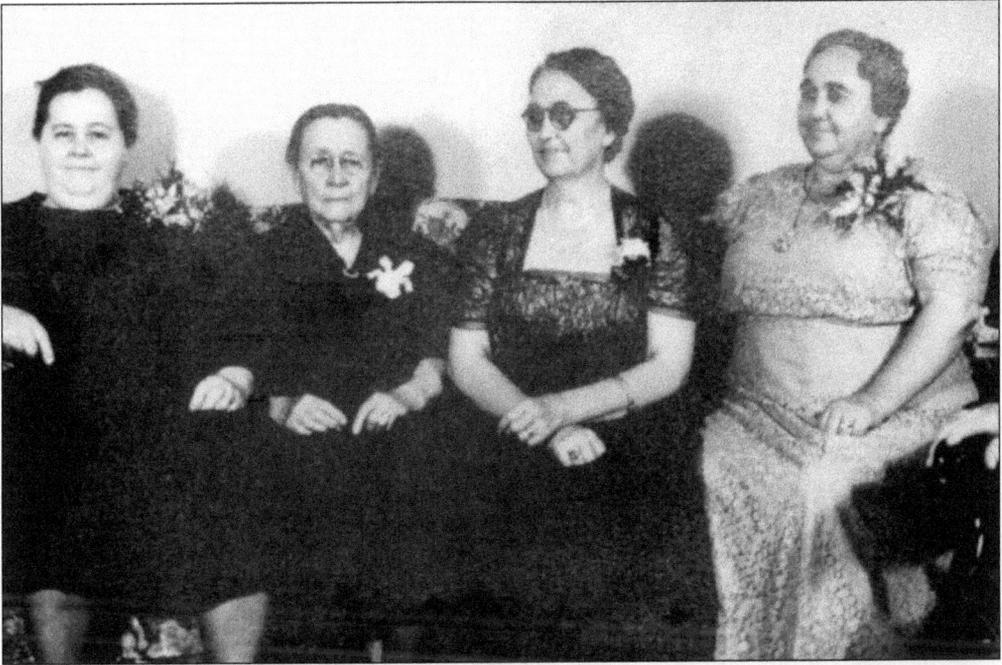

This family picture shows the Wyatt girls with their mother, from left to right, Clyde Verdilia Wyatt Lewis, Amelia "Aunt Melie" Wyatt (mother of the girls), Mary Wyatt Bentley, and Sue Wyatt Clark.

Bill and Alleyne Wyatt have two daughters: Betsy Wyatt Everette King and Barbara Wyatt Chandler. Bill was the owner/manager of Wyatt Brothers Clothing Store after the death of his two older brothers, "Windy" and "Jack" Wyatt.

Alonza L. ("Windy") Wyatt (top photograph) was born in 1880 and John S. ("Jack") Wyatt (bottom photograph) was born in 1881. They founded Wyatt Brothers Clothing Store in 1903 with a few hundred dollars of borrowed capital. The clothing store was a new venture for the Wyatts. Up until this time, they had fished with their father, William T. Wyatt. Their mother was the former Miss Amelia Routten, a Fox Hill belle who died in 1952 at the age of 93.

Abigail Routen Mason, pictured here c. 1851, was the wife of Levin Mason. She was survived by the following three children: Levin Mason II, John T. Mason, and Mary Mason Lewis.

Mildred Lewis and Vivian Routten Wilson bicycle to Grandview Beach to attend Fox Hill Central Church's sunrise service and breakfast in 1935.

Blanche Routten was born November 10, 1896. She married Edward Taylor Lewis and they were the parents of Eleanor, Mildred, and Carolyn Lewis. Blanche died January 28, 1987.

Edward and Blanche Lewis spent Easter Sunday 1953 with their daughters. The family is, from left to right, Mildred, Blanche, Edward, and Carolyn Lewis.

Sarah Eliza Holston Roaten was born May 5, 1823 and died in 1907. She was the Fox Hill midwife. She had three granddaughters: Emma, who married Tom Evans; Ida, who married Richard Routten; and Mary Elizabeth (Mag), who married William Wallace.

John William Holston was born in 1820. He was purported to have had two wives and fathered 26 children. His first wife was Elizabeth Ann Johnson, daughter of William Johnson.

The Oldfield family is, clockwise from top left, Beatrice, Doris, Alice, Mattie, Georgie, Delia Underwood Oldfield (Granny), and Myrtle. Delia was born June 13, 1870 and died December 14, 1952. She married George Henry Oldfield (born January 21, 1870 and died November 26, 1938). They had six children. Beatrice Ida married Edward Thomas (Ed Tom) Wyatt in 1913 and had one child, Edith Mae (who married Earl Councill Jr.). Myrtle married Vincent Lewis and had two children: Beulah (who married Preston Messick) and Charles Ray Lewis (who married Carolyn Porter). Georgie Oldfield married Harold Westcott and had three children: Betty, Tux, and Ann. Mattie married John William Lewis "Junk" and had two children: Harrison (who married Louise Tyler) and Ruth (who married a Martin). Alice married Buck Topping. Doris married Swanson Hunt.

Edith May Wyatt and Earl Councill are seen here. Edith is the daughter of Ed Tom and Beatrice Wyatt. Ed Tom ran the Do Drop Inn ice cream parlor, which was located at the corner of Beach and Willow Roads. Peppermint was a favorite flavor.

Gloria Elliott Case and Fred Brown Case visit Clark Cemetery in Fox Hill. Gloria is the sister of Charles Elliott.

Ilma Dixon Lewis (daughter of Taylor Dixon and Carrie Mae Morgan) is standing in front of a house that is representative of the architecture of the early 20th century in Fox Hill. Most houses were two-storied with a porch where families would sit and visit. It was also typical to have a picket fence along the front of the property to separate it from the road and the drainage ditch alongside. It also kept out wandering dogs or other animals. Each house had a "bridge" or walkway over the ditch. It was a frequent Halloween prank to remove the bridge from as many houses as possible.

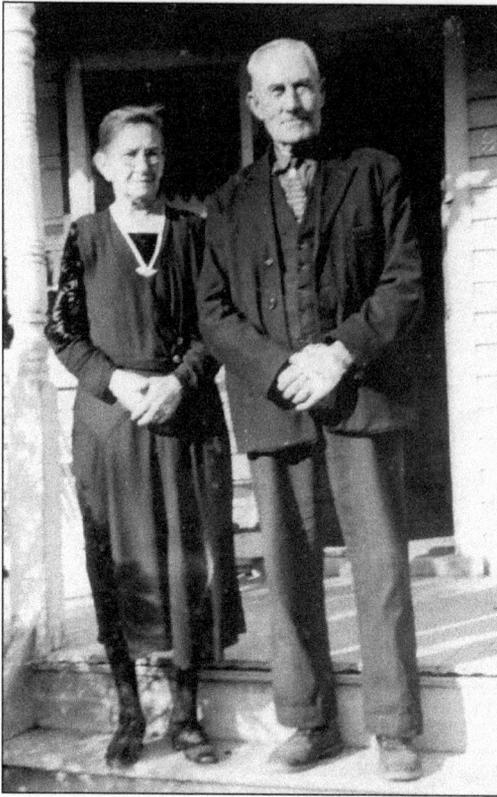

William Obadiah Elliott was the son of George Thomas Elliott and Emmaline Lewis Elliott and brother of Harriet Elliott Copeland. He was born August 13, 1863. Martha V. Wallace was born May 1, 1965. William and Martha were married on November 8, 1883 and lived on the corner of Beach and Grundland Roads. Martha died from diabetes on August 24, 1939. In his later years, William O. Elliott peddled fish from his old Model T Ford. William died June 10, 1956. Both Martha and William are buried in Clark Cemetery. William and Martha's daughter, Martha, married Clarence Mason.

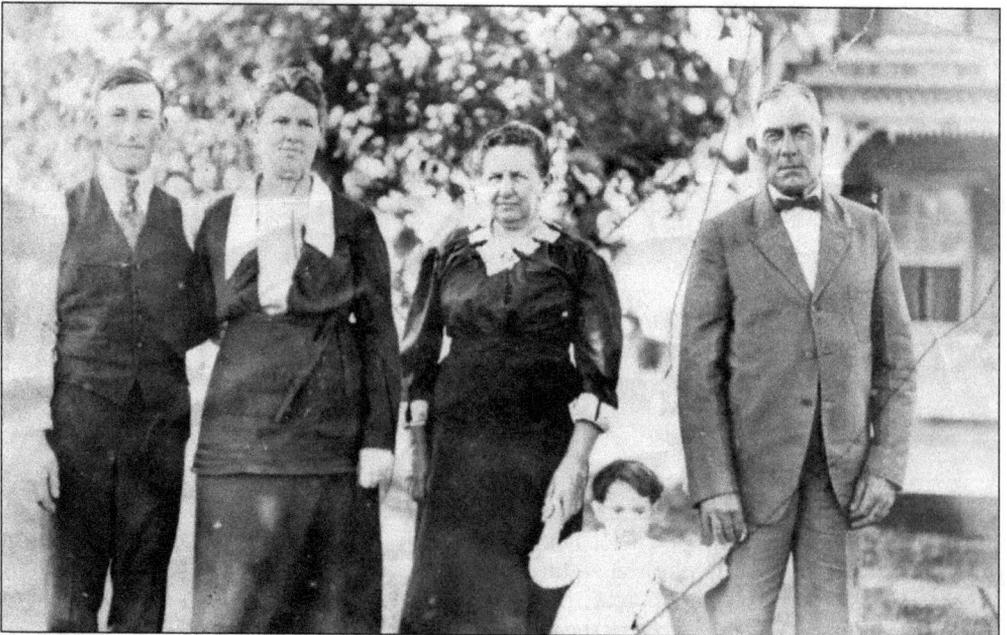

The Elliott/Mason family poses for a photograph. They are, from left to right, Clarence McCoy Mason, Martha Rebecca Elliott Mason, Martha V. and William Obediah Elliott, and Eleanor Elliott.

Clarence McCoy Mason was born April 18, 1896. He went into the seafood business with his brother, Thomas J. Mason. Their market was on Chestnut Avenue in Newport News. Their father, John T. Mason, also known as Captain Jack, died at the age of 93. He was a pound net fisherman until well advanced in age. Clarence worked in the Newport News Shipyard until he went to work with his brother Tom in the market. Clarence married Martha Elliott. Martha Elliott was born September 10, 1896. Clarence died May 14, 1972. Martha died October 16, 1991. Both are buried in Clark Cemetery.

John William Mason, here with Shirley Mason Green, is the son of Clarence and Martha Mason. He was born October 15, 1921 and was killed in action in the Invasion of Normandy on June 6, 1944. Shirley Mason Green is the only daughter of Clarence and Martha Mason. She was was born March 2, 1925. Shirley married Robert Green. Robert was born September 21, 1921 and died December 26, 1982. Shirley and Robert have two children: Robert and Mason.

Emma Elliott Moon ("Emmie") was Charles Elliott's aunt and the daughter of "Al" and Matt Elliott. Emmie is pictured here with her car. This car was the love of her life. Each night she would put it to "bed" by wrapping it in quilts. Notice the wooden spoke wheels and small whitewall tires.

Emma's tombstone is typical of the tombstones in Clark Cemetery. While the cemetery does not have rules on the type of tombstone allowed, this is the style commonly used.

Lola Mae Lewis Stewart (December 21, 1902–August 17, 1942) poses with her father, William Franklin Lewis, c. 1920. William (January 2, 1876–March 22, 1960) was the oldest of 11 children born to Martin and Mary Lewis. He married the former Rosa Lee Evans (born June 27, 1875 and died June 15, 1955) and had two children, Howard and Lola. William was a waterman for the first half of his adult life and in the latter half was employed by the federal government at Fort Monroe, Virginia. He was also the teacher of what is now the Fidelis Sunday School Class at Fox Hill Central United Methodist Church. That class is now taught by his niece, Mildred Lewis.

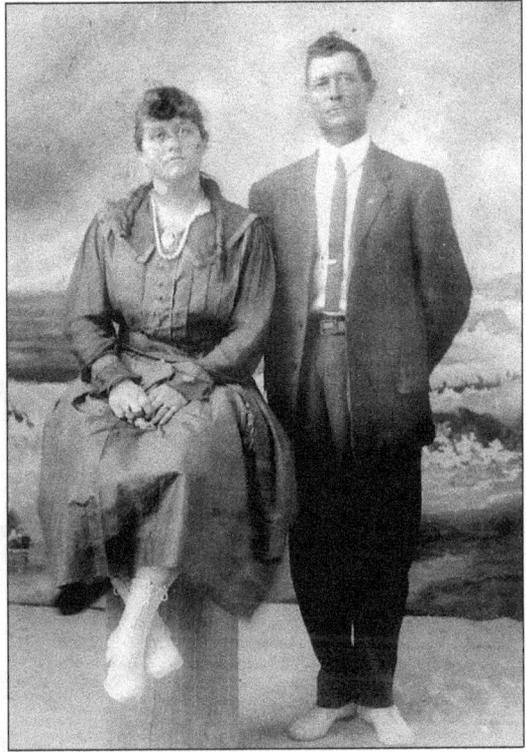

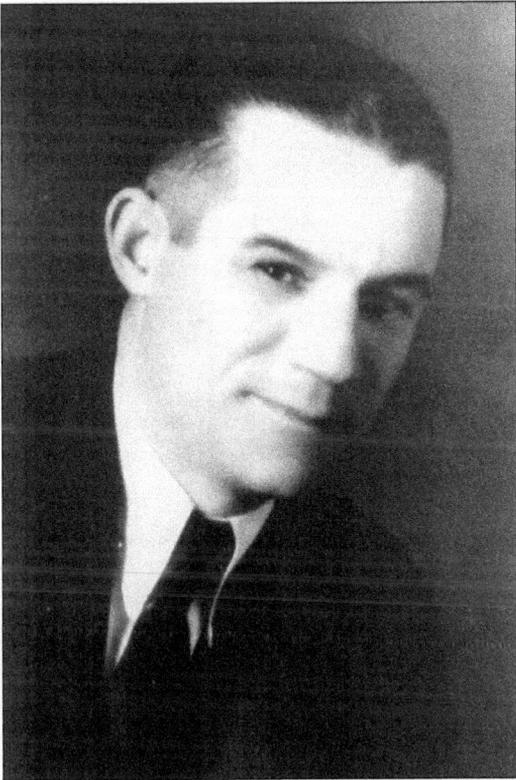

At the age of 22, Lola Mae Lewis married Duncan Stewart. Duncan (born March 27, 1902 and died February 13, 1944) came from Neilston, Scotland when he was a small child. He was employed by Hampton University and painted the decorative dome of the concert hall. The hall itself has been painted since, but the dome has remained the same as it was when Duncan painted it. Duncan and Lola had three children: Duncan Jr., David, and William.

Duncan Stewart Jr. was the eldest son of Lola Lewis and Duncan Stewart. Duncan was born October 25, 1934 and died September 14, 1995. He was a lifelong Fox Hill resident and member of Fox Hill Central United Methodist Church. He retired after 39 years of service from Newport News Shipbuilding where he led the Steel Hull Fabrication Division. He also designed the replicas of the *Godspeed* and *Discovery*, which are located at Jamestown Festival Park.

David Steward is the son of Duncan and Lola Lewis Stewart. He was born August 11, 1937. David attended the Shenandoah Conservatory of Music. After graduating college, David made his home in Northern Virginia. There he worked as an educator in Fairfax County for 30 years and was also a baritone soloist and assistant to the director at the National Methodist Church in Washington, D.C. He currently operates his own business from his home in Great Falls, Virginia. After their mother died in 1942 and their father in 1944, Duncan and David were raised by their grandmother, Rosie Evans Lewis. The third son, William, was raised by Laura Lewis Hayes and Dan Hayes.

William Stewart (known as Bill Hayes) is the son of Duncan and Lola Stewart. He was born March 7, 1942. When his father died, he was adopted and raised by Laura Lewis Hayes and her husband Dan Hayes. Laura was the daughter of George Reilly Lewis and Clyde Wyatt. After graduating high school, William began work at what was then known as Poquoson Motors. He is currently the president and general manager of Pomoco Chrysler-Jeep of Hampton and the vice-president of the Pomoco Auto Group.

Jewel Mae Lewis Winn is the daughter of Howard Lewis and Rose Cunningham Lewis. Rose died when Jewel was six. Her grandfather is William Franklin Lewis. Jewel has been the organist for Central United Methodist Church for many years. She teaches piano to the local children. She married LaVern Winn and had five children: Jewel Mae Winn Mason, Larry Winn, Joanie Winn Beatty, LaVern Winn, and Sabrina Winn.

John Thomas Wallace was born May 15, 1884. Alice Agatha Pauls was born February 16, 1889. John and Alice, shown here at their 50th Wedding Anniversary, were married June 8, 1905. They had seven children: Clifton Lee, James Edwin, William Francis, Virginia Alice, Gladys Marie, Grace Frances, and John Thomas Wallace Jr. John Thomas Wallace, who had his own fish vending business, died July 13, 1957, and Alice died August 25, 1974.

Andrew C. Johnson and Beatrice C. Holston celebrate their 50th wedding anniversary. Andrew was born July 2, 1886. Beatrice was born June 3, 1891. Andrew and Beatrice were married November 24, 1909. They had 11 children: Hasting, Rupert, Aretha, Paul, Elroy, Otis, Hilda, Maxine, Phyllis, Barbara, and Burley. Andrew was a fisherman for the first part of his life. Later, he worked as a carpenter for the federal government at Fort Monroe, Virginia. Andrew died March 17, 1978 and Beatrice died December 31, 1983.

Four

HOME GROWN HEROES

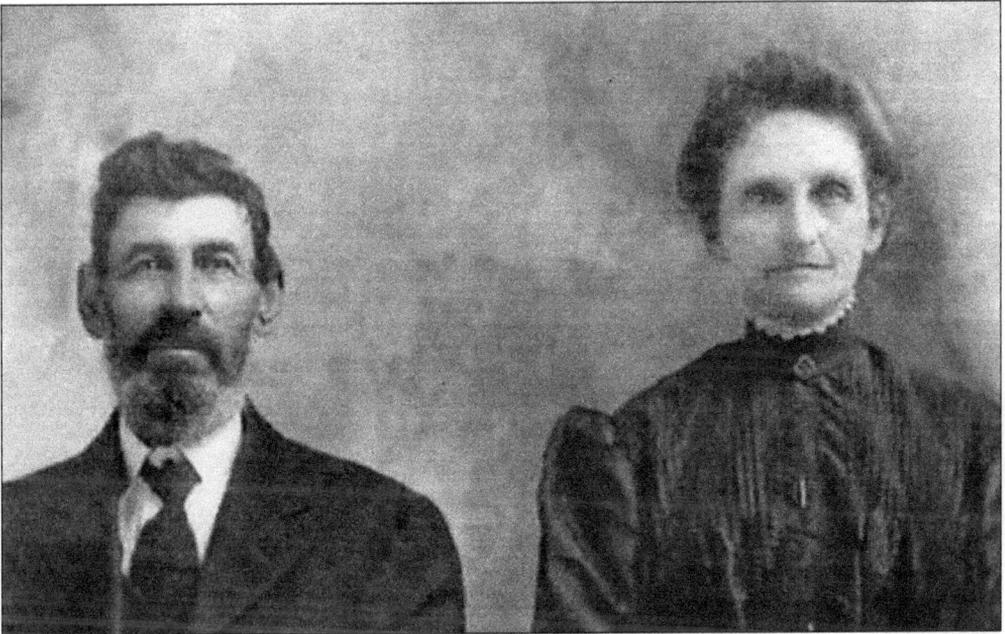

This picture depicts the beloved great-grandparents of Ann Evans Perry and all of her Routten cousins. They are John Thomas (born February 15, 1842 and died November 22, 1935) and Catherine Guy Cain (born March 3, 1852 and died October 24, 1926). Mr. Cain was the last Elizabeth City County native-born survivor of the Confederate Army. He served with the Old Dominion Dragoons. It was said to have been a crack organization, leaving Hampton when the first troops were called by the Confederate Army. Ann remembers seeing him when she was a child, since he lived until 1935.

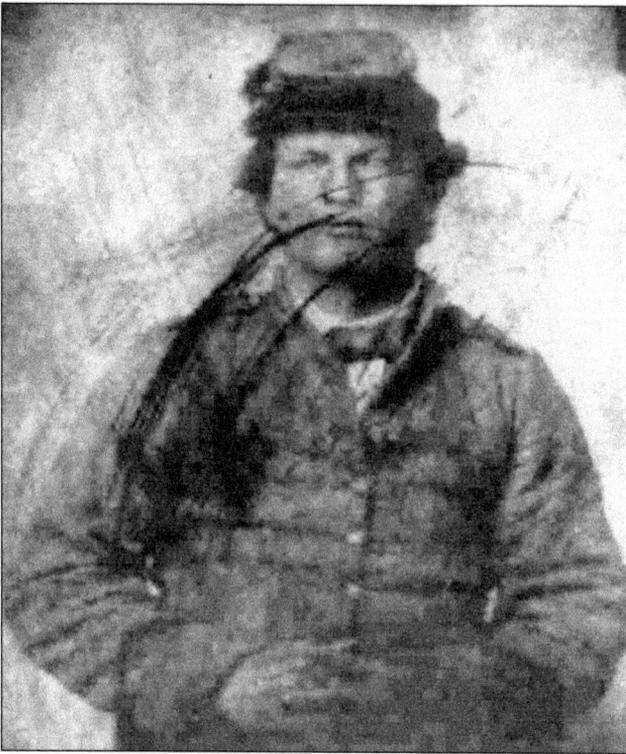

Adolphus Guy stands here in uniform during the Civil War. Adolphus Guy was born April 12, 1841 in Elizabeth City County. He was the son of William H. and Catherine Snead Guy. Adolphus Guy was a stone cutter, having served his apprenticeship with a stone mason. Family lore says that he cut stones used at Fort Wool, which is a man-made island in Hampton Roads. On June 5, 1861 at Yorktown, Virginia, Adolphus enlisted in the Army of the Confederate States of America. He fought until the end of the war, with the exception of three months when he was recovering from a wound. He served in three different companies during the war, at one point under Robert E. Lee, who he thought was a great man and soldier.

Adolphus Guy had this picture taken at the celebration of his 72nd birthday. After the war, Adolphus returned to the family farm in Fox Hill. He married Sophia Benthall. The first of their 11 children was born in 1867. The same year, Adolphus purchased a part of the family farm and became a farmer. The Guy family was active in the Methodist Church. Adolphus served as a steward of the church and treasurer of the Sunday School. Adolphus Guy died March 5, 1919, at almost 78 years of age.

Ernest Rowe, shown here in training, was married to Myra Wallace. He worked at Newport News Shipyard and loved to hunt and fish. Ernest and Myra had two children: Amos Rowe and Mildred Rowe Wise. His grandchildren can be proud of his legacy.

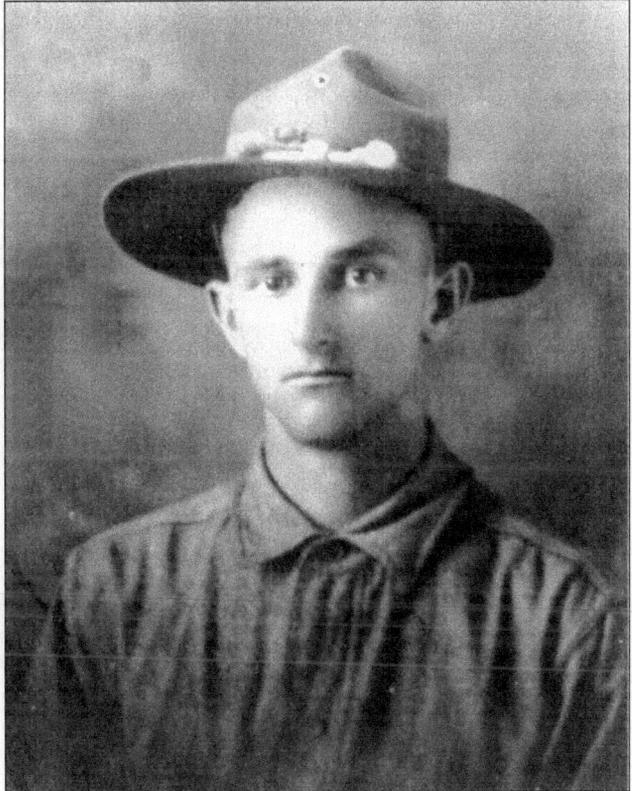

Raymond Linwood Johnson married Edith Spencer. They had three children: Anna Marie Johnson Smith, Betty Frances Johnson Johnson (who married Henry Johnson Jr.), and Neal Johnson. Raymond was the son of Robert Samuel Johnson ("Dipper"), who was a veteran of the Civil War and fought under Robert E. Lee.

Fifty-eight years and eight days after Edward M. "Sody" Smith Jr. risked his own life to save that of a fellow B-24 Liberator crew member, the U.S. Army finally recognized his act of bravery with the Distinguished Flying Cross. On New Year's Day, 1945, during what began as a routine bombing run over Coblenz, Germany, three bombs dropped as planned, but the fourth did not release, thus leaving an armed bomb dangling out of the bay. The nose gunner, Gale J. Raymond, went to fix the problem and was able to kick the bomb free. Due to a lack of oxygen, however, Raymond passed out. Smith went to check on Raymond and pulled him to safety. Paperwork being what it is, the war ended before Smith received a medal. After meeting Raymond at a reunion, Smith contacted the former commander of American Legion Post #48, Hampton, who helped him apply for the long overdue medal. A letter from the Air Force Board for Correction of Military Records informed Smith of the good news.

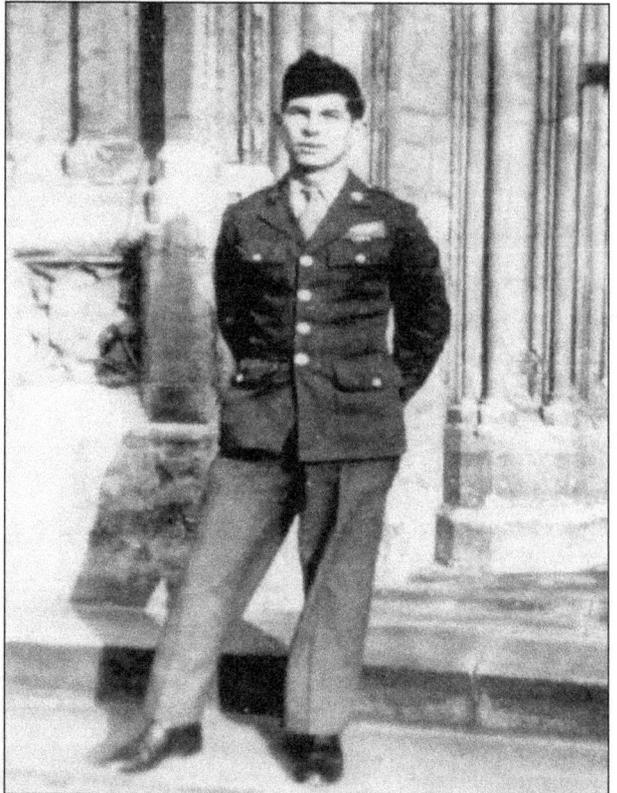

Edward M. Smith Jr. is pictured here in 1944 in London, England.

Donald A. Johnson of the U.S. Marine Corps is the son of Frances and Marvin Johnson. He returned home safely after serving in World War II.

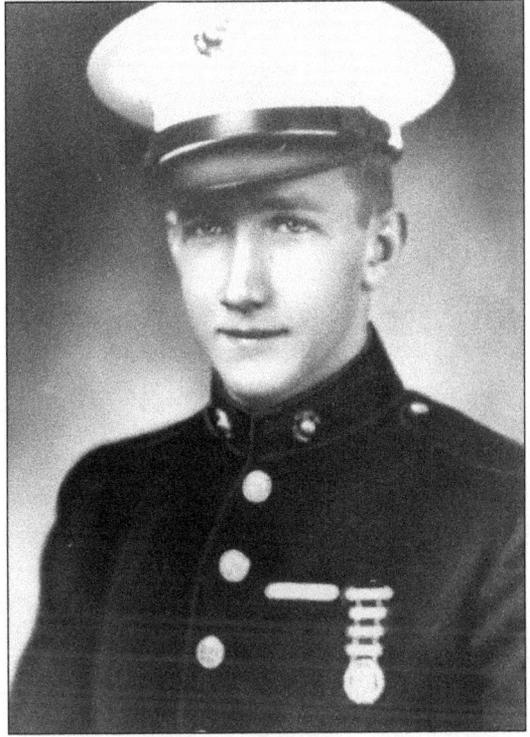

Linwood Wallace "Pappy" served in World War II and returned home to raise a family.

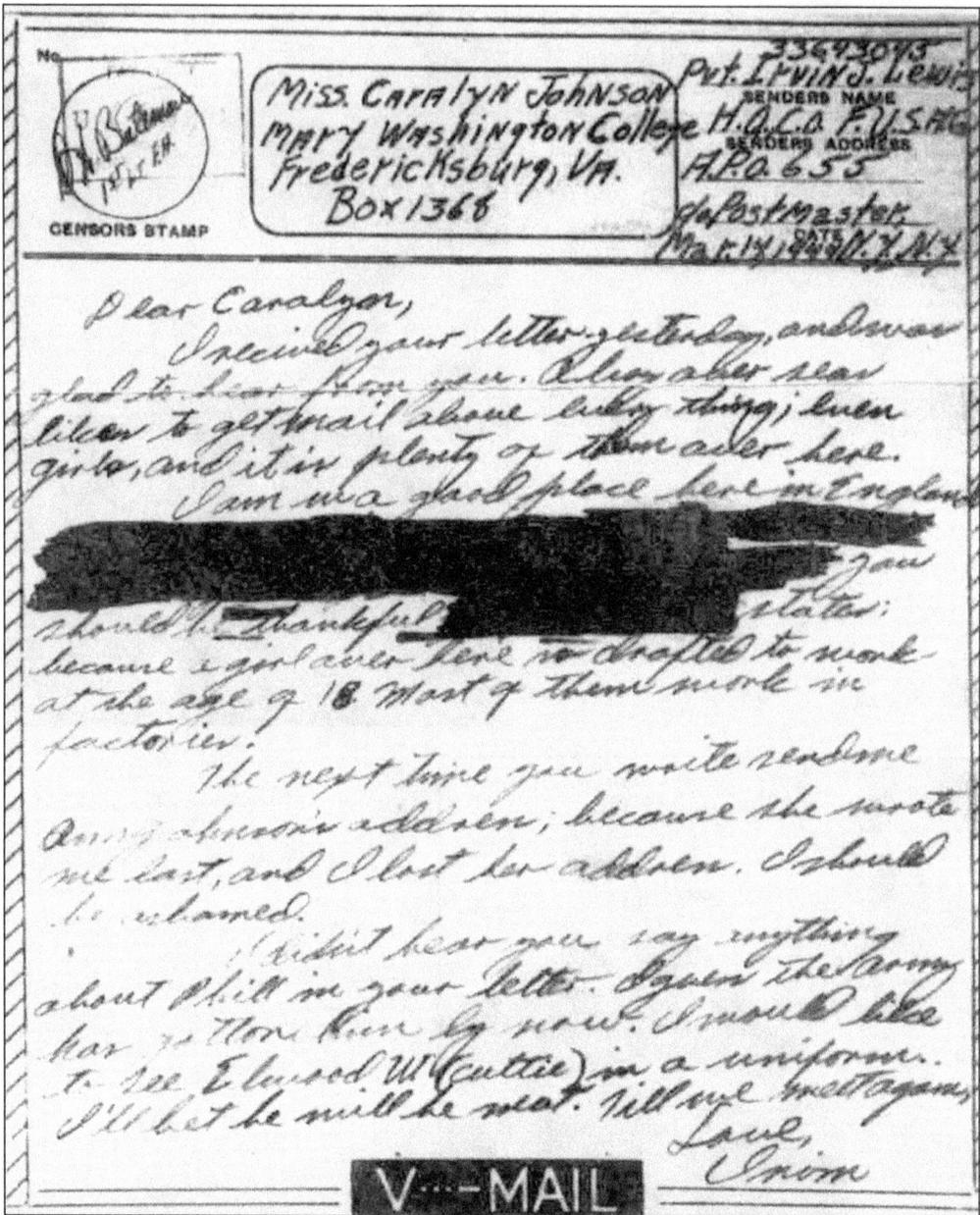

Dear Caralyn,

I received your letter yesterday, and was glad to hear from you. Also over seas like us to get mail above lucky thing, even girls, and it is plenty of them over here.

I am in a good place here in England ████████████████████████████████ you should be thankful ████████████████████ states; because a girl over here is drafted to work at the age of 18. Most of them work in factories.

The next time you write send me Amy Johnson's address; because she wrote me last, and I lost her address. I should be ashamed.

I didn't hear you say anything about Phill in your letter. I guess the Army has gotten him by now. I would like to see Elwood W. (Cuttie) in a uniform. I'll bet he will be neat. Till we meet again,

Love,
Irvin

V---MAIL

This is an example of V-Mail from Irvin Lewis, HQ lst Army Group, Xll Army Group. Lewis was in England until July 31, 1944. Then he traveled to France and Germany. The blacked out lines are censored. The envelope was mailed in 1944 through the U.S. Postal Service.

To the men and women of Fox Hill, Elizabeth City County,
now the City of Hampton, Virginia.

In 1941 Fox Hill had a population of approximately 600 to 700. This small community
sent 90 people to the military to serve their country. These men and women
served in every branch of service. Some were wounded, some were prisoners of war,
and some were decorated for bravery. Of these men and women, 85 returned after
the war was over. Five did not return. They paid the supreme sacrifice.
We dedicate this bit of history in their memory.

Warren H. Bales, of the U.S. Army Air Corps, was the brother of Nancy Bales Routten and was killed in action.

Elvin Roy Mason, of the U.S. Navy, was the son of Mr. and Mrs. John A. Mason. He was killed in action.

Melvin Milton Melson, of the U.S. Army, was the son of Mr. "Rabbit" and Mrs. Daisy Melson and was killed in action.

Lewis Franklin Spencer, of the
U.S. Army, was killed in action.

John William Mason (Billy), of
the U.S. Navy, was the son of
Clarence and Martha Mason.
He was killed in the invasion
of Normandy, France in World
War II on June 6, 1944.

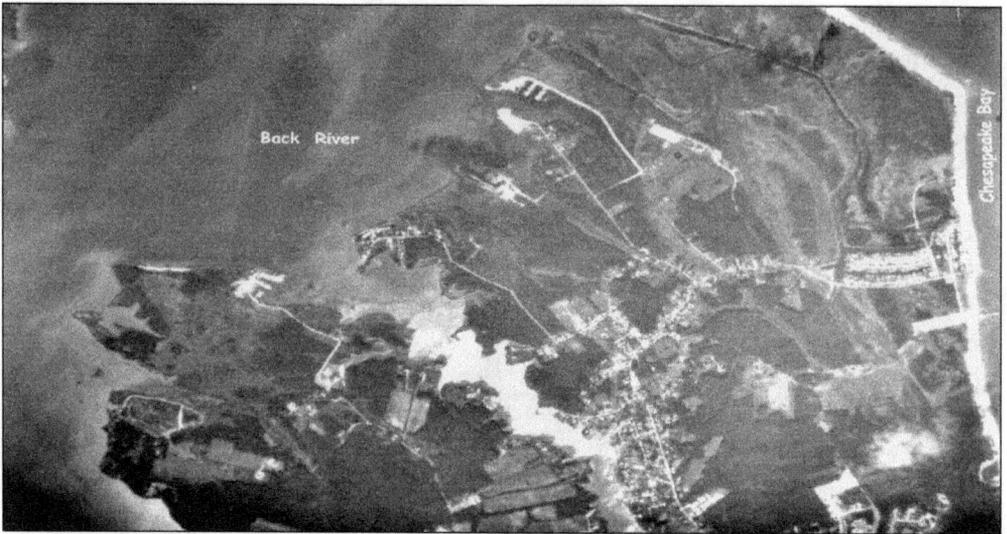

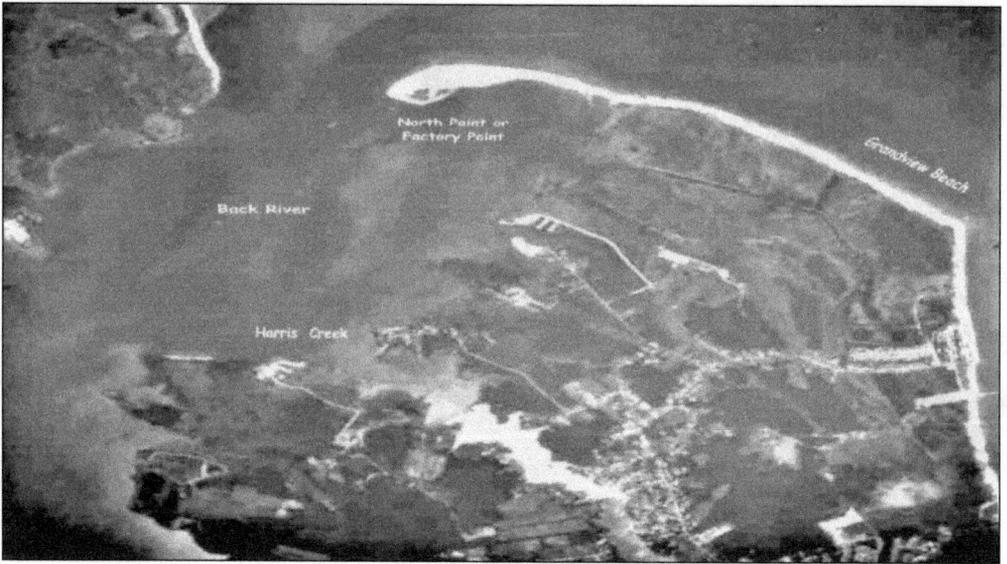

These aerial views show Fox Hill.